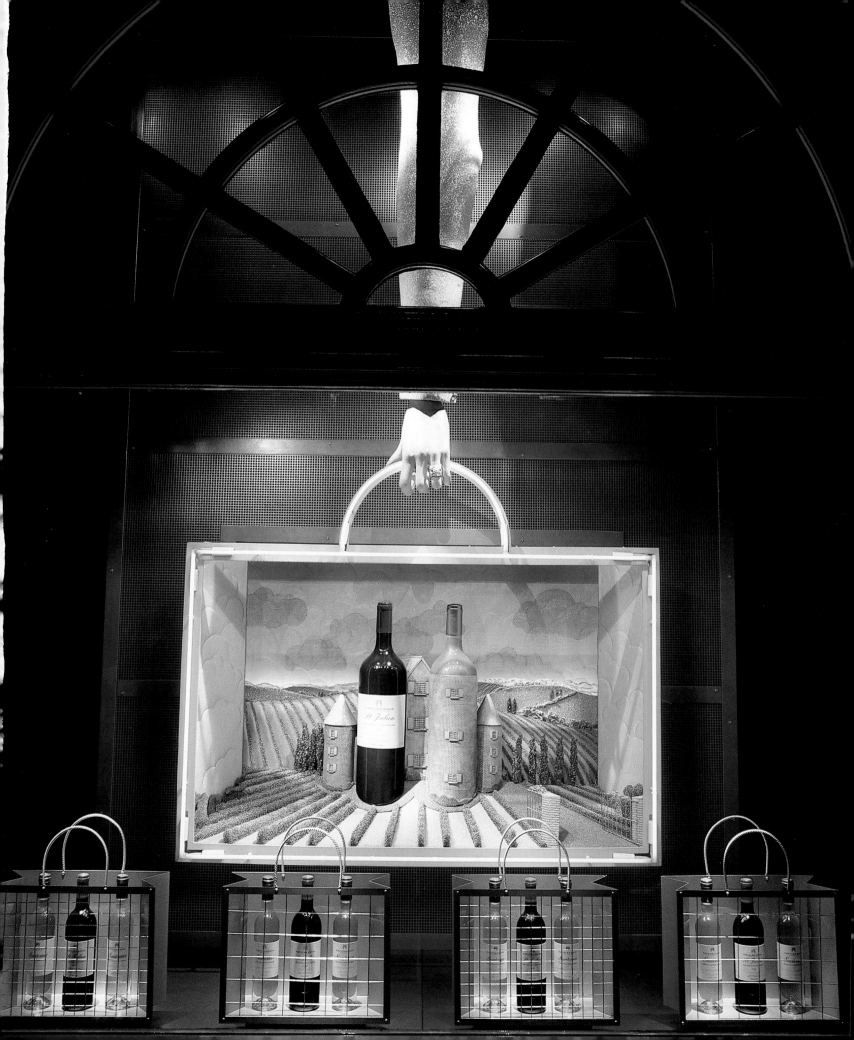

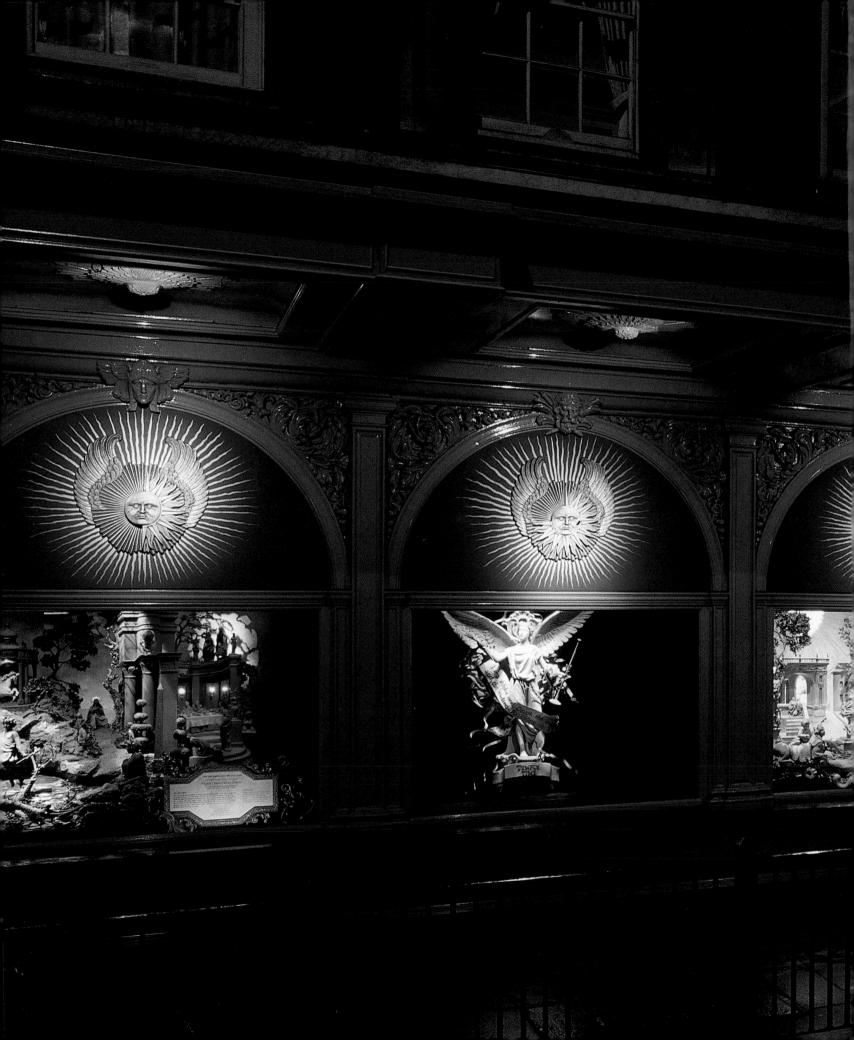

FORTNUM & MASON
WINDOWS FOR ALL SEASONS
CHRISTOPHER BLACKWELL

conran
OCTOPUS

CONTENTS

INTRODUCTION 6

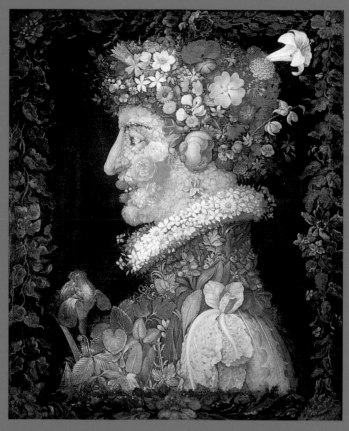

Spring – Giuseppe Archimboldo (1573)

The Human Seasons

Four Seasons fill the measure of the year;
There are four seasons in the mind of man:
He has his lusty Spring, when fancy clear
Takes in all beauty with an easy span:
He has his Summer, when luxuriously
Spring's honey'd cud of youthful thought he loves
To ruminate, and by such dreaming high
Is nearest unto Heaven: quiet coves
His soul has in its Autumn, when his wings
He furleth close; contented so to look
On mists in idleness — to let fair things
Pass by unheeded as a threshold brook.
He has his Winter too of pale misfeature,
Or else he would forego his mortal nature

JOHN KEATS (1819)

INTRODUCTION

Before the nineteenth century, shops were, by and large, small and specialized. Often the shopkeeper's premises were also his workshop. But after the Industrial Revolution and the development of urban centres, their design and purpose were reassessed, most notably in London. Covered shopping arcades were built in The Royal Opera on The Strand in 1817 and The Burlington, Piccadilly in 1819. Although the shopkeeper still lived above his shop, these arcades were part of a new and aggressive urban development. Concurrently, shopping bazaars developed, where space was hired out to small traders in return for a commission on their sales; for example, the Pantheon which opened on Oxford Street in 1840. When the Great Crystal Palace Exhibition of 1851 opened, it resembled a huge walk-in window display and gave birth to the concept of the department store.

The idea of a store that could satisfy all of the shopper's needs proved immensely popular, resulting in the palatial shopping centres of this century. And the increase in spending power of the middle classes combined with the opening up of world markets through air travel now means that the availability of merchandise is no longer at the mercy of geography or the seasons. These physical limitations of the past are now replaced by infinite opportunities for the determined shopper. The efficiency of the global shop is exemplified by the travelling customer who can buy clothing in the depths of a cold London winter to be worn a few days later in a tropical heatwave on the other side of the world.

Yet despite this ability to transcend the seasons at will, remarkably their individual characters are still clearly recognizable. Certain patterns evoke the freshness of spring, some styles create the languid mood of summer, a particular palette of colours can be reminiscent of the ripeness of autumn and the weave of certain fabrics imply the harshness of winter. Always unequivocal, these responses are a confirmation of the instinctive relationship we retain with the natural world and the strong emotions that are prompted by our acknowledgement of the inexorable cycle of the seasons.

THE INSPIRATION OF NATURE

The inherent compulsion for display is not an exclusively human obsession; it is found at its most brilliant and spontaneous in the natural world as each season brings its own character and decoration.

The spring brings a resurgence of new radiance. Ice cracks as bulbs break the earth's surface. Buds burst their constraints and blossom weighs the boughs, dripping with the scent of fecundity and the essence of life's continuity.

In summer, flowers bloom. It's a time of indulgent pleasure and joy, captured in the benevolent rays of the sun. Birds sing as the whole world seems to dance in the dazzle of the flame.

Fruits ripen in the autumn and it is time for reflection as the fire of the sun fades. It is also a time of mists and for gathering and storing the precious gifts of life.

By winter, dark has now descended. It is time for faith to prevail as the only fire left is in the soul. It is time to rejoice in the cycle of life and find comfort in the retelling of familiar legends as we wait for the return of the light.

In the world of nature, display is also used to attract, to ensnare prey, to protect by the concealment of camouflage or to intimidate by signals of danger. Early man copied these visual devices in order to mimic their purpose, in an attempt to control his relationship with his habitat. Sometimes the skins, feathers and bones of actual creatures were employed or their patterns were painted with coloured earth or dyes from plants found in the natural world.

Man began to evince a spiritual and temporal need for self-expression through visual statements. Primitive man painted images on cave walls and began to collect the precious metals discovered buried deep in the earth, which were fashioned into beautiful adornments as well as sacred works of worship. These became part of a vocabulary of visual communication in pagan cultures before the written word.

From the sixth century BC, votive offerings were on display in temple treasuries, essentially becoming the first museums and reserves of wealth, reflecting man's inherent desire to see and value beautiful objects of his own creation. All these sacred and profane ancient works of art were a universal response to the awesome beauties of the natural world man could see around him.

As time progressed, these fundamental precepts have not disappeared. On the contrary, we still seek and create visual stimuli as nature's benign and destructive forces (seemingly without compassion for the effects they produce) continue to astound and beguile us. This symbiotic inspiration remains the basis of fashions in clothing and décor, even as civilization develops and becomes more sophisticated.

THE ART OF WINDOW DISPLAY

Window display, as we now perceive it, did not appear until the early twentieth century as the emergence of the department store brought a more imaginative use of space previously used in a functional rather than decorative way.

In response to the 1925 *Exposition des Arts Decoratifs* in Paris, there grew an emphasis on Art Deco, and exhibitions were held in collaboration with department stores, which featured objects and paintings in the new style. At the time, stores such as Lord & Taylor in New York and Marshall Fields in Chicago were involved in exhibitions with art museums, which gave the kudos and status of fine art to a commercial environment that was used to entice affluent clients.

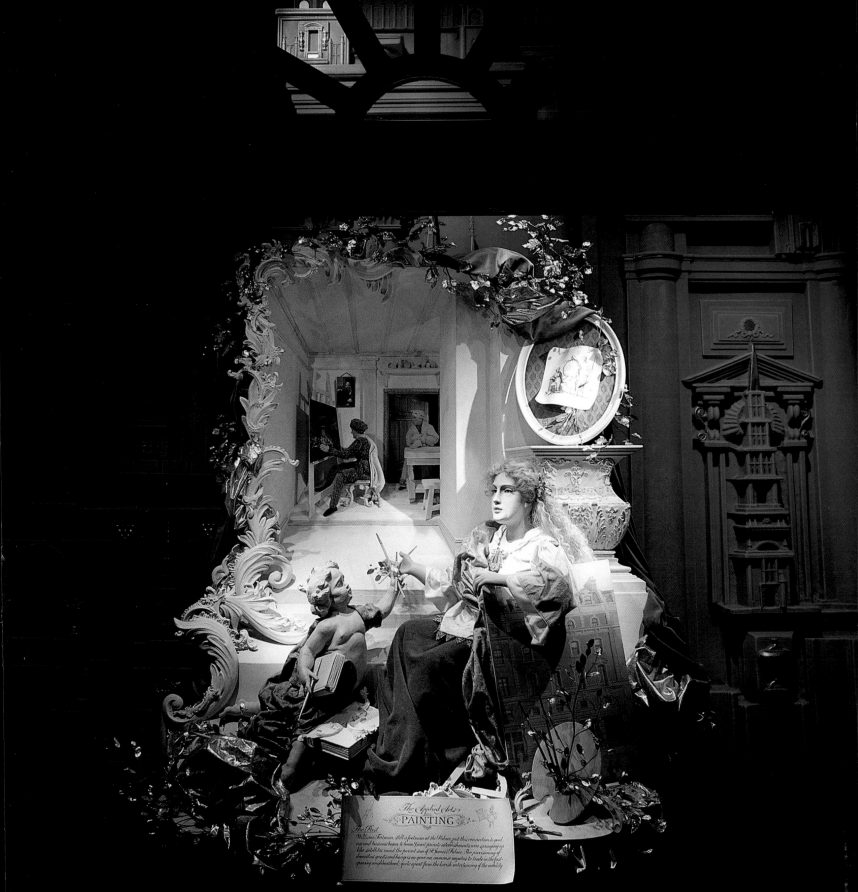

The Applied Arts
PAINTING

The Past
William Tolman, still a footman at the Palace, put this connection to good
use and business began to boom. Good private establishments were springing up
like satellites round the parent sun of St. James's Palace. The provisioning of
boundless guests and hangers-on gave an immense impetus to trade in the fast-
growing neighbourhood, quite apart from the lavish entertaining of the nobility.

INTRODUCTION

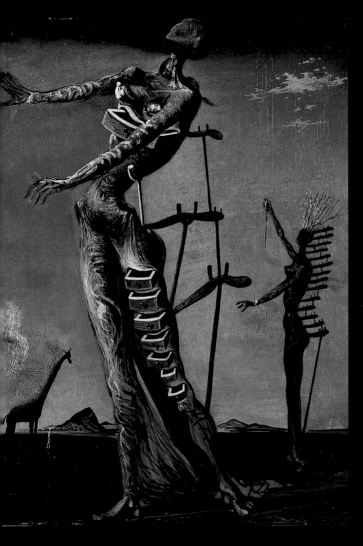

The Burning Giraffe – Salvador Dalí (1936–7)

This association encouraged the commissioning of artists to design windows, rather than professional window dressers, effectively blurring the distinction between the museum and the retail world. In Paris, the belief that fashion and art were synonymous produced the famous partnership of Elsa Schiaparelli and Salvador Dalí. They shared a penchant for the sensational and bizarre in visual statement, influenced by the writings of Sigmund Freud, which analyzed the world of dreams and the unconscious mind. The pyschoanalyst's couch was at this time a fashion accessory, a status symbol of the privileged and cultured, and was much discussed.

The most famous windows designed by an artist must be those by Salvador Dalí in New York for Bonwit Teller in 1939 on the theme of the metamorphosis of Narcissus. Ironically, because the installations were almost immediately removed by the outraged management because of their controversial content, they were hardly seen by the public. Nonetheless, they achieved huge publicity from the scandal they created, resulting in Dalí's arrest. The various accounts of the event added to the already dazzling mythology of Dalí's own personal ego.

Dalí had achieved notoriety for window display, which, through his genius for fame, immediately established it as a valid means of expression for the avant garde. They realized that it was possible to capitalize on this realm of dreams, which could be evoked by reaching the unconscious by deliberately bypassing the constraints of reason and logic. Surrealism therefore became an important enhancement to visual statement in urban culture and a symbol of awareness and style. A simple definition of surrealism is 'outside reality' and this should be the aim of window display.

This effect can be achieved by placing the real (mundane) within the context of the unreal (fantastical) – the merchandise becomes enhanced or unreal in the context of the artifice of the window space. But what is this strange location poised in limbo between the street and the interior of the store that, when looked into cannot be seen beyond, and, unlike a true window, cannot be looked out of once in the building? It is not a room or corridor, but a specific space designated for a particular purpose, the proffering of selected merchandise. The dresser cannot see the results of his work until he stands outside it and sees what effect the view through the glass creates – a reversed image of the worked-in space, adding its own influence to the final result.

It is little wonder that surrealist artists were attracted to this potentially fertile territory for expression with its contradictory elements. Consonant with this is the fascination with the display mannequin. Once a wax figure with glass eyes, the strangeness of the realistic mannequin is heightened by its appearance in the window space. The more successful its representation, the more otherworldly and incongruous it appears. There is always a strange association with something that resembles a human form, but which obviously is not. When handled expertly, the representation of the human figure can produce a deep, even emotional, effect in the

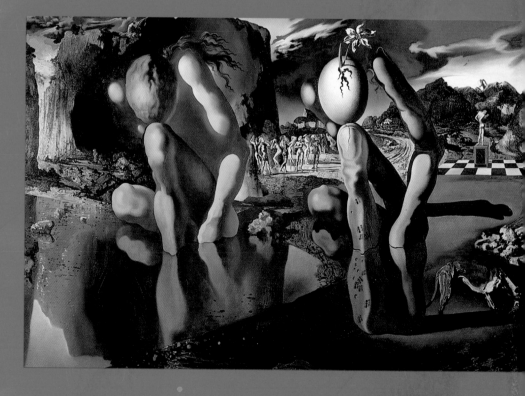

Metamorphosis of Narcissus – Salvador Dalí (1937)

The Wrestlers' Tomb – René Magritte (1961)

viewer of a window display that can create a willing conspiracy with the gazer, allowing the plate glass to become a mirror in which a form of narcissism or voyeurism is established.

This is increased when the scale is altered. Oversized bodies or parts such as faces or hands always evoke a reaction in the viewer. Conversely, when reduced in size, figures can be charming and beguiling because of their association with fairies and elves, which create a particular fascination and atmosphere of their own.

Symbolism is another influence that was part of the vocabulary of the surrealists. In *The Archetypes and the Collective Unconscious*, Jung describes what he sees as the layers of the unconscious mind existing on two levels; there is the upper or superficial layer, which is personal to each individual, and this rests on a deeper level, which he calls the collective unconscious shared by all individuals universally. For the artist, especially the surrealist, this concept provides a rich prospect as a device for communication that is almost irresistible. Magritte and Dalí painted fantasies and dreamscapes that were intended to be merely an apparatus devised to trigger further images and ideas. Magritte said that 'an idea cannot be seen with one's eyes'. His famous painting of a pipe titled *The Betrayal of Images* (1928–29) was captioned 'this is not a pipe' and reinforced Magritte's belief that it was the artist's prerogative to paint his thought and not what his eyes see.

Although surrealism was eventually replaced by other styles in window display such as psychedelic and pop in the 1960s and 1970s, it was perceptively and shrewdly adopted by the astute world of advertising, where it still resonates.

In the brief, ephemeral history of window display, one man stands out. Gene Moore's career spanned 60 years, 39 of which were spent at Tiffany & Co. in New York. Although he fostered the work of emerging artists including Andy Warhol, Jasper Johns and Robert Rauschenberg, it is for his own timeless genius that he is remembered. A great innovator, he introduced the concept of the celebrity mannequin in the early 1950s, basing them on, amongst others, Audrey Hepburn and Suzy Parker (one of the great fashion models of the time). A charming man of refined taste, he was incapable of presenting anything as shabby or vulgar for mere effect, and his own words, 'I am my window and my window is me' are his most eloquent testimony.

A PERSONAL PHILOSOPHY

The quest for new ideas or a fresh interpretation of existing ones is a constant challenge for any designer. Even when successful, these grand, yet fragile, visions can vanish elusively when exposed to the withering disciplines of budget and the limitations of the physical realization. Concepts develop through hard research and perseverance as well as the less

definite realm of the subconscious. It is this combination of visual/literary sources and the deeply personal images of the psyche that sometimes can create an individual statement.

An indelible memory from early childhood is of being taken to see the Christmas shop windows displays. I was enchanted and enthralled by the sense of wonder awakened by these fantastical apparitions that materialized tantalizingly behind the protective glass. The glass seemed to me to represent the division between the real world and the unlimited realm of fantasy. Once I returned home, these impressions would be painstakingly recreated in paintings, drawings or elaborate scenery for my model theatre. Consequently the aim in any window I design is an attempt to recreate this emotional response of excitement and occasion, regardless of the season of the year or the age of the viewer.

Originally, I trained and worked as a professional theatre designer and this has also proved an important influence on my design, method and style. It is often said that my window installations evoke a theatrical atmosphere – the black walls and floors, the proscenium within the window frame, the miniature stage setting, the dramatic subject and lighting.

For me, a window is therefore a surreal concept, the glass offering a vista that is charged with the tension between fact and fiction, resonating with a strange familiarity to the unconscious mind with its aspirations and desire for expression.

styles in window display such as psychedelic and pop in the 1960s and 1970s, it was perceptively and shrewdly adopted by the astute world of advertising, where it still resonates.

In the brief, ephemeral history of window display, one man stands out. Gene Moore's career spanned 60 years, 39 of which were spent at Tiffany & Co. in New York. Although he fostered the work of emerging artists including Andy Warhol, Jasper Johns and Robert Rauschenberg, it is for his own timeless genius that he is remembered. A great innovator, he introduced the concept of the celebrity mannequin in the early 1950s, basing them on, amongst others, Audrey Hepburn and Suzy Parker (one of the great fashion models of the time). A charming man of refined taste, he was incapable of presenting anything as shabby or vulgar for mere effect, and his own words, 'I am my window and my window is me' are his most eloquent testimony.

A PERSONAL PHILOSOPHY

The quest for new ideas or a fresh interpretation of existing ones is a constant challenge for any designer. Even when successful, these grand, yet fragile, visions can vanish elusively when exposed to the withering disciplines of budget and the limitations of the physical realization. Concepts develop through hard research and perseverance as well as the less

visual/literary sources and the deeply personal images of the psyche that sometimes can create an individual statement.

An indelible memory from early childhood is of being taken to see the Christmas shop windows displays. I was enchanted and enthralled by the sense of wonder awakened by these fantastical apparitions that materialized tantalizingly behind the protective glass. The glass seemed to me to represent the division between the real world and the unlimited realm of fantasy. Once I returned home, these impressions would be painstakingly recreated in paintings, drawings or elaborate scenery for my model theatre. Consequently the aim in any window I design is an attempt to recreate this emotional response of excitement and occasion, regardless of the season of the year or the age of the viewer.

Originally, I trained and worked as a professional theatre designer and this has also proved an important influence on my design, method and style. It is often said that my window installations evoke a theatrical atmosphere – the black walls and floors, the proscenium within the window frame, the miniature stage setting, the dramatic subject and lighting.

For me, a window is therefore a surreal concept, the glass offering a vista that is charged with the tension between fact and fiction, resonating with a strange familiarity to the unconscious mind with its aspirations and desire for expression

CURIOUSER
AND CURIOUSER

Exotic and voluptuous, billowing flower chairs and a lamp surround an anemone table laden with honey and nuts in tall stem vases (*opposite*). The treatment of the flowers is in the style of fanciful wrought-metal garden furniture. Each of the flowers is hand-painted and the colours evoke the warm moisture-laden air of a tropical conservatory.

A symbol of transience, the Greek name for the anemone means 'wind', and in his *Metamorphoses*, Ovid describes how Venus transformed the blood of Adonis into the flower. Some Christians identify the anemone with the 'lily of the fields' mentioned in Christ's sermon on the mount. In the early Christian church, the triple leaf of the anenome symbolized the Holy Trinity. It was also said that the flower sprang up on Calvary after the death of Christ.

The amalgamation of flowers and food provokes the anticipation of longer days spent in the open air and meals taken in the garden. Here, the fully flowering anemone offers itself as a garden table enticingly laden with food, while half-flowers act as chairs. Tall flowers represent standard lamps. On the tables, the elongated stem vases give an idea of the upthrust of plant life in spring and contain natural produce such as crystallized fruits, tea and coffee. There is also a hint of the giant-effect of the 'Eat-me, Drink-me' scenes in *Alice's Adventures in Wonderland* in which normal-sized objects become colossal. The curious table settings invite the spectator to come and sit down and partake of the luxurious foods on display.

There is a rich, tropical hothouse atmosphere running through the scheme, which, accentuated by the colour of the flowers, implies an impatience for summer to begin. The sensuous, voluptuous, vibrant and exotic atmosphere is brought out by the vibrancy of the anemones.

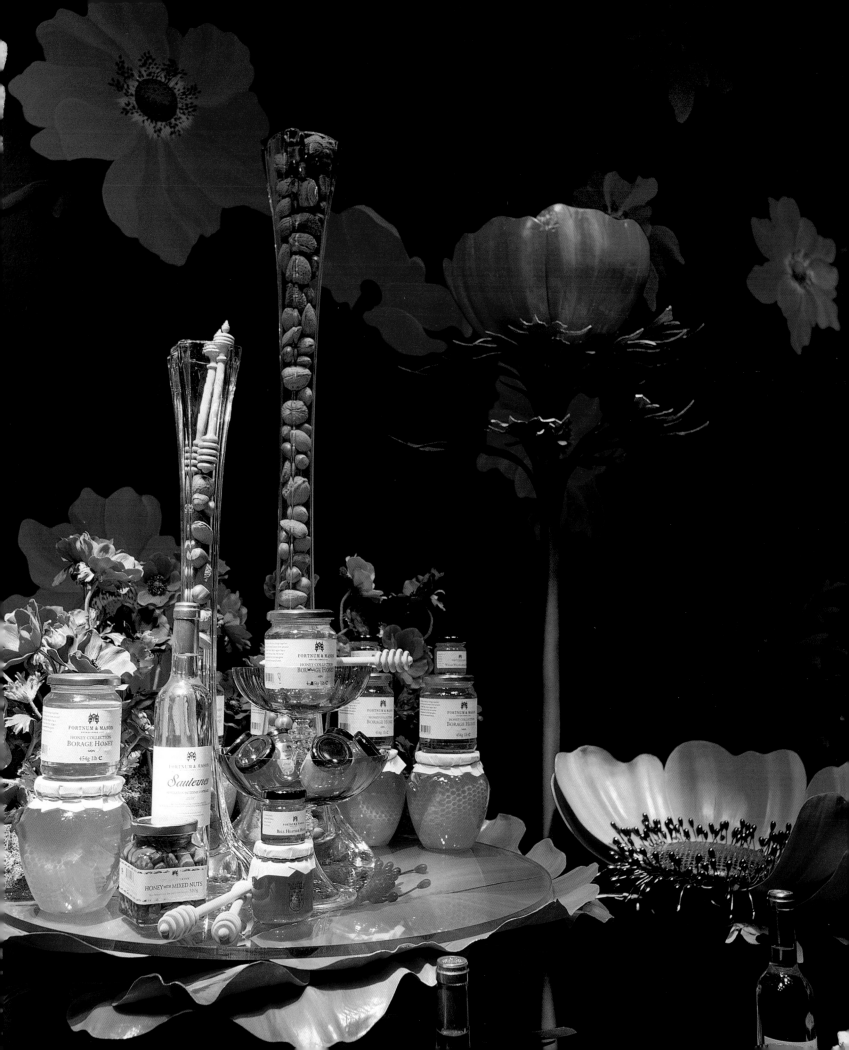

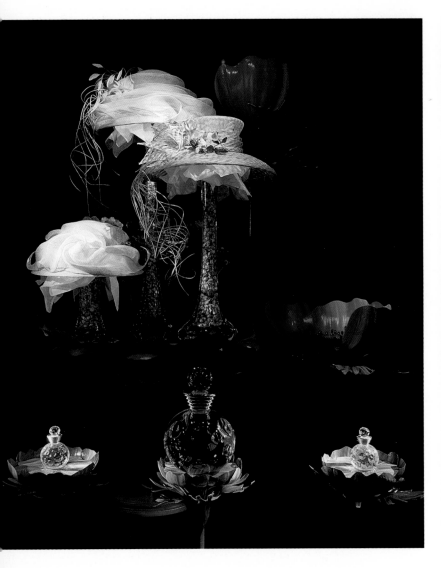

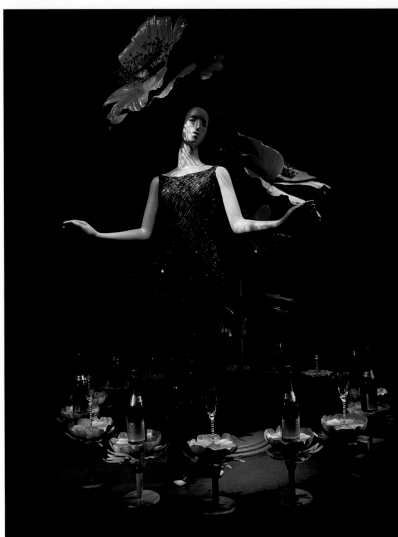

Exuberant millinery is imaginatively displayed upon elegant crystal vases (*above left*) filled with fragrant petals, to echo the costly perfume set on the open flowers in the foreground. In the revolving fashion windows (*above right and opposite*), giant anemones tower above mannequins dressed in luxuriously opulent evening wear. They are encircled by smaller flowers that display crystal flutes and vintage champagne.

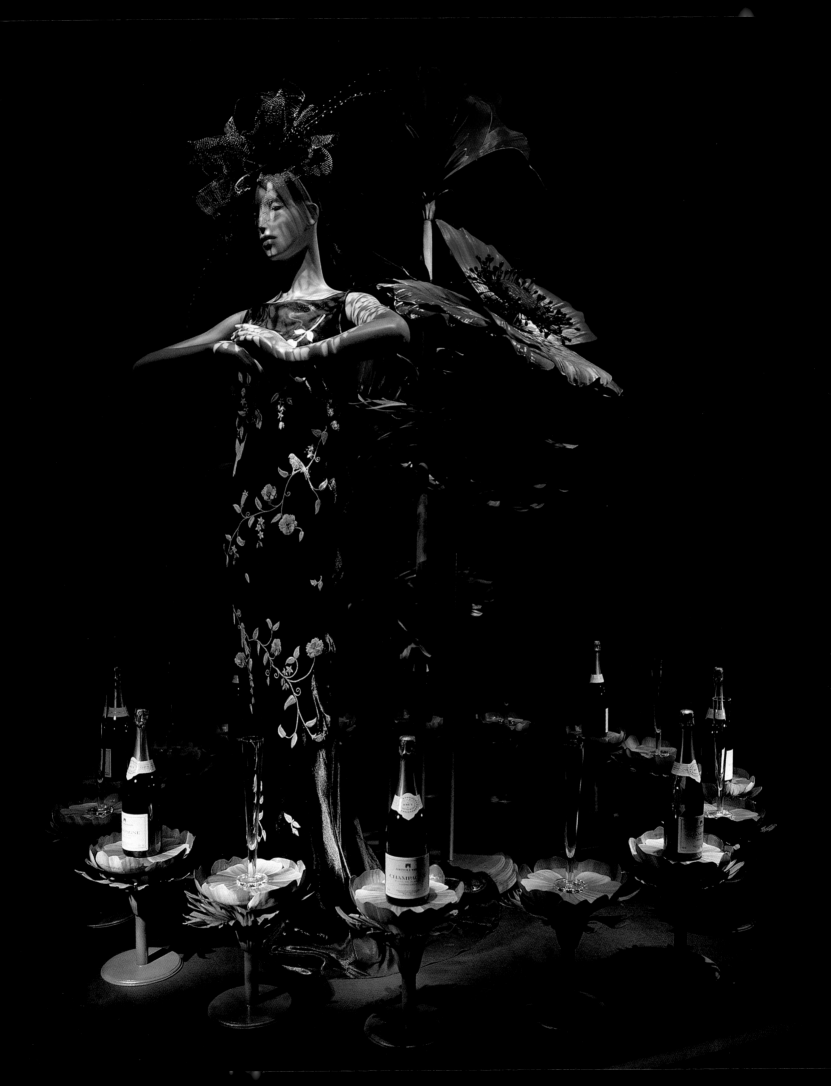

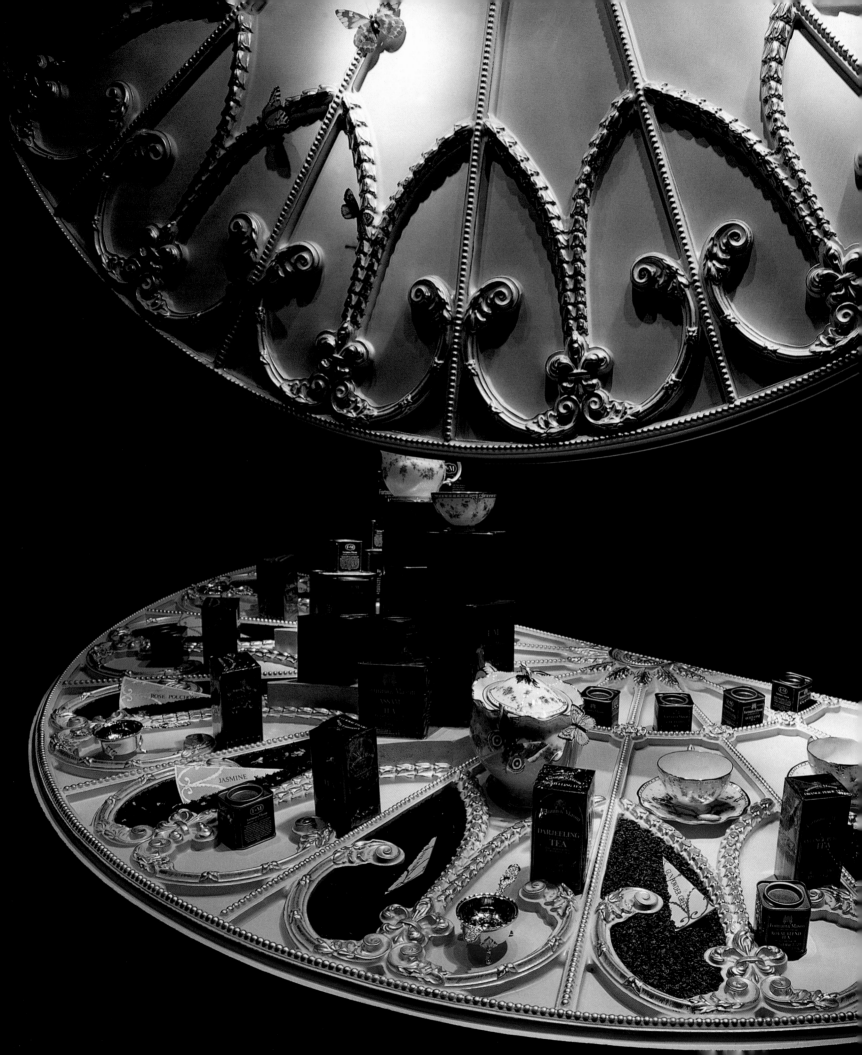

THROUGH A
GLASS BRIGHTLY

One of the most readily recognizable features of the Fortnum & Mason façade in Piccadilly is its Georgian-style fanlight windows, which link it distinctively to the company's eighteenth-century origins: it was founded in 1707. During the Georgian period, architecture, interior design and furniture-making were revolutionized by architects and designers such as Sir Christopher Wren (1632–1723), Robert Adam (1728–92), Thomas Chippendale (1718–79) and Thomas Sheraton (1751–1806). Eighteenth-century craftsmanship in England was second to none and this window display was created to evoke Fortnum & Mason's enduring policy of classic quality.

Georgian fanlights are found all over London where the elegant buildings of the Georgian period survive. The delicate tracery that forms the pattern is usually made in wood or metal and then painted. The fanlight designs are very varied – they are both decorative and functional and before the advent of gas and electricity were used to light shop windows.

The status symbol of the fanlight is ever-present at Fortnum's and it therefore creates an ideal motif for spring, when the idea of the resurgence of light after a gloomy winter seems particularly appealing. Although the design is based on an original Georgian fanlight taken from a pattern book of the period, it is radically altered and pared down to a semi-circular shape that is solid instead of transparent, so that a varied selection of merchandise can be displayed. The display fanlights are identical but each is individually positioned and lit, giving a different effect to each configuration.

The Georgian fanlight is simplified to an elegant motif in which the stylized shape is repeated at different angles as a platform for display (*above and following pages*). The elegance of the fanlight (*opposite*) is sensitively adapted to display Fortnum's exclusive teas. Tea leaves are strewn in the fine moulding, with labels showing some of the many different blends available.

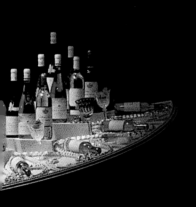
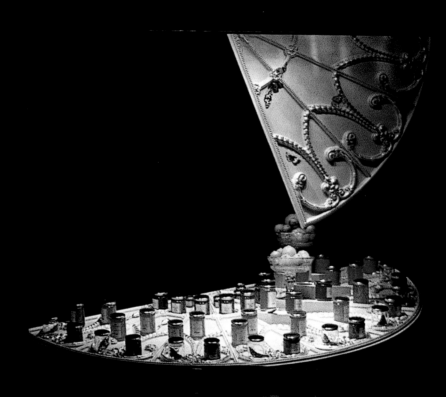

TULIPOMANIA

The first cultivated tulips were grown in the Ottoman Empire. The Persian word for turban is *tulipant* and one of the first recorded references to the tulip appears in a letter in 1554 from the Viennese Ambassador to Sultan Suleiman the Magnificent. The tulip was a royal symbol at his Constantinople court.

In Holland, the seventeenth century was the golden age of gardening and botanical illustrations. Abraham Munting's book of this period contains beautiful prints of flowers, including tulip and many of the Dutch veritas paintings show glorious horticultural tulips, their brilliant colours amazing in their variety and combination. These true-to-life, exquisitely detailed paintings and engravings reflect the then allied sciences of medicine and botany and were virtually catalogues of the Dutch horticulturalists. They exhibit a richness akin to the abundance of food that makes them an ideal device in which to present Fortnum & Mason merchandise.

These **glorious tulips** exhibit a **richness** akin
to the **abundance** of **food** that makes them an ideal
device in which to present Fortnum & Mason merchandise.

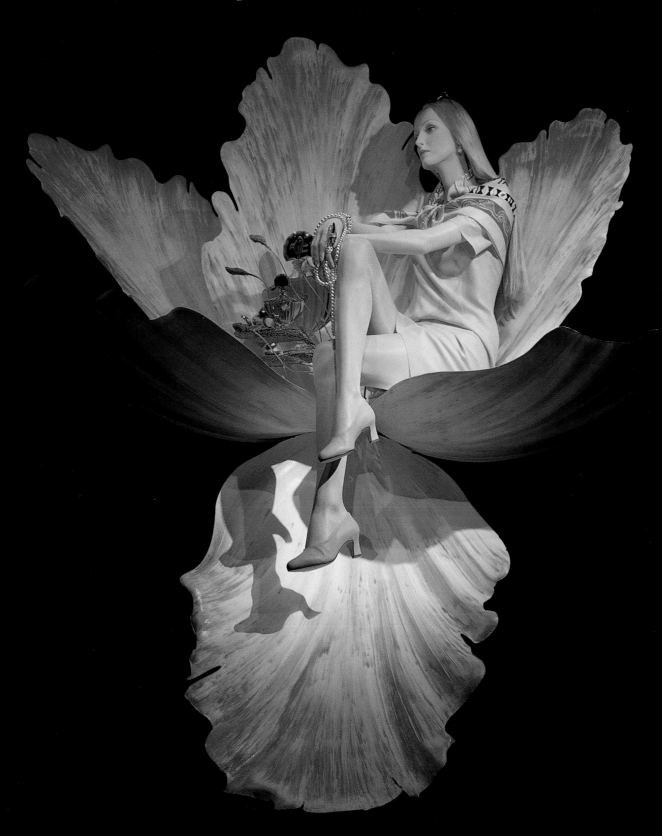

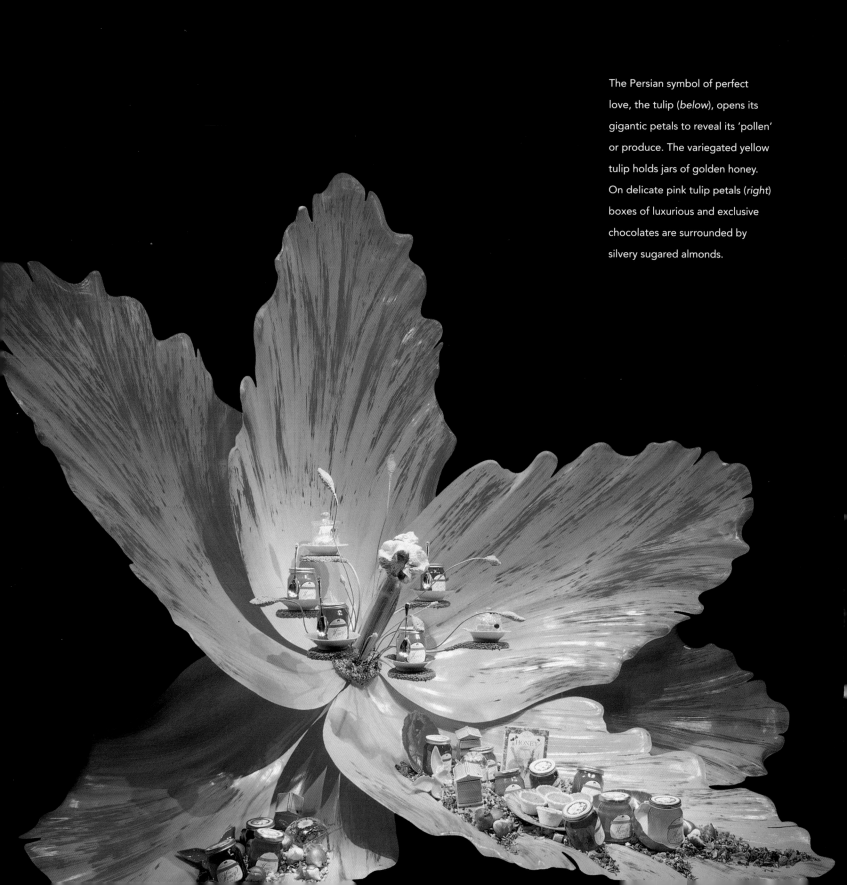

The Persian symbol of perfect love, the tulip (*below*), opens its gigantic petals to reveal its 'pollen' or produce. The variegated yellow tulip holds jars of golden honey. On delicate pink tulip petals (*right*) boxes of luxurious and exclusive chocolates are surrounded by silvery sugared almonds.

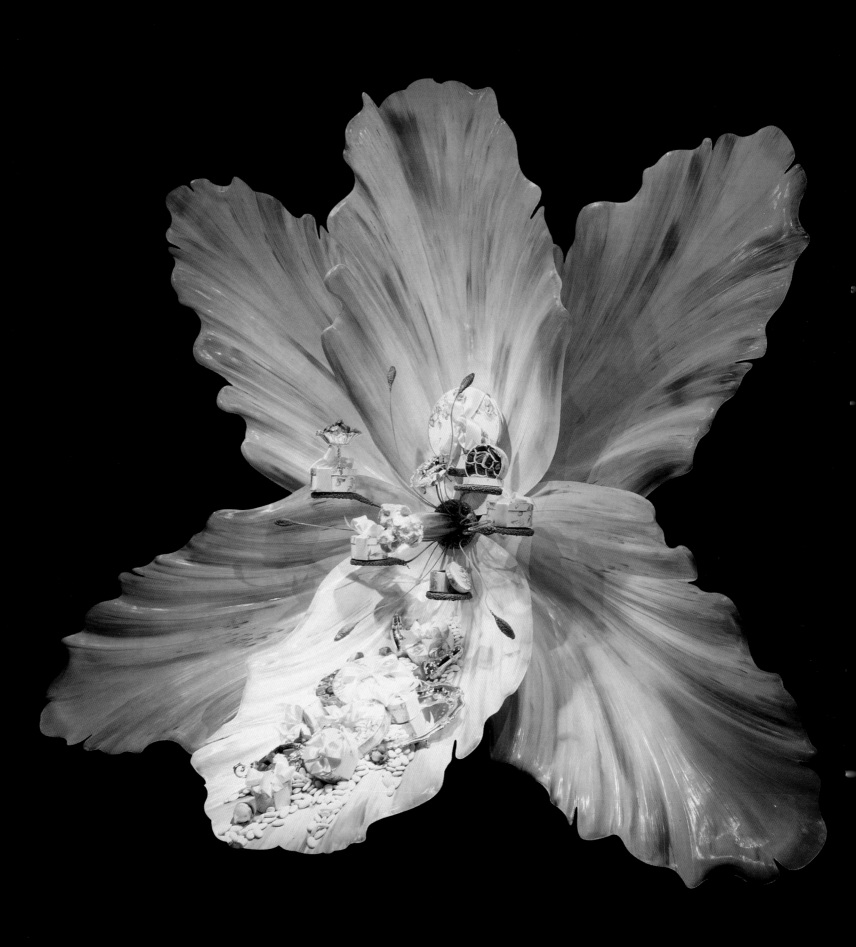

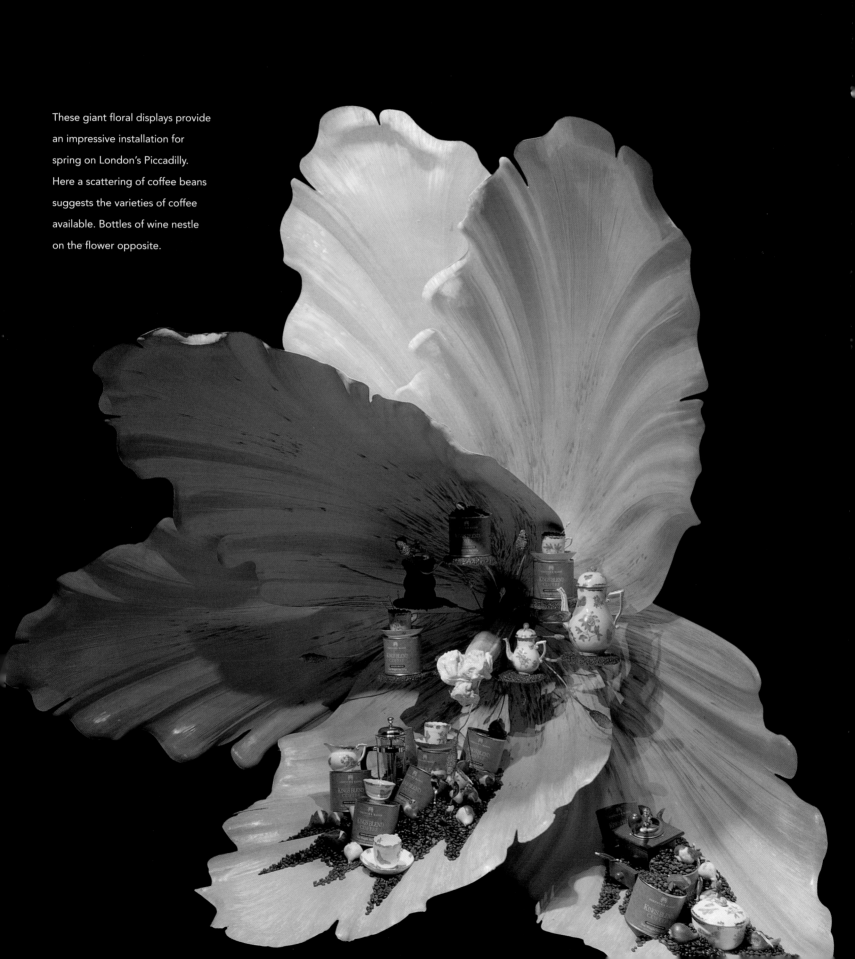

These giant floral displays provide an impressive installation for spring on London's Piccadilly. Here a scattering of coffee beans suggests the varieties of coffee available. Bottles of wine nestle on the flower opposite.

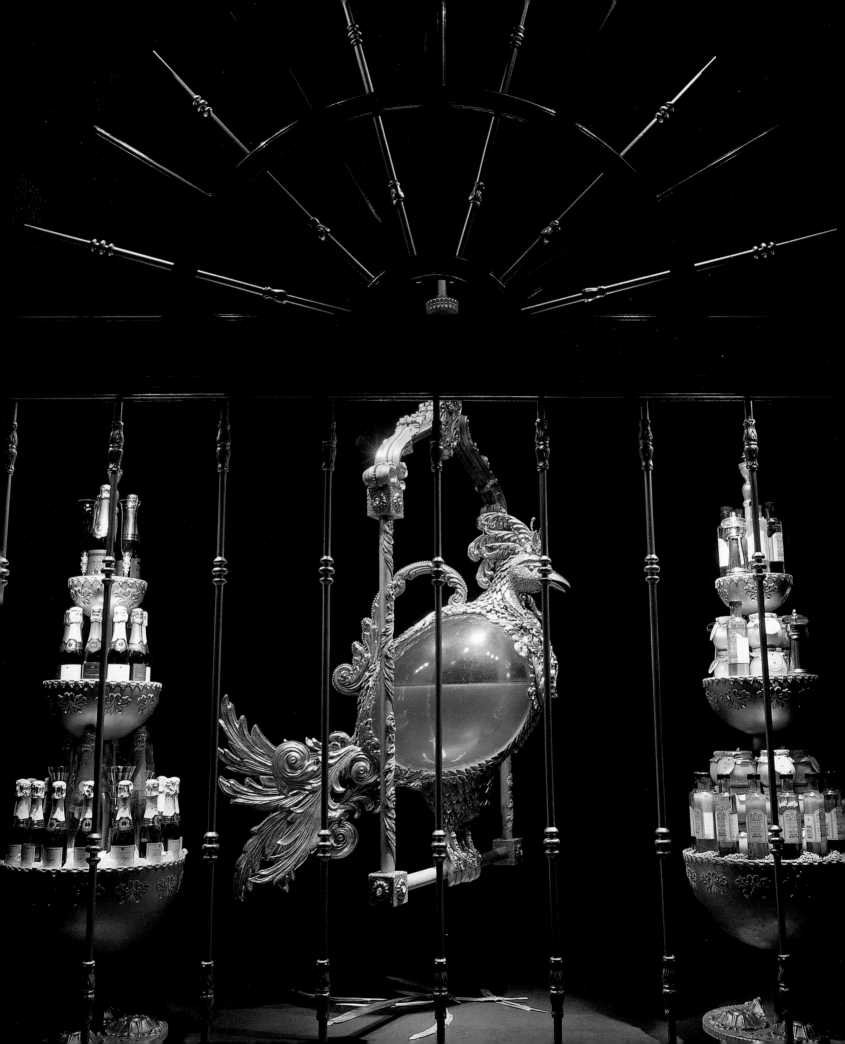

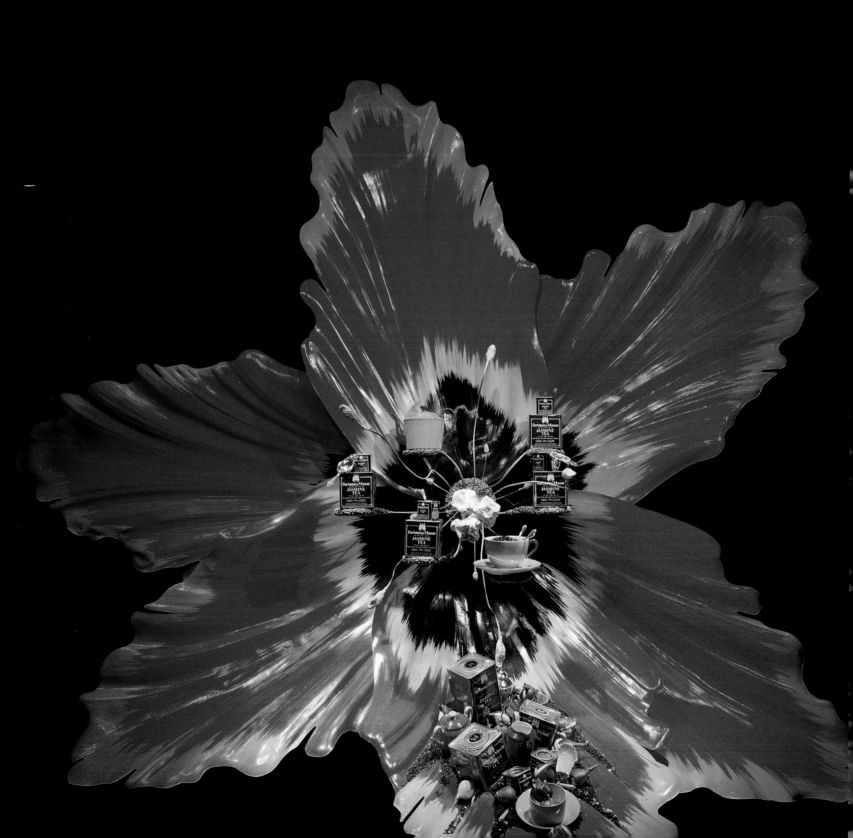

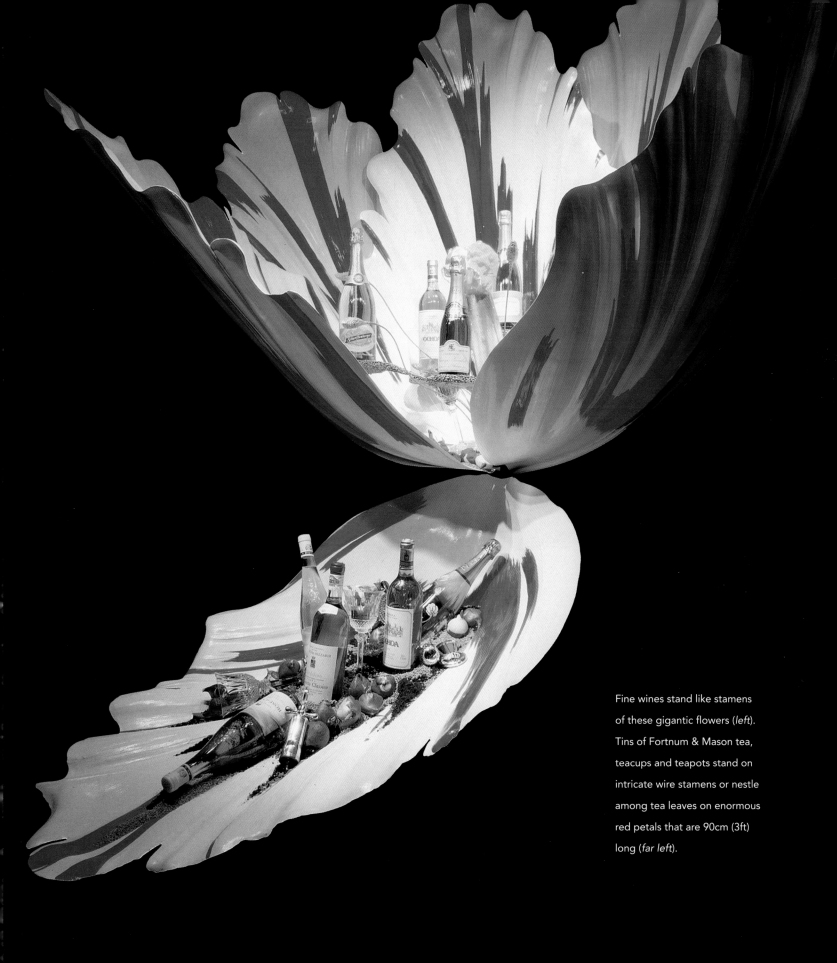

Fine wines stand like stamens of these gigantic flowers (*left*). Tins of Fortnum & Mason tea, teacups and teapots stand on intricate wire stamens or nestle among tea leaves on enormous red petals that are 90cm (3ft) long (*far left*).

The tulip flowers early in the year, which makes it a fitting image for spring, and here the flowers are dramatically opening to reveal the rich produce within. The stamens are specially made to hold heavier items such as bottles of wine and jars of preserves, which are designed to represent the pollen, the richness of which weighs down the petals. Many of the lower petals are scattered with sprouting tulip bulbs, which is a rather charming addition to the theme of fecund spring.

In the seventeenth century, when tulips were rare in Europe, they became a symbol of great luxury that only the extremely wealthy were able to afford. Bulbs changed hands for vast sums of money. At the height of Tulipomania, the frenzy for tulip bulbs was so great that in one case a house was exchanged for just three precious bulbs. This incredible demand was caused by the tulip's unpredictable propagation. They can mutate suddenly, changing colour and petal shape and this characteristic led horticulturalists to experiment in the hope of producing ever-more valuable variants. Speculation on new hybrids led to high-risk gambling that became known as the 'wind trade'; the market inevitably crashed in 1636.

Elegantly nestled in the warm, accommodating petals of this opulent tulip (*opposite*) a sophisticated lady epitomizes an indulgent world of high luxury and extravagance.

CAPTURED FLAVOURS

During the Renaissance, the goldsmith's art, like that of Benvenuto Cellini, reached new heights in the dazzling pieces such as great salt cellars, wine carafes and ewers made for the banqueting tables of aristocrats and crowned heads of Europe. In some designs, the art of the glass-blower and the gold- or silversmith were combined to form exquisite bird-shaped containers. In these magnificent carafes, the glass body of the bird, which contained the wine, was mounted on gold or silver legs. The head and tail were also fashioned from gold or silver and the head was sometimes a hinged stopper, enabling the wine to be poured through the bird's beak.

The atmosphere and mood of the window display is that of an exotic aviary of rare birds of spectacular eccentricity that are both whimsical and fantastic. Their inspiration came from the mythology and decorative arts of Europe, China and Arabia. The two wine carafe birds, one for white, the other for red wine, are Renaissance in style. The two teapot birds typify tea and are based on Chinese teapots. One represents the blue and white porcelain that so invokes the spirit of Chinese ceramics; the other is close to the technique of Chinese decorative ceramic work. Two coffeepot birds are in the style of Arabian copper coffeepots.

The metre-high birds are mounted on a central perch suspended from above. Each of the highly decorative perches is appropriate in style to its theme. Ornate bird feeders like those found in decorative bird cages would usually have contained seed or water; these pampered birds, however, are offered luxurious food and wine from Fortnum & Mason's larder.

The peacock is delightfully appropriate for presenting fashion, and each fashion window contains a fantastical interpretation of this proud bird. These imaginary flights of fancy are an amalgam of all those beautiful members of the bird kingdom that have enthralled designers for generations.

A bird in a gilded cage (*opposite*) represents an ornate Renaissance carafe for white wine, surrounded by champagne and fine foods. Beneath the perch, scattered feathers give an enchanting nod to reality. A stylized and fantastic peacock (*below*) combines elements of that proud bird and a bird of paradise.

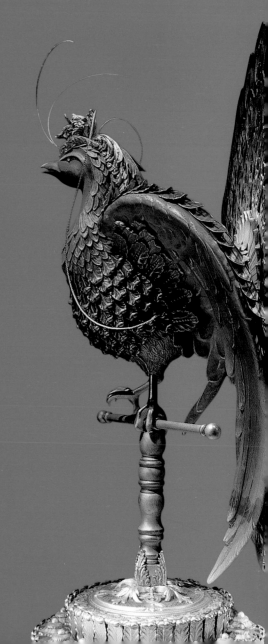

A highly decorative interpretation of this
proud bird on an ornate perch,
the peacock is a delightfully appropriate
mannequin for presenting fashion.

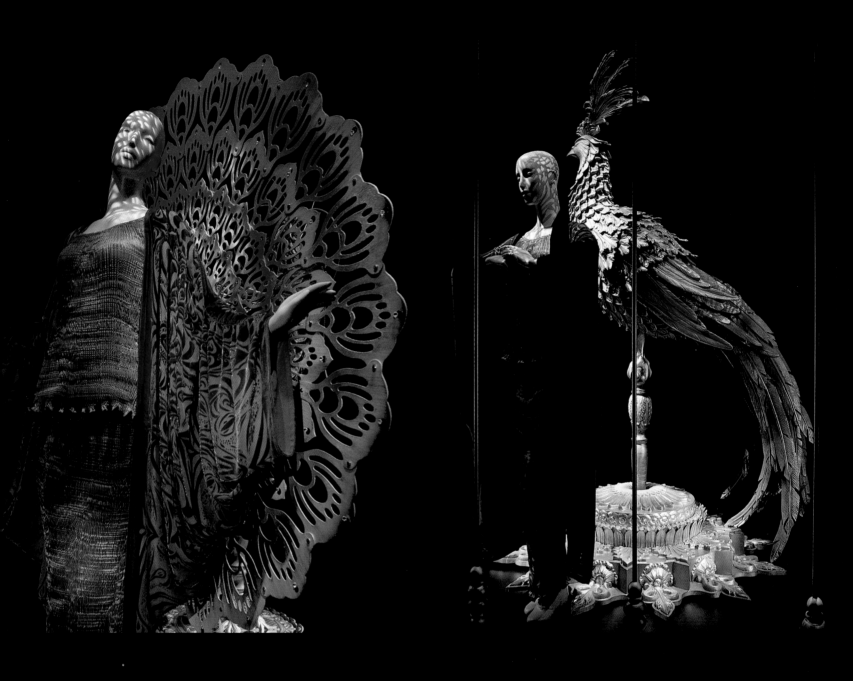

Peacocks adorn the fashion windows in a decorous statement. Throughout the ages, peacock feathers have been used as ornament to embellish garments and headdresses. On the left, the bird's fabled tail is opened in a pierced fan to provide a delicate tracery against which a gorgeous gown for evening wear is set off to perfection. On the following pages, a Chinese teapot and an Arabian coffeepot are seen as exotic birds, perched in their elaborate cages. Their bird feeders are laden with a luxurious array of food, ready for devouring.

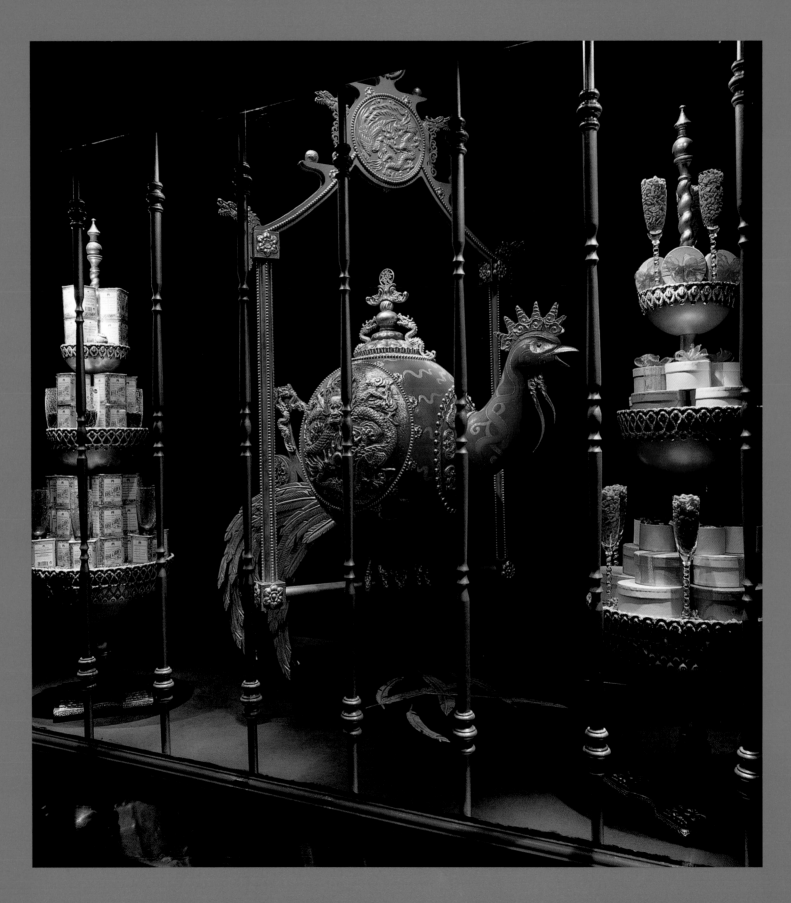

An exotic aviary of rare birds of spectacular

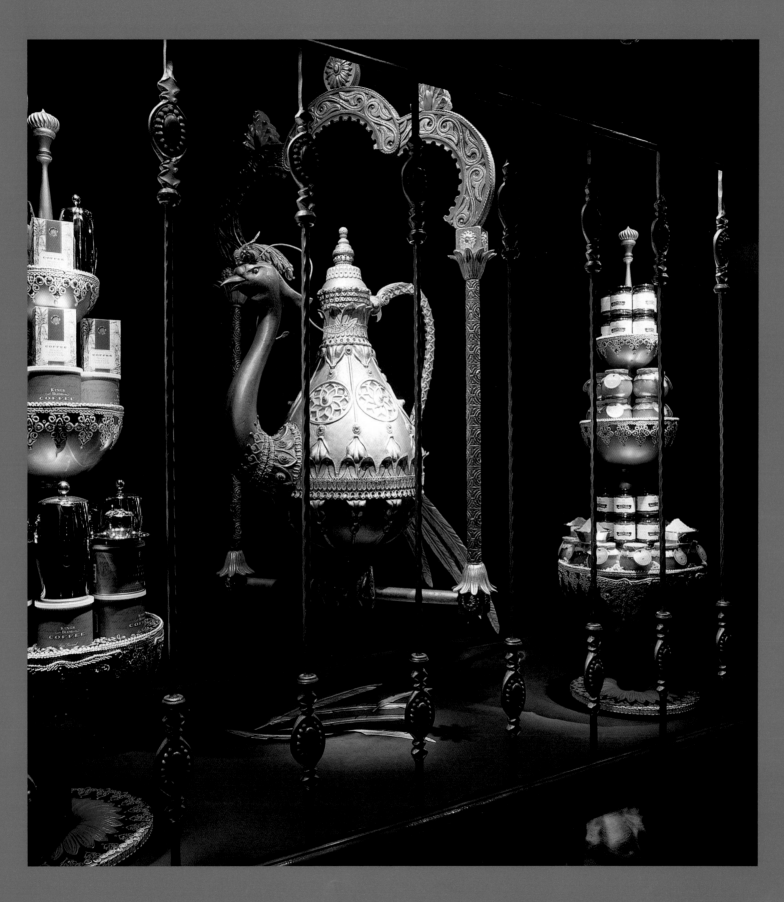

eccentricity, both whimsical and fantastic

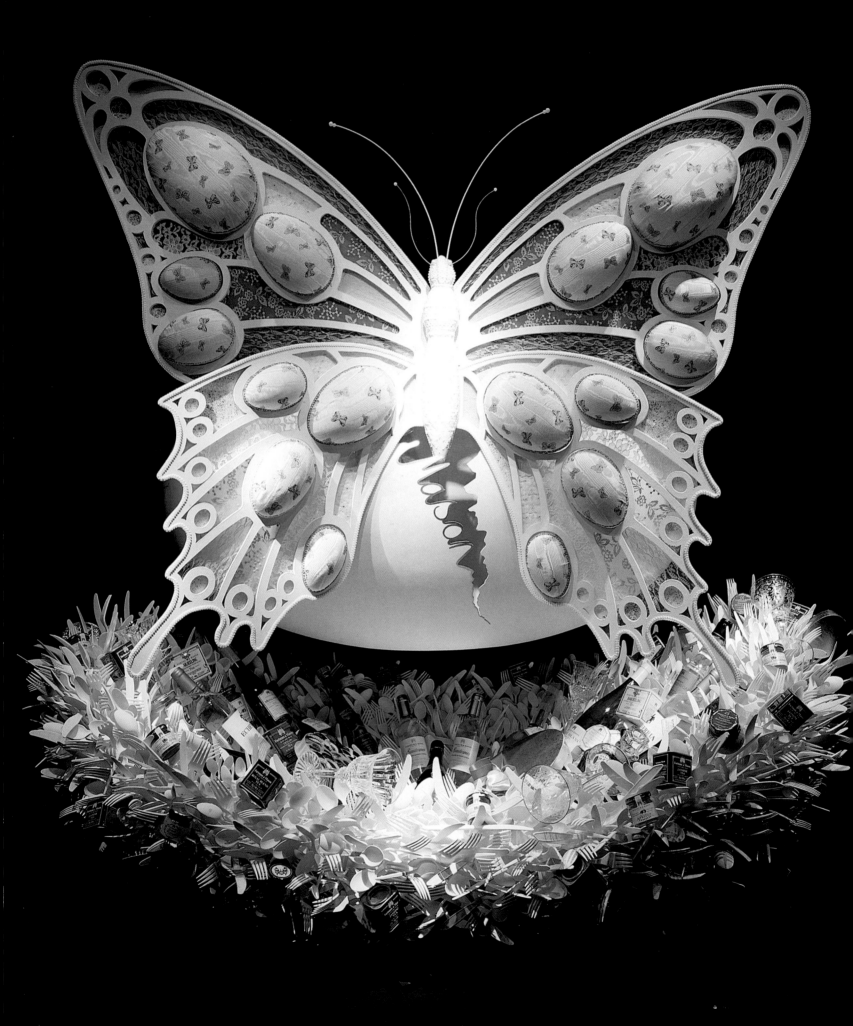

A CLASH OF SYMBOLS

The design for this installation is inspired by three of the recurring classic symbols of spring: eggs, birds' nests and butterflies. They are each recognizable individually but here they are given a surreal logic by their incongruous juxtaposition and displacement. Instead of a chicken hatching from the egg, a butterfly emerges as if from a chrysalis. Freed from the constraints of convention, the egg seems weightless (as the floating rock in Magritte's painting *The Castle in the Pyrenees*) as it hovers above a bird's nest woven from stylized cutlery.

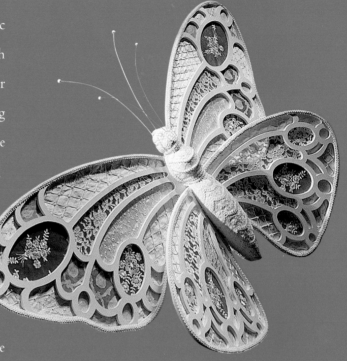

Various foods are caught in the weave of the nest to convey the concept of the pleasure of eating and of an appetite for life. The birth sequence, shown here in a series of still frames from the first egg to the full emergence of the butterfly, captures the essence of spring and the full fecundity of new life in an optimistic and joyful manner.

The crack in the egg progressively spells out the words Fortnum & Mason, reminiscent of one of Salvador Dalí's egg paintings that shows an egg breaking open and the yolk forming the continents of Africa and the Americas. By the time the butterfly has fully emerged, it has blossomed into a unique image of Easter bounty, resplendent on wings of silk and lace. The transformation of caterpillar to butterfly and its emergence from its chrysalis is also a metamorphosis of ugliness into beauty, and a symbol of resurrection. Just as the egg represents the seasonal renewal of the natural world, the nest, set high in the tree tops, symbolizes paradise and represents the spiritual world.

The windows are peppered with tiny butterflies (*above*) that seem intent on escaping from behind the glass and fluttering to freedom. In a wonderful burst of life to symbolize spring, a dazzling butterfly finally emerges from its egg (*opposite*), lacy wings outstretched. The wings are laden with the store's famous Easter eggs. Each egg is covered in silk, powdered with a butterfly print.

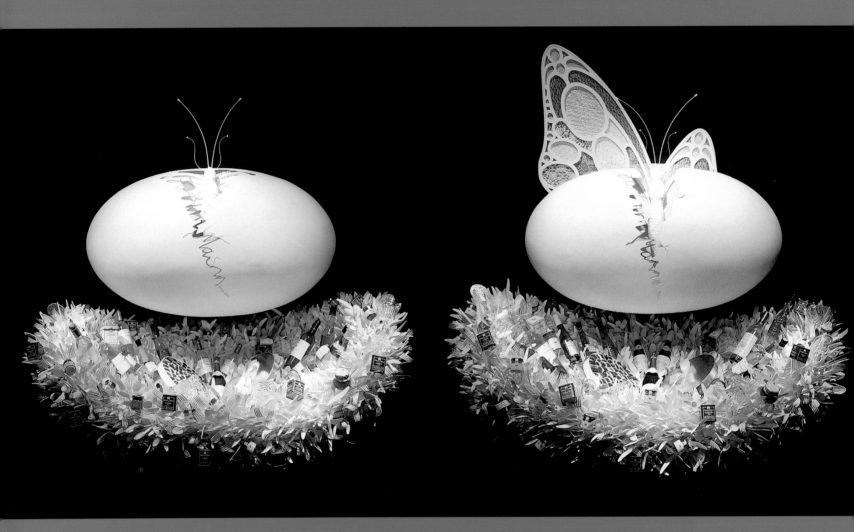

The birth of a butterfly is shown in a sequence resembling the still frames of a film. The
intention is to create the unexpected, as in Dalí's *Metamorphosis of Narcissus* (see page 11).
In the first frame, the egg cracks along the words 'Fortnum & Mason' and antennae emerge.
Next, the wing tips appear, and then a body.

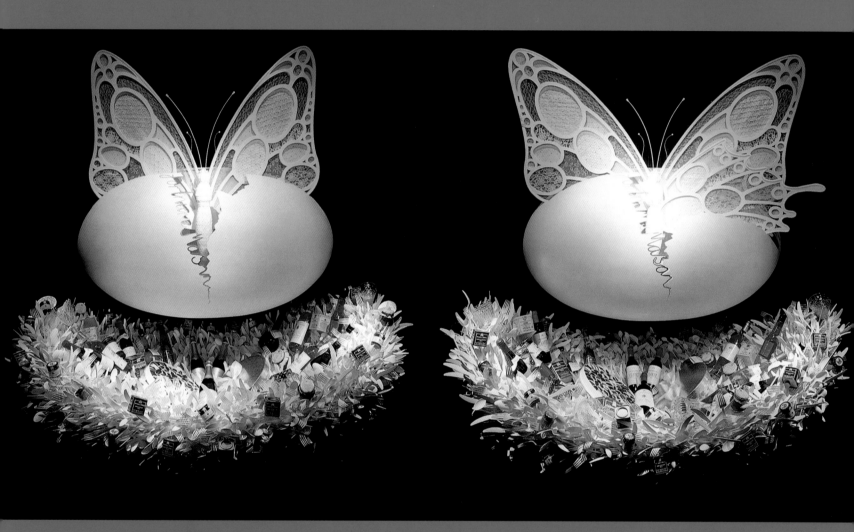

By the third frame it is apparent that a butterfly is emerging above a nest of cutlery. At this stage, the wings have not yet acquired the silken eggs. The colours are fresh and clear and range in tone from cool through warm to hot to represent spring emerging from the winter cold and the warming of the days as the season progresses.

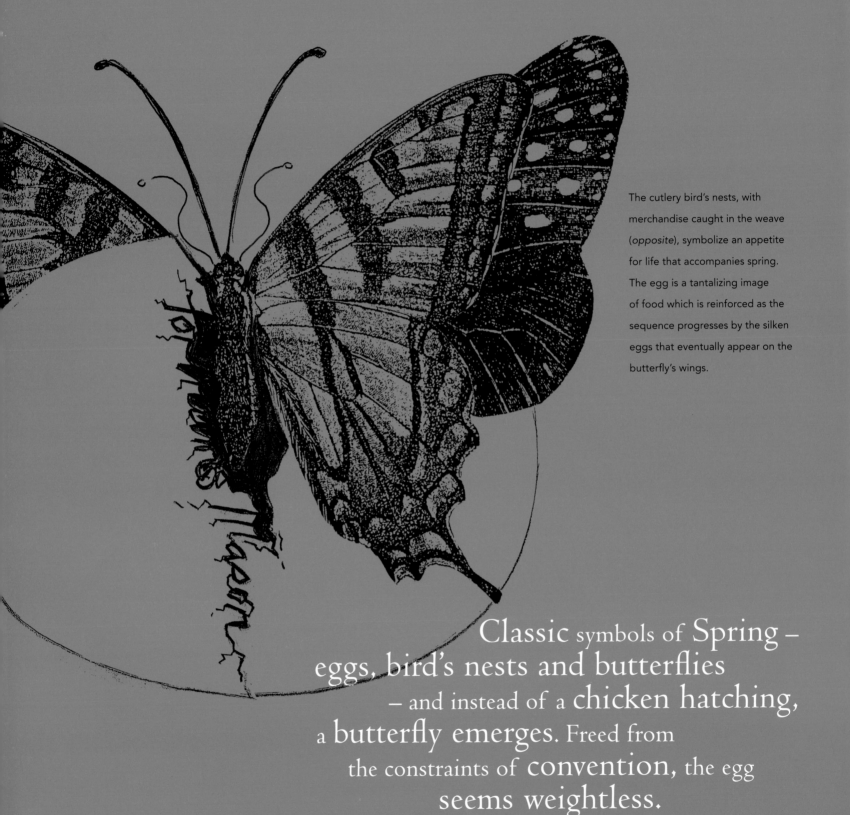

The cutlery bird's nests, with merchandise caught in the weave (*opposite*), symbolize an appetite for life that accompanies spring. The egg is a tantalizing image of food which is reinforced as the sequence progresses by the silken eggs that eventually appear on the butterfly's wings.

Classic symbols of Spring –
eggs, bird's nests and butterflies
– and instead of a chicken hatching,
a butterfly emerges. Freed from
the constraints of convention, the egg
seems weightless.

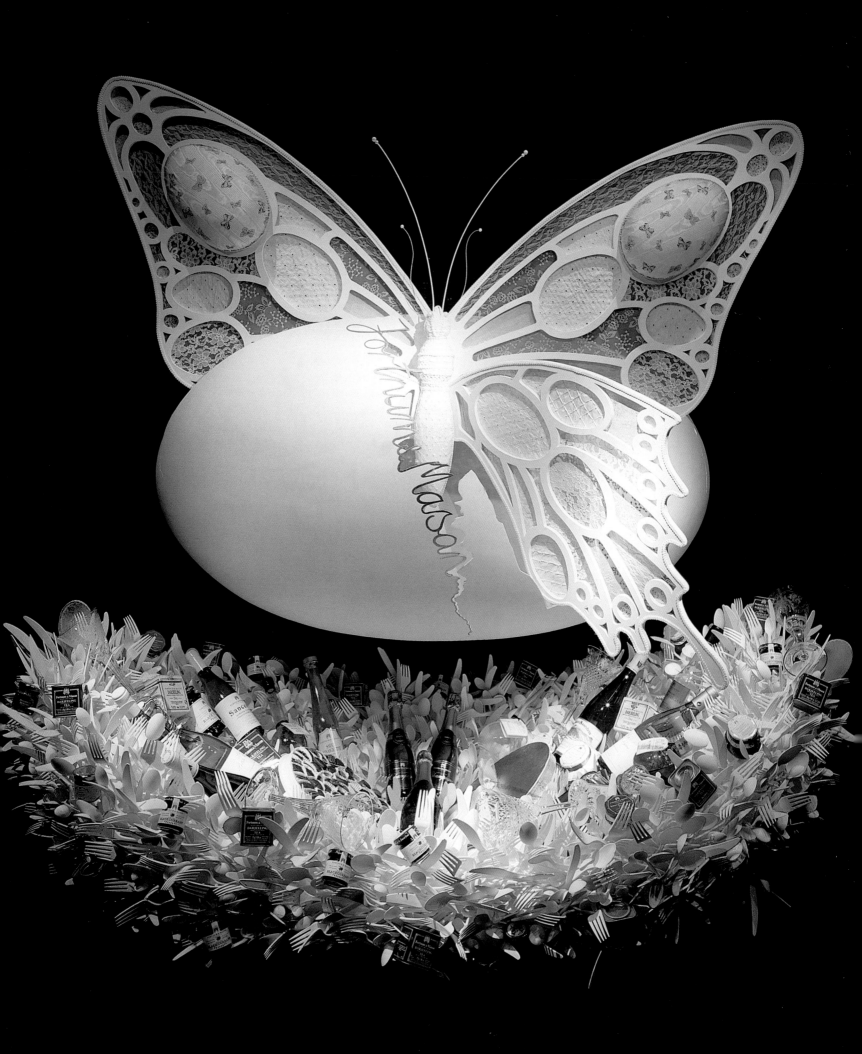

AFTER 400 YEARS

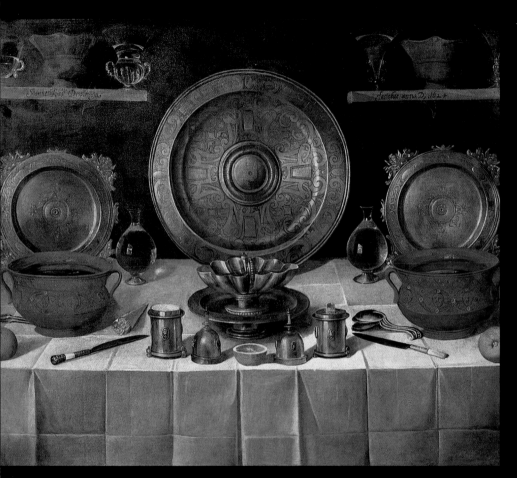

An exhibition of Spanish still-life paintings at the National Gallery in London inspired a sequence of windows that are three-dimensional replicas of these works of art. They are particularly appropriate to Fortnum & Mason as many of these seventeenth-century paintings display sumptuous and abundant food. This made the theme an ideal collaboration between Fortnum's and the National Gallery.

Each window began as an exact replica of one of the still lifes in the exhibition, set in a gilded frame. Beneath the frame, the exhibition catalogue lies open at the appropriate painting. Four paintings by the artists Juan Bautista de Espinosa (c.1585–1640), Juan van der Hamen y León (1596–1631) and Antonio de Pereda (1611–78) were selected. Careful examination of the window installation reveals that Fortnum & Mason merchandise is introduced into the replica still life with wit and subtlety.

The objects in the windows are exact copies of those in the paintings, which required items to be specially sculpted, moulded or carved. The glass items are hand blown to scale so that the still life in the window holds as much of the original painting's atmosphere and authenticity as possible. The aim is to recreate the mood of an art gallery in Spain, with the blue Spanish skies shining through the fanlights at the top of each window.

All the table accoutrements of a wealthy seventeenth-century family are formally displayed in *Still Life with Silver-gilt Salvers*, (*above*) which Juan Bautista de Espinosa painted in 1624. This splendour is exactly captured in Fortnum's window (*opposite*). Here, boxes of chocolates and bottles of fine wine have been subtly introduced among the reconstruction. Below the frame, a copy of the Spanish Still Life Exhibition catalogue lies open.

SPANISH
STILL LIFE
from Velázquez to Goya
William B. Jordan and Peter Cherry

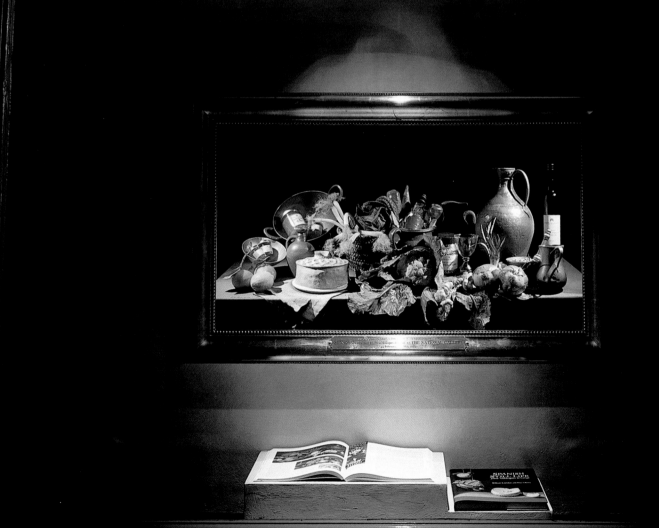

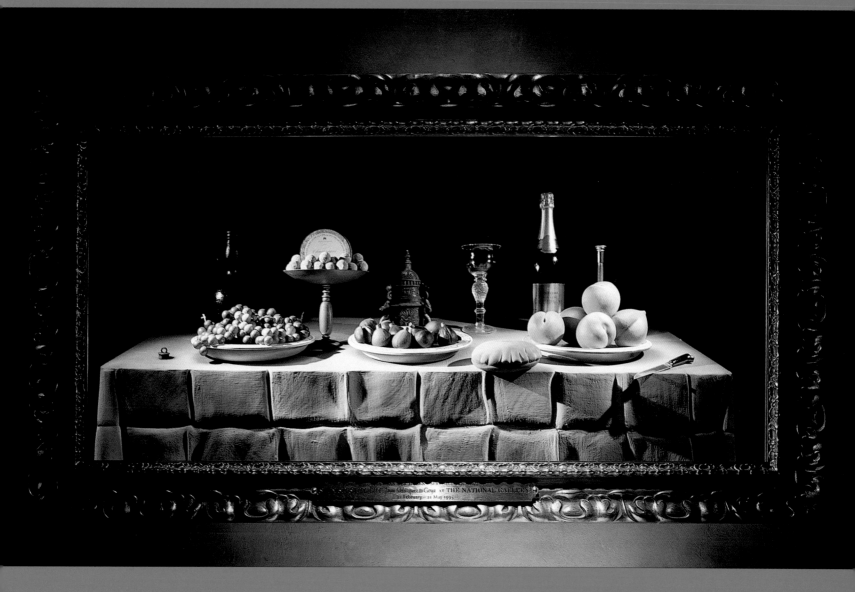

The intimate and sumptuous atmosphere of Juan van der Hamen y León's still life of
succulent peaches and glowing grapes, *Serving Table*, is captured in the Fortnum's
installation (*above*), where port and marrons glacés are enticingly introduced among replicas
of beautiful seventeenth-century glass and other tableware. With immense attention to
detail, Antonio de Pereda's 1651 *Still Life with Vegetables* has been lovingly transformed
into a three-dimensional display (*opposite*) where Fortnum's luxury foods nestle among the
precise replicas of seventeenth-century tableware and culinary utensils.

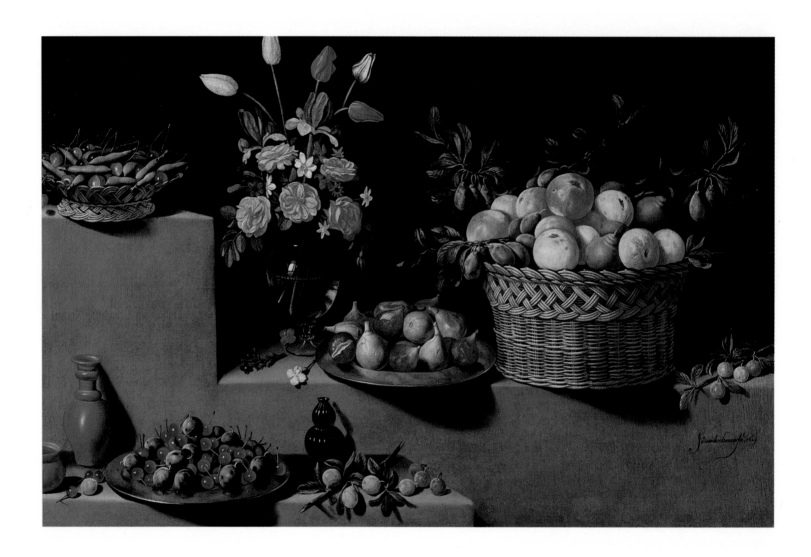

In Juan van der Hamen y León's *Still Life with Flowers and Fruit* (1629), a delicate glass
goblet holds a display of exuberant flowers (*above*). The Fortnum's adaptation (*opposite*)
combines a three-dimensional replica of this picture with the addition of a bottle of wine.

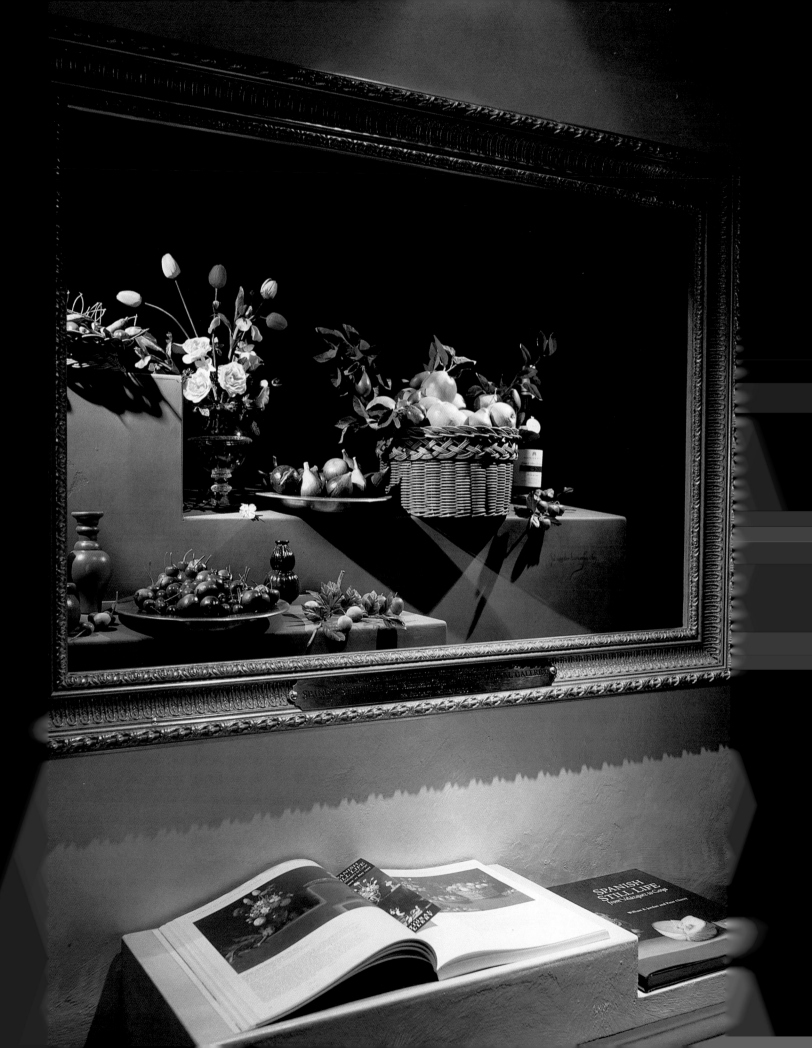

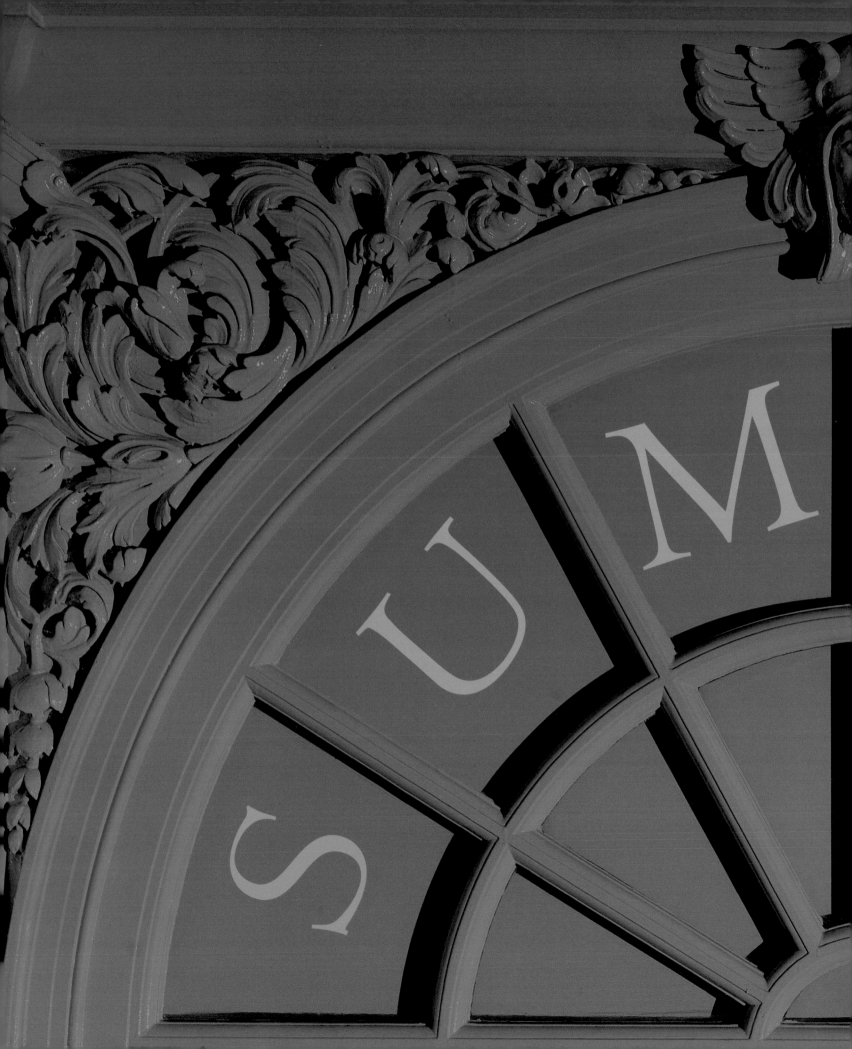

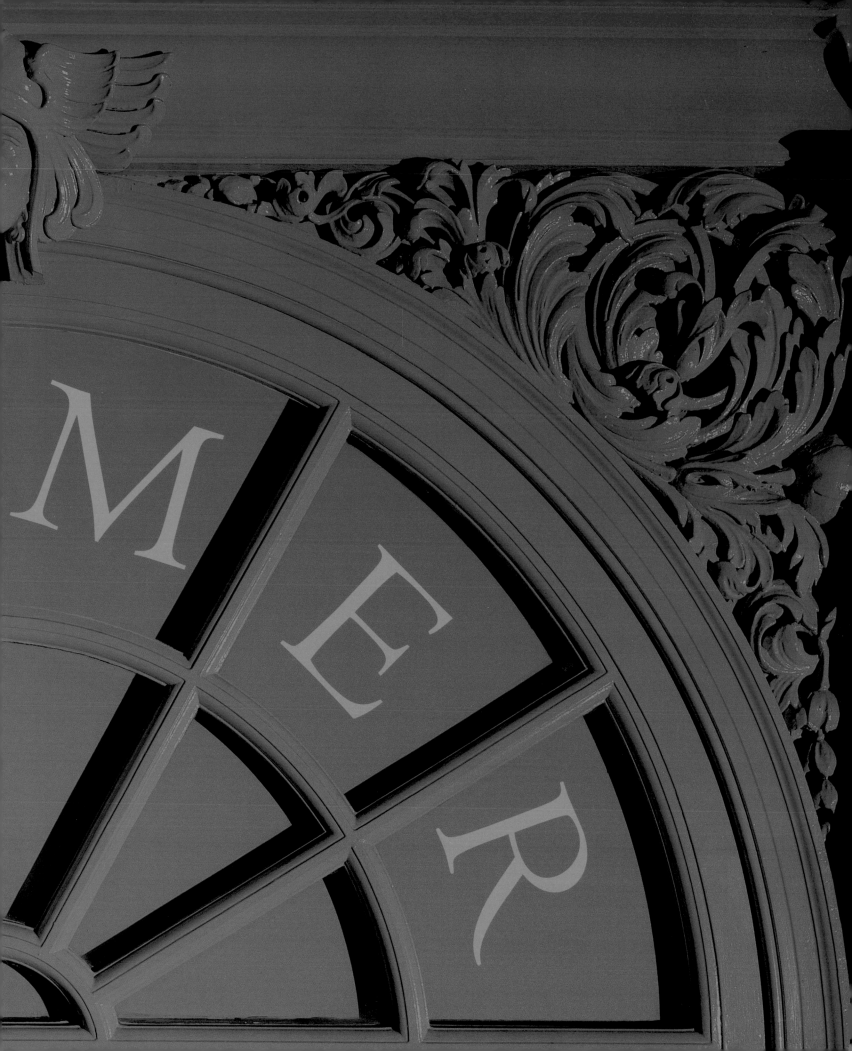

A SCRUMPTIOUS SHOW

Black-gloved puppeteers' hands hold evening bags and jewellery aloft in the miniature stages of an exquisite, striped puppet theatre (*below*). The kiosk revolves to reveal a fashion mannequin on the other side. Jack Pudding confronts his naughty dog Toby, who has just stolen a pie from the teetering pile (*opposite*). Toby's mischievous thievery is a recurrent theme in each scene. Merchandise from Fortnum & Mason is displayed on either side of the proscenium arch.

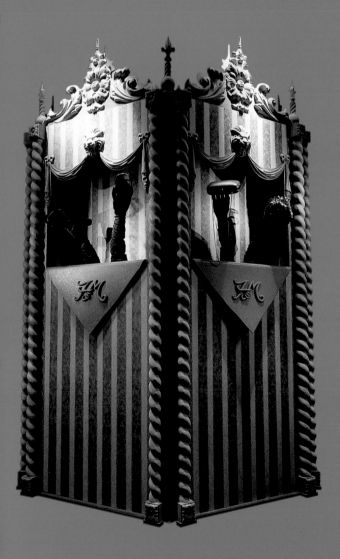

The characters of the Italian popular theatre *commedia dell'arte* have roots that stretch back to the farces of ancient Rome, and flourished in Europe from the sixteenth to the eighteenth centuries. *Commedia dell'arte* was extremely influential and Harlequin, Pulcinella, Pantaloon and the Doctor are among the most memorable theatre characters ever created. Originally performed by strolling players, the characters were lovingly adopted by various countries that imbued them with their national characteristics. Pulcinella, known for his voracious appetite, becomes Don Christoval in Spain; in Germany he is known as Hanswurst, and in England, at first as Jack Pudding and then as Punch. He was made extremely popular in England by Italian puppeteers in the late seventeenth century, which eventually led to that icon of the English seaside holiday – the Punch and Judy show.

Before retiring to the coast, however, Punch appeared in Covent Garden, London, and his reported audience in 1662 included Samuel Pepys. In the early nineteenth century, a letter appeared in *The Spectator* from a sexton complaining that this show was enticing the congregation away from the nearby St Paul's Church and that the tolling of the bell calling them to prayer was taken instead as an indication that the show was about to commence. This invective-filled and sardonic puppet also inspired one of Britain's oldest satirical magazines to name itself *Punch* in a tribute to this bickering character.

Here, because of his associations with food, the earliest English version – Jack Pudding – is used to represent the spirit of the season. Shown in various food-related scenes and assisted by his mischievous dog Toby, Jack Pudding is seen in an ornate, striped canvas puppet booth that evokes a cheery mood for a festive celebration in a light-hearted and amusing vein that is both traditionally English and international.

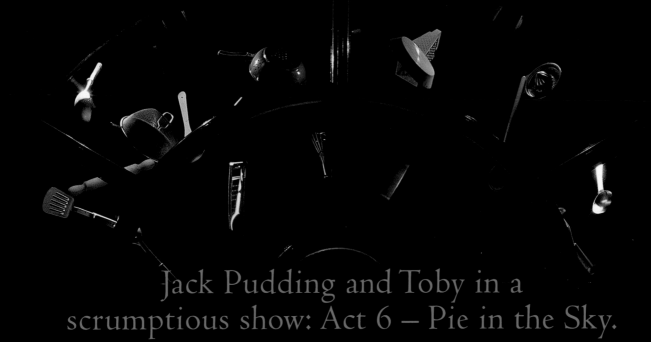

Jack Pudding and Toby in a
scrumptious show: Act 6 – Pie in the Sky.

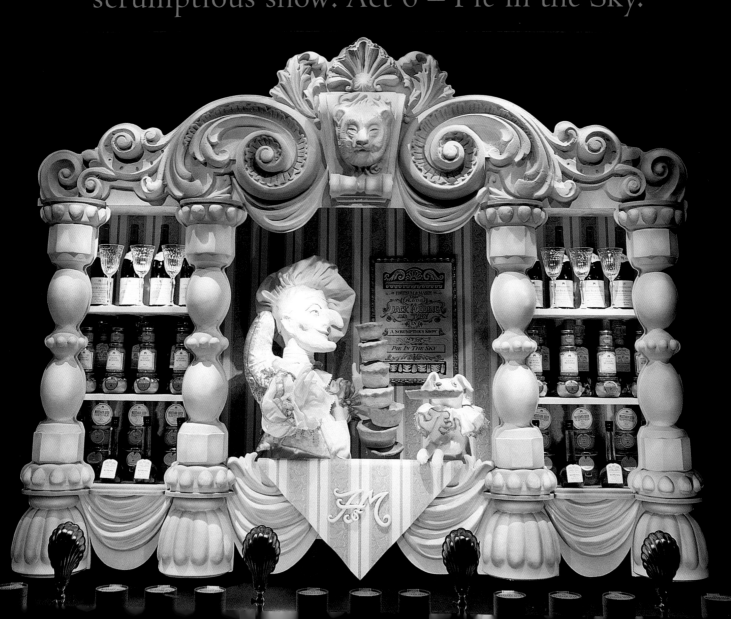

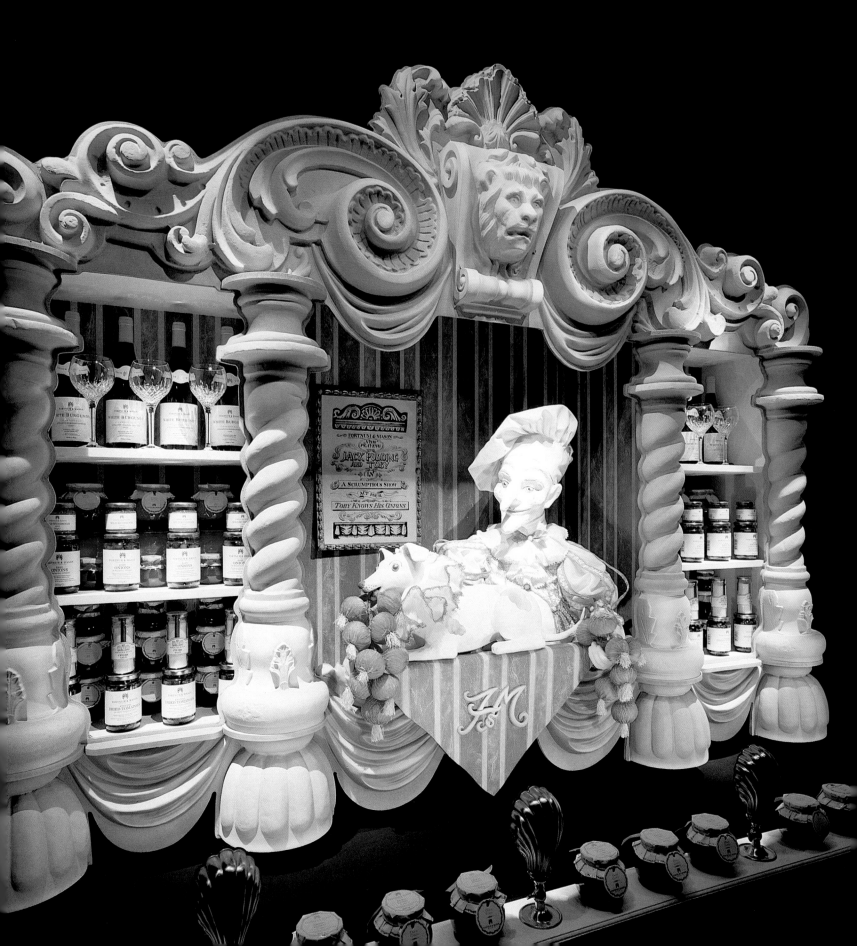

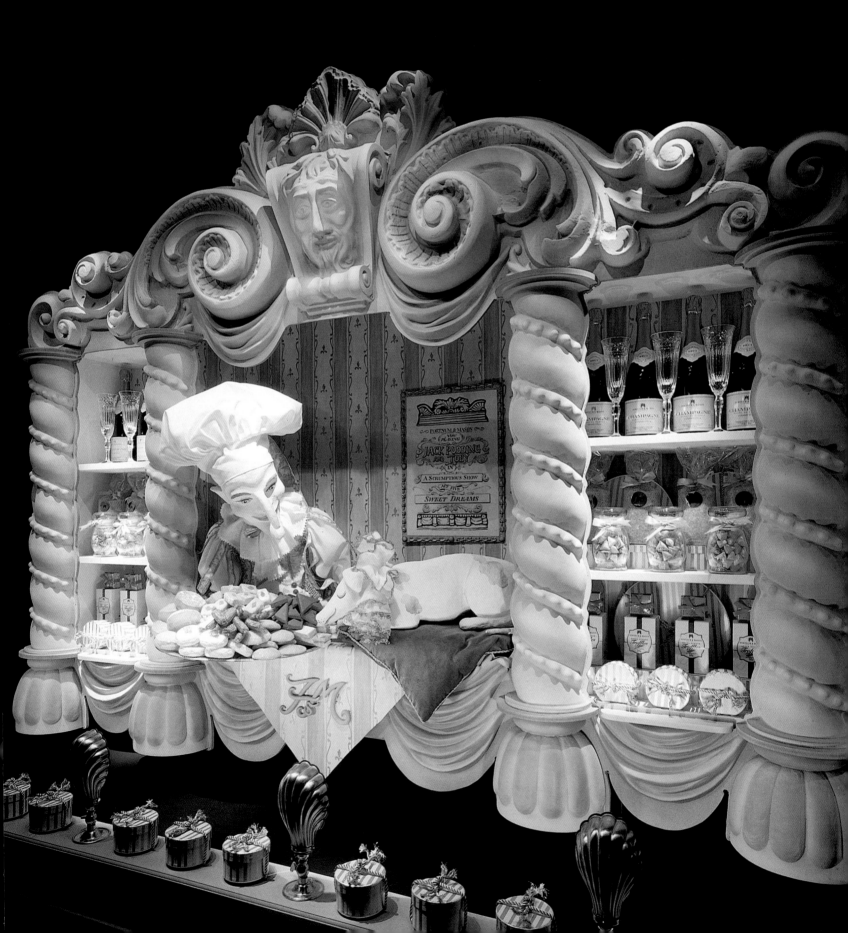

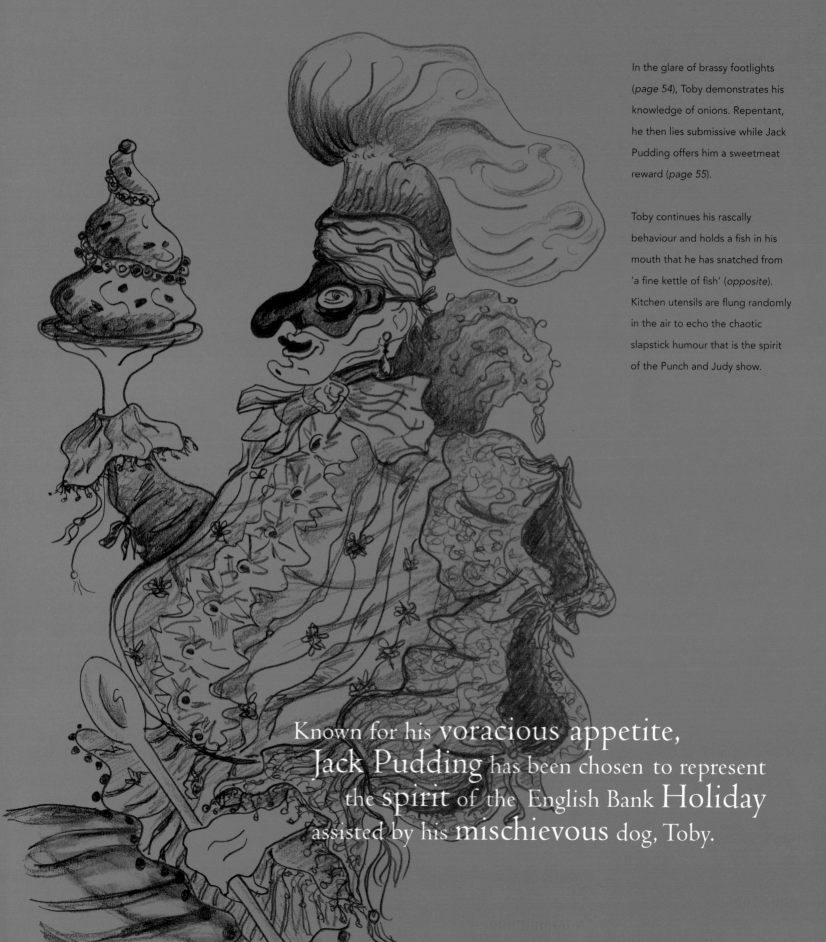

In the glare of brassy footlights (*page 54*), Toby demonstrates his knowledge of onions. Repentant, he then lies submissive while Jack Pudding offers him a sweetmeat reward (*page 55*).

Toby continues his rascally behaviour and holds a fish in his mouth that he has snatched from 'a fine kettle of fish' (*opposite*). Kitchen utensils are flung randomly in the air to echo the chaotic slapstick humour that is the spirit of the Punch and Judy show.

Known for his voracious appetite, Jack Pudding has been chosen to represent the spirit of the English Bank Holiday assisted by his mischievous dog, Toby.

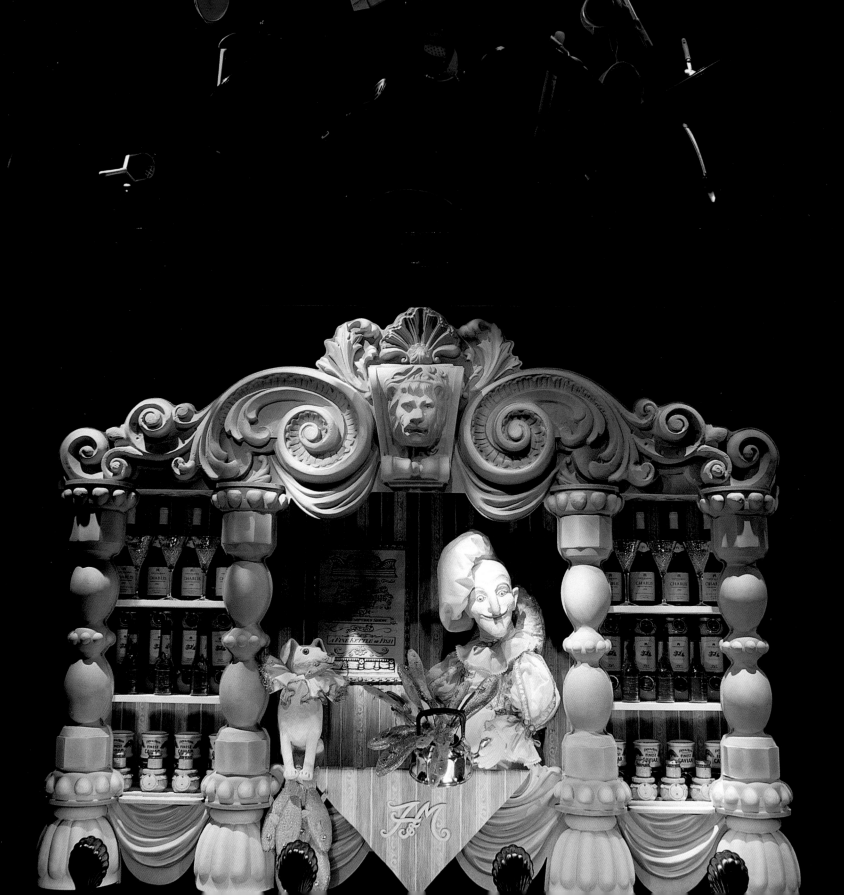

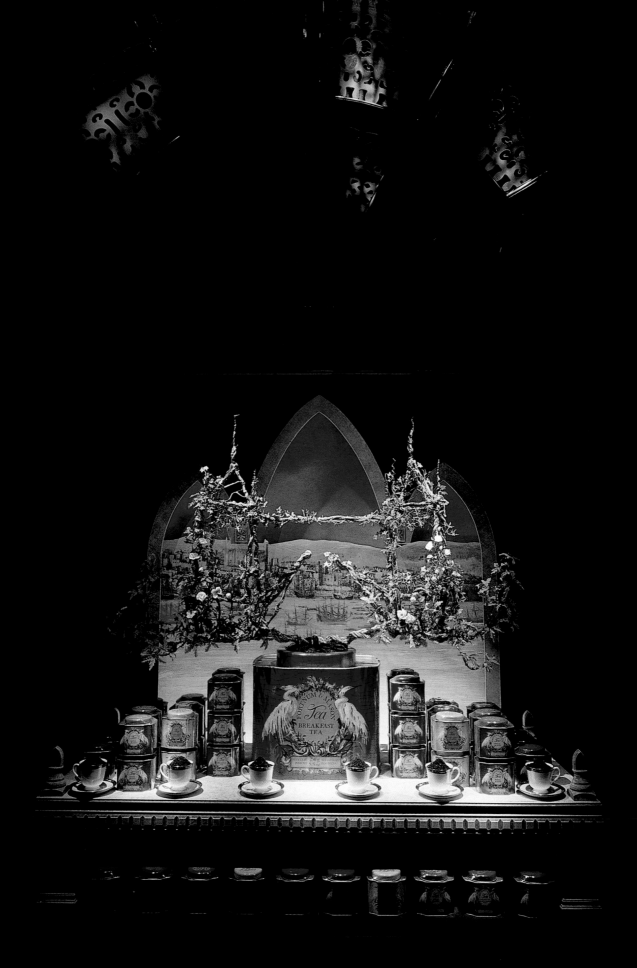

ORIENTAL BLEND

Depending on the literal translation, the word bonsai can mean either 'potted dwarf tree' or 'planted in a pot'. Whatever the translation, these curiously shaped miniature trees that are grown only in containers are very precious and regarded by the Japanese as heirlooms – some live for 300–400 years. The technique of bonsai as an art form first developed in China over 700 years ago and eventually crossed to Japan where it became a refined art form by the fourteenth century.

With its Eastern origins, bonsai seems a perfect vehicle to present the extensive range of Fortnum's tea. And where East meets West at Fortnum's, the idea of merging English topiary and Oriental bonsai led to these witty and creative miniature trees in their containers. Enlarged versions of the store's distinctive tea chests and tins form planters for fanciful tree designs, inspired by the speciality blends of tea. These bonsai are fantastical, ranging from a tree moulded in the shape of Tower Bridge that displays Fortnum & Mason's blended teas and a tree shaped to resemble a taj displaying Indian tea, to a dragon tree representing China tea.

Another tree is wrought into the appearance of an old tea clipper, an evocative representation of the incredible journey that tea makes to reach the Piccadilly store and of the fact that Fortnum & Mason tea is hugely enjoyed all around the world. Fortnum's specialist teas are highly prized among connoisseurs and are rightly given centre stage here.

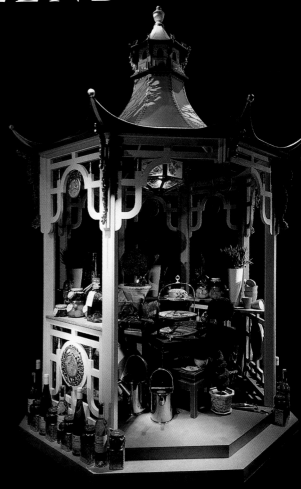

Tower Bridge, its road open and aloft, is wrought from the branches of a bonsai tree, which grows in a giant version of a Fortnum & Mason tea tin (*opposite*). Fortnum & Mason import tea from across the world, a fact that is reflected in this theme by the view of the River Thames framed in the triptych behind London's most famous bridge. Two tea houses, one Indian in design, the other Chinese, overflow with Fortnum's summer bounty of luxury goods, gardening artefacts and merchandise (*above and left*).

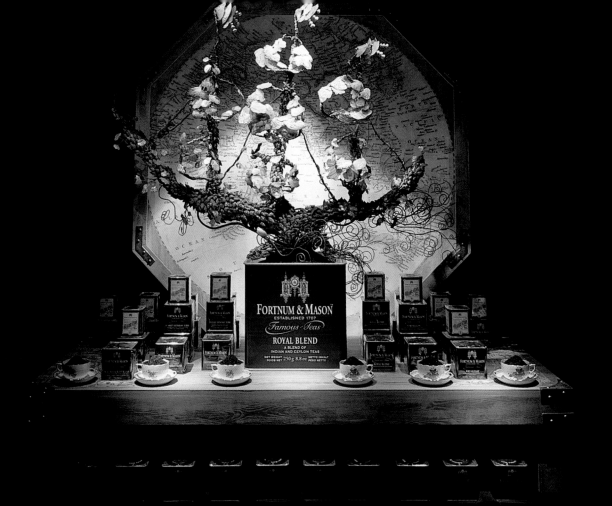

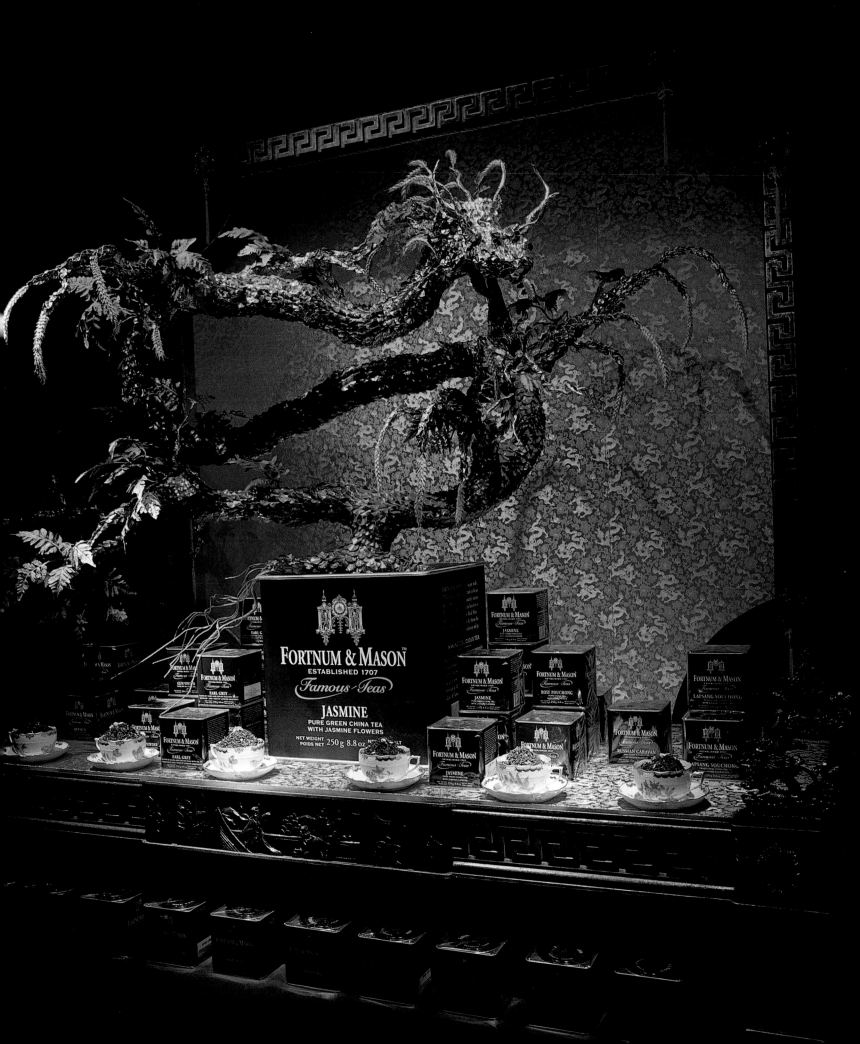

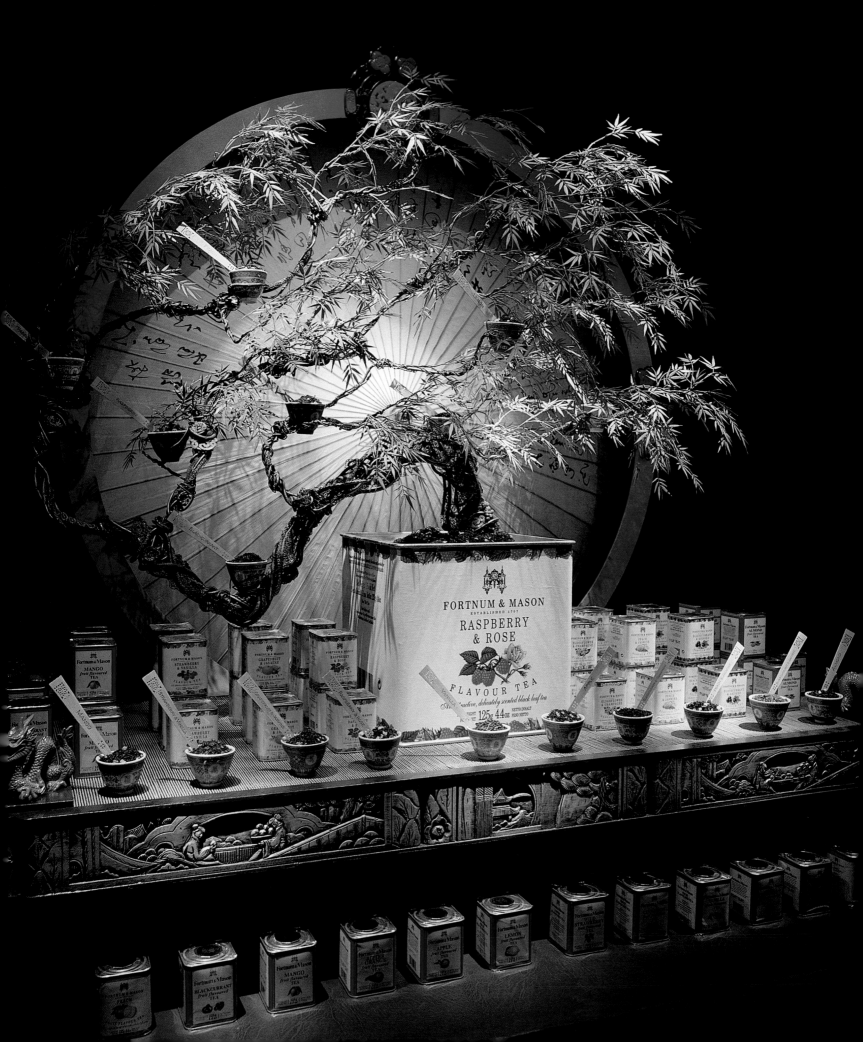

A fantasy bonsai in the shape of a tea clipper (*page 60*) is an arresting and beautiful symbol of the journey that Fortnum & Mason's tea makes both to reach the store in London's Piccadilly and, once purchased, out again to all corners of the globe. In keeping with the marine theme, the hull of the ship is constructed of driftwood and its sails are seashells. On page 61, Fortnum & Mason's China teas surround a fanciful dragon-shaped bonsai that grows in an enlarged Jasmine tea tin.

Tiny oriental porcelain bowls containing fruit teas are caught in the branches of an elegant bonsai (*left*). Each tea in the display is labelled with a segment of a fan. Behind the tree an oriental paper parasol lies open to emphasize the Far Eastern theme and the whole scene is backlit by a glowing sun. Fortnum & Mason's Indian teas are graced by an exquisite bonsai tree in the shape of a taj laden with blossom (*right*). A giant fan of oriental pierced work fills the fanlight above.

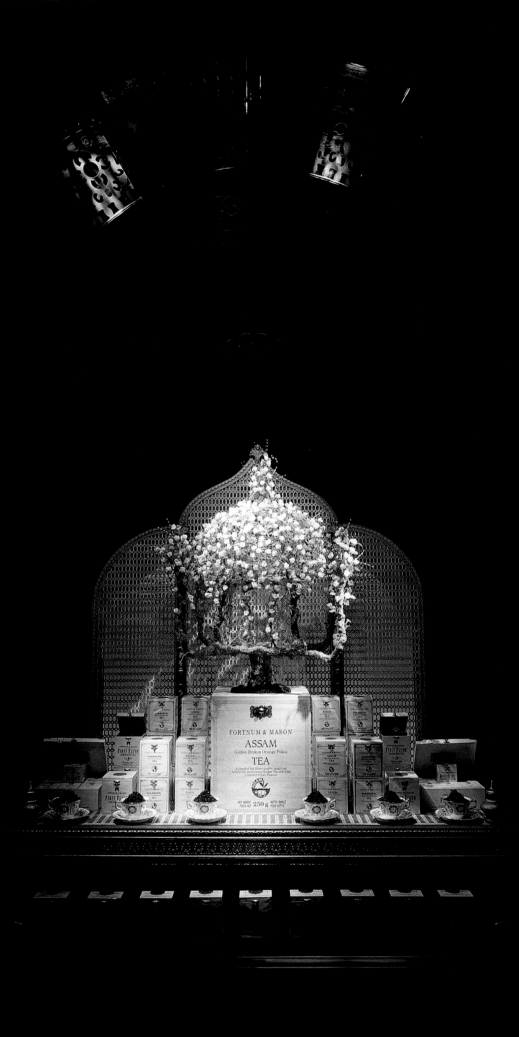

HIGH TEA

The English Summer Season, once the exclusive domain of England's aristocracy, is celebrated in a series of events that includes the Royal Garden Party, Henley Regatta, cricket at Lord's, tennis at Wimbledon and opera at Glyndebourne. The season culminates in the Proms – the Promenade Concerts at the Royal Albert Hall. This social season is associated with the luxurious food and wine such as champagne, chocolates and other delectable goods that are consumed at such events, particularly those that take place in the open air. To celebrate the Summer Season, each event is represented by a giant teacup, as none of them would be complete without that most traditional of drinks and its purveyor, Fortnum & Mason.

Each teacup evokes the epitome of English summers and represents Fortnum & Mason's traditional contribution to this great season. The style of each porcelain teacup reflects the event: the Glyndebourne cup is opulently decorated in the spirit of the opera; the Albert Hall cup is designed on classical lines and has

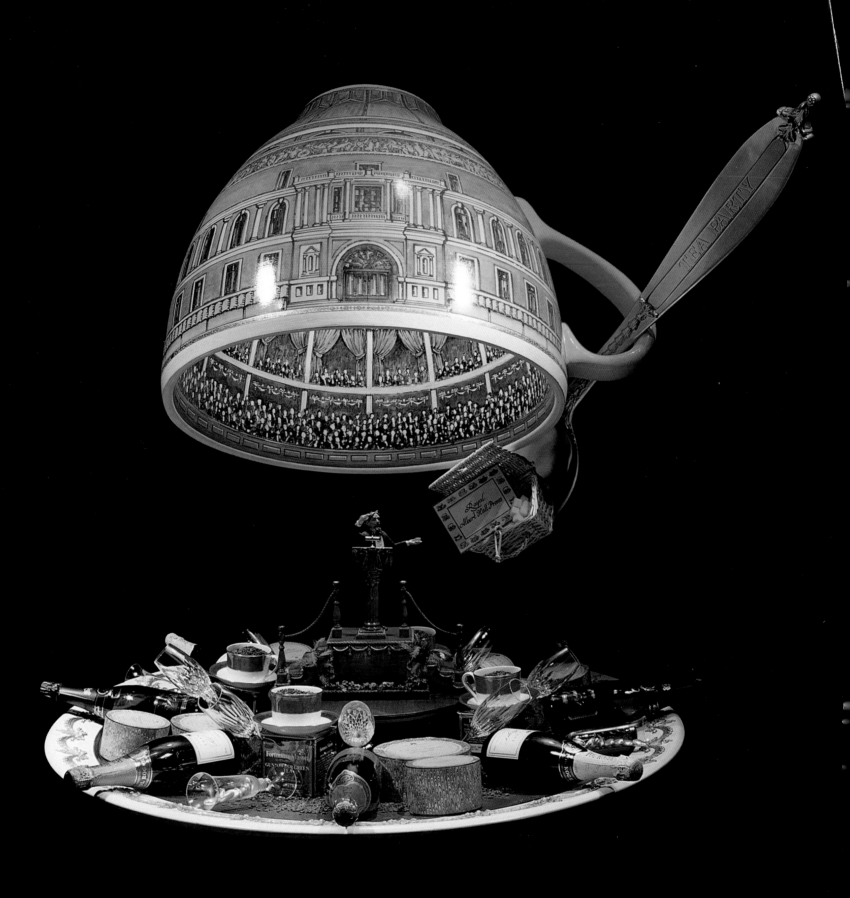

Tea Party – Proms at the Royal Albert Hall

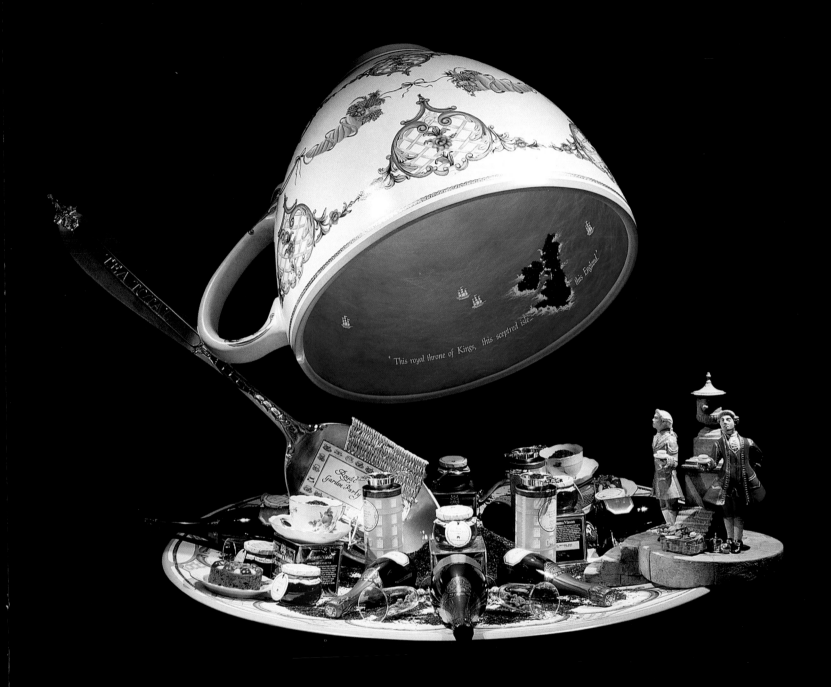

There are few hours in life more agreeable than the hour

HENRY JAMES

The Queen holds a series of
summer garden parties in the
grounds of Buckingham Palace
(*left*). The tradition of the
royal occasion is captured in
Shakespeare's lines from *Richard II*,
'This royal throne of kings, this
sceptred isle … this England.'
The bustle and excitement
of the Wimbledon Lawn Tennis
Championships is represented
in this rainy teacup scene (*right*).
Beneath the teacup court, the
saucer is laden with essential
refreshments that traditionally
accompany a visit to Wimbledon.

dedicated to the ceremony known as afternoon tea.

A river punt, complete with picnic hamper, seated lady and her gallant punter, floats on the surface of a giant porcelain cup decorated with pastoral Thames-side scenes. They represent that most elegant of the English Summer Season's river sports, the Henley Regatta. A gigantic teaspoon holds a picnic hamper and invitation to the event, and preserves, vintage champagne and speciality teas are displayed in the outsized saucer.

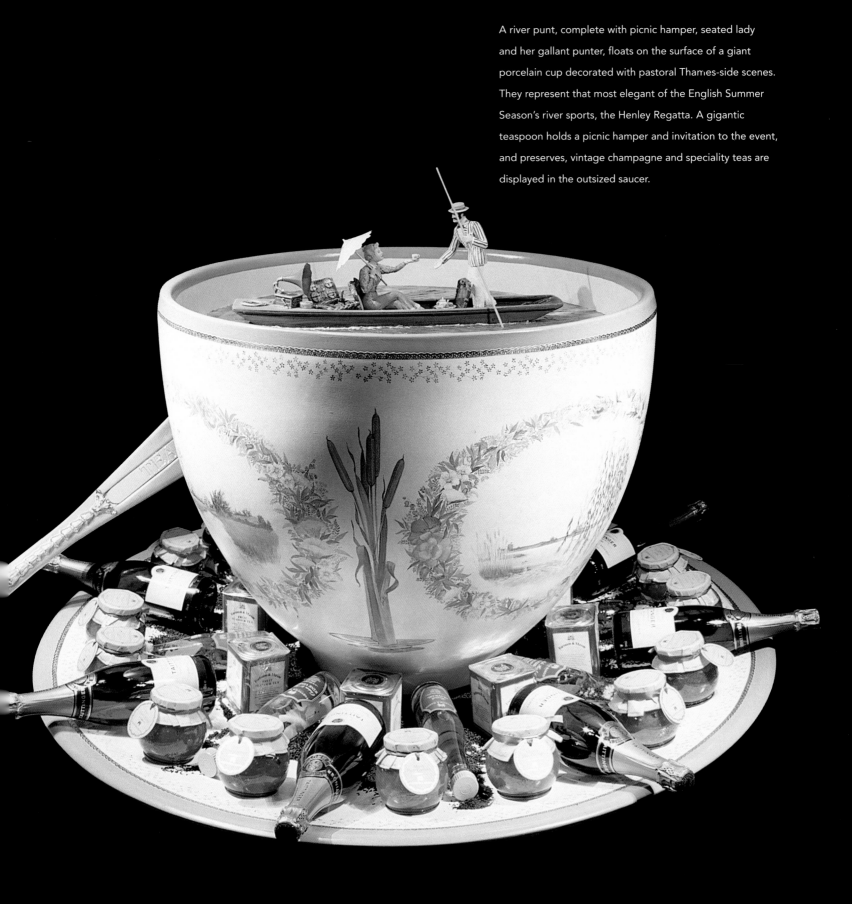

The English Summer Season
culminates in the Promenade
Concert at the Albert Hall
(*opposite*). Here, the rousing music
has lifted the lid off the splendid
Kensington landmark to reveal the
tiers full of enraptured concert
goers. The conductor, Sir Henry
Wood, mounted on his podium,
beats time, while at his feet, the
saucer is laden with Fortnum &
Mason delights.

the rosy glow of the original; the Henley cup is in pastel shades decorated with English summer flowers and bulrushes. The Royal Garden Party teacup has a suitably refined and elegant decoration.

A giant teaspoon placed close to each of the cups holds a miniature hamper to remind us that, although many of the Summer Season venues now have restaurants and cafés, there was a time when spectators had to take their own provisions along to these events and Fortnum's provided hundreds of hampers filled with luxurious feasts every day in the season. Here, each hamper carries an elegant invitation to the appropriate event.

Poised on the edge of the Royal Garden Party saucer are two extremely important figures. Not guests of honour, they are, in fact, Mr Fortnum and Mr Mason, and they are serving cups of tea to the guests. William Fortnum's right to be included is historic as he was a servant in the Royal Household from the reign of Queen Anne.

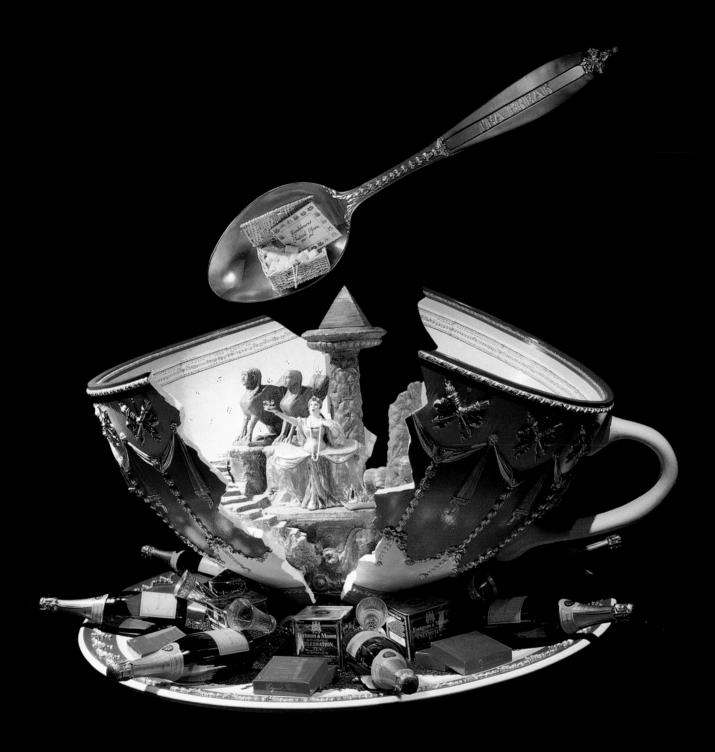

the midnight, and with tea welcomes the morning.

DR JOHNSON

W G Grace stands at the wicket, a cup of tea in his hand, to represent that mecca of the Summer Season, a cricket match at Lord's (*right*). The famous ground is faithfully painted on the inside of the cup, complete with tiers of enthusiastic spectators. A soprano triumphantly hits her topmost note at Glyndebourne and cracks her ornate teacup in two to reveal a perfect stage set in miniature (*far right*) – a suitably dramatic representation of this 'exotic and irrational entertainment' (Samuel Johnson).

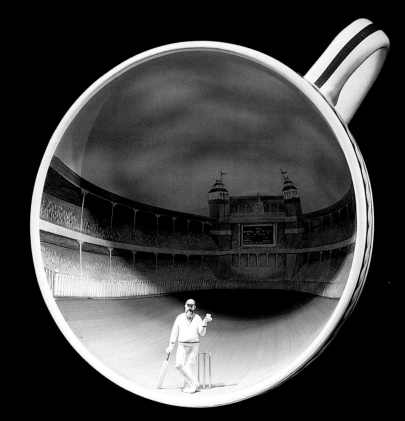

Who with tea amuses the evening, with tea solaces

SUMMER NOCTURNE

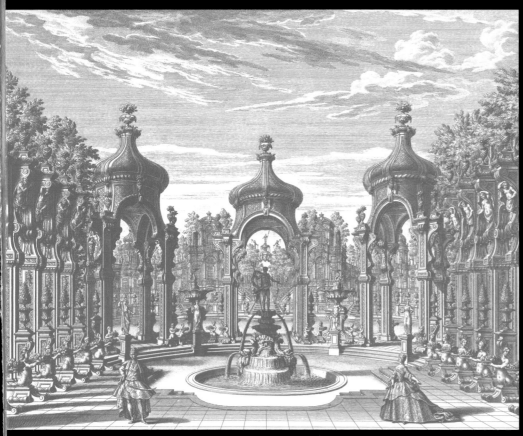

Fortnum & Mason has long been associated with the delights of outdoor eating through its supply of picnic hampers and luxury foods. So two exquisite eighteenth-century garden scenes are the inspiration for a theme that perfectly encapsulates the atmosphere of a quintessential English summer evening: a picnic listening to music or a fête champêtre in the grounds of a stately home.

Guiseppe Galli Bibiena (1696–1756) was the principal theatrical engineer and architect to the Hapsburg court of Charles VI, in Vienna, Austria. During this time, Europe was dominated by the Baroque style of architecture, which created the the illusion of forced perspective. Bibiena's genius gave the stage a new concept when he swept away the rigidity of Renaissance stage sets and introduced angular perspective, which allowed greater dimension and depth to the confines of the stage. Fifty of Bibiena's magnificent Baroque architectural designs were published in 1740, as *Architectural and Perspective Designs*. These sensational engravings include settings for religious dramas, sets for court theatricals and pageants, and the transformation of the Viennese Riding School for the wedding of the Archduchess Marianna.

Bibiena's intricate designs draw the onlooker deep into a fantasy world, and his stately garden scenes have been recreated here in three dimensions. The enchantment and mood of the garden is heightened by the night scene, lit by moonlight and the stars.

One of Bibiena's original engravings is shown above, which inspired the three-dimensional reconstruction opposite.

A magical scene, based on Bibiena's designs spans three windows (*following pages*). The image has been altered to enable merchandise to be shown in the foreground where the performers would have stood. Layer upon layer of cutouts based upon the original engravings give the effect of three-dimensional scenery and effect of how these grandiose fantasies could have been realized in the theatre.

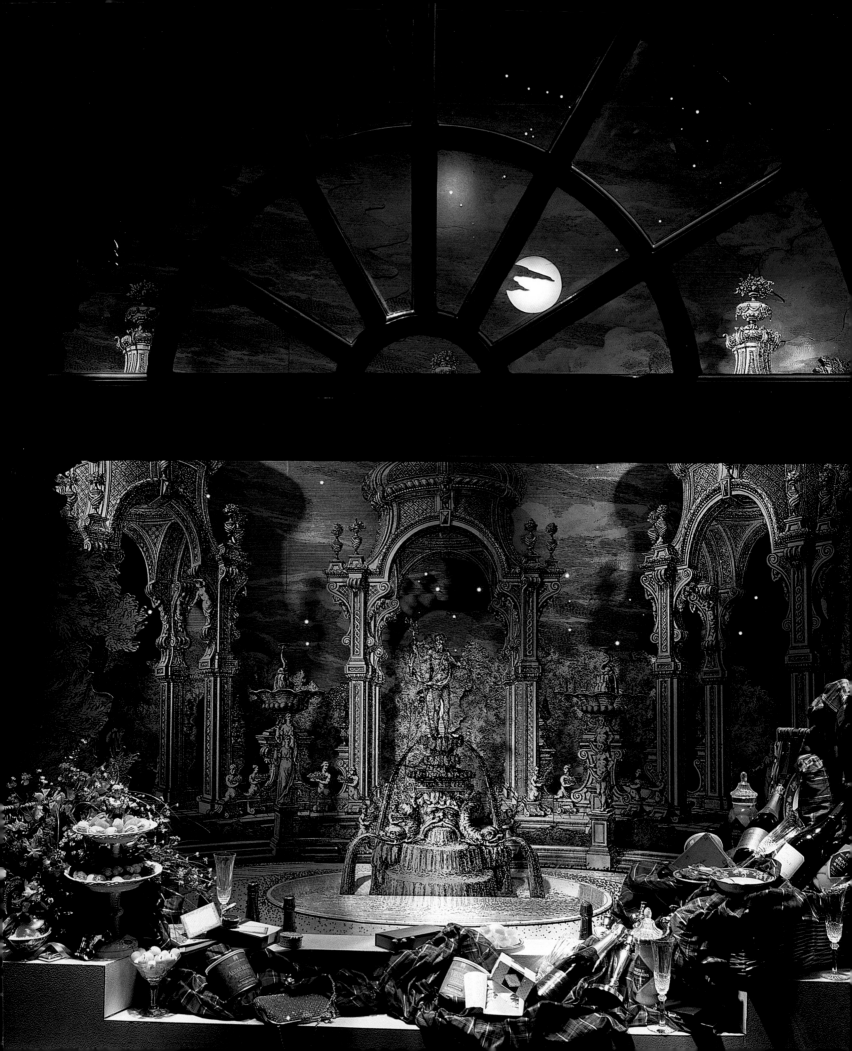

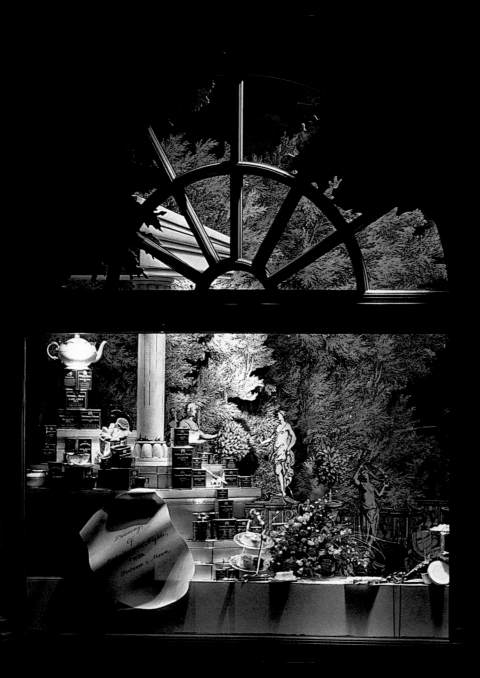

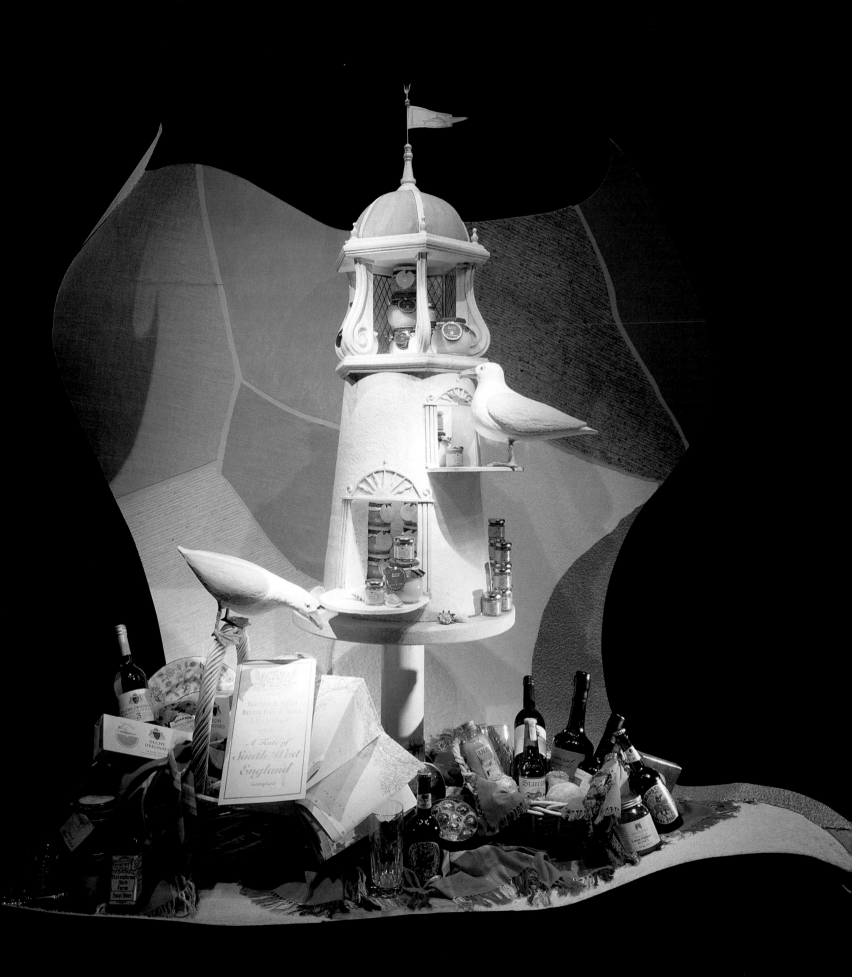

BIRD'S EYE VIEW

In addition to its reputation for international specialities, Fortnum & Mason is also renowned for fine British merchandise, a tradition that continues to this day with unique produce sourced from small suppliers. That line of excellence is celebrated here in a series of designs that display regional specialities of the British Isles, many of which continue to be produced by artisan suppliers. The theme is based on the areas of the British Isles from which the various foods come. Each region, be it county, principality, country or province, is represented by a birdcote in the style of the vernacular architecture together with a pair of birds native to that location; East Anglia has a windmill and magpies and Scotland has a castle with ospreys.

Each scene has an abundance of local produce, such as bread, wine, cheeses and preserves, spilling out of baskets as if the birds are about to have a picnic. A map of the area lies open near the basket and the background to each birdcote is a collage of fabrics representing field patterns – the landscape in a bird's eye view.

One of nature's most spectacular seasonal displays is the phenomenon of migration. Many species, in particular birds, travel thousands of miles to change their habitat in search of a more favourable climate and a more congenial food supply to breed and raise their young. This annual journey is regarded by man as a portent of the approaching changes in climate.

In a sturdy Scottish towerhouse birdcote, complete with chimneys and castellations, ospreys observe local produce with a keen eye (*above*). Two seagulls survey the speciality Cornish produce that spills lavishly from a basket (*opposite*). Their lighthouse birdcote is stacked with Cornish honey and other provisions indigenous to the Duchy.

Mallard ducks live in this rustic birdcote that captures all the endearing character of a water mill (*right*). Unique, and sometimes handmade, produce from Middle England is invitingly spread out beneath the mill like an abundant and exciting picnic.

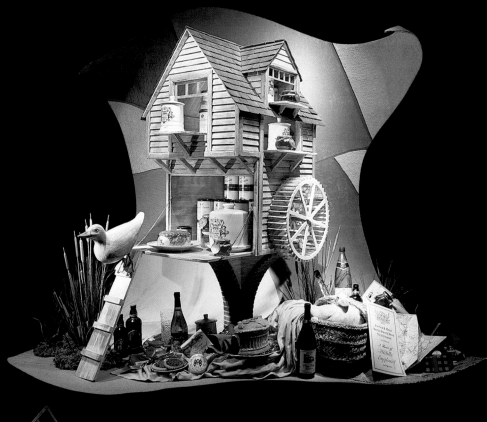

Windmills are seen throughout East Anglia and here, an enchanting miniature is home to two magpies who oversee a magnificent picnic of produce from the area (*left*).

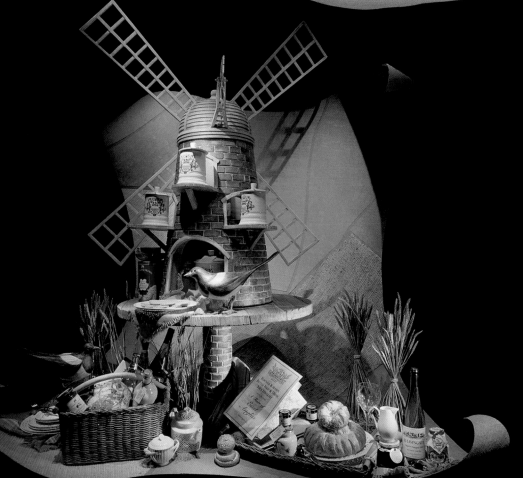

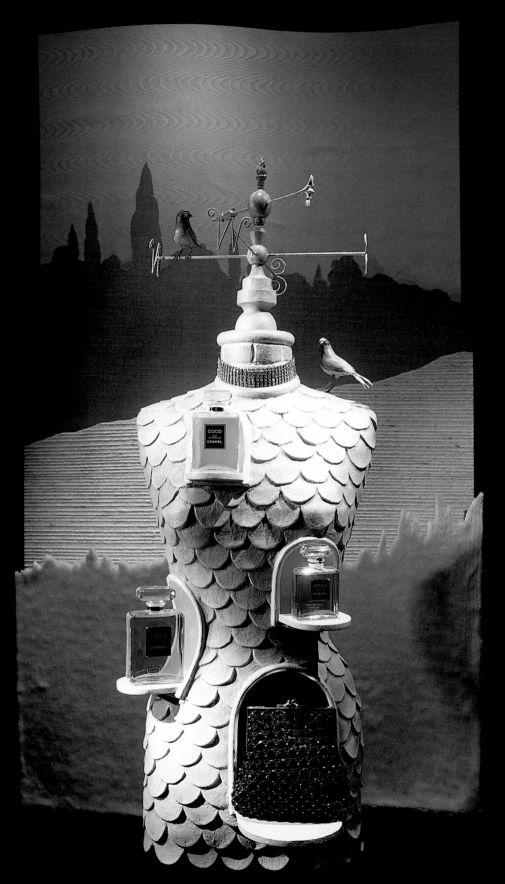

A rural landscape composed of layers of textured fabric forms the background to this bucolic tailor's dummy dressed in rustic shingle tiles. The inspiration for this surreal birdcote is drawn from Salvador Dalí's *Venus de Milo with Drawers*, 1936, and *The Burning Giraffe*, 1936–37 (see page 10).

MYTHICAL CREATURES

Since the Age of Chivalry, fabulous beasts of heraldry have graced coats of arms throughout Europe. The lion and the unicorn appear emblazoned on the British Royal Arms and are part of the mythological menagerie known as the Queen's Beasts – fantastic guardians that faithfully protect our monarch from harm. To celebrate the anniversary of the Queen's Ascendancy, the lion and the unicorn animate this regal tribute. The design is particularly fitting as it underlines Fortnum & Mason's long tradition of service to the Royal Family as the company has held Royal Warrants for more than 100 years. These coveted Royal Warrants are a mark of recognition that a company is a regular supplier of goods or services to the royal family. The holder of a Royal Warrant may use the legend 'By Appointment' and display the Royal Arms on stationery, advertisements and other printed material and on the place of business itself. The Royal Warrant Holders Association was granted a Royal Charter in 1907, but its origins are believed to go back as far as Henry II (1133–89) and Royal Arms began to be displayed by tradesmen in the eighteenth century. Today, Fortnum & Mason is still honoured by Warrants of Appointment to several members of the royal family.

In this installation, the royal lineage is represented by a stylized tree, which is lovingly tended by either the lion or the unicorn. The dynastic tree is protected by these fastidious beasts who whimsically ascend ladders to arrange and maintain oval portraits of previous monarchs nested in the branches. The symbolic tree is topped with a crown cushioned on eau de nil drapes – the Fortnum & Mason house colour. Beneath each tree an array of sumptuous fare is spread as a reminder that no occasion for gracious living in the open air is complete without a Fortnum & Mason hamper.

A fantasy heraldic shield (*above*) with the Fortnum & Mason monogram is swathed in rich fabric and gold embroidery. The fabled unicorn, symbol of strength, fierceness and purity, (*opposite*) prepares to hang another royal portrait on the branches of the royal family tree. In the fifteenth century, the unicorn was one of the heraldic beasts that supported the Scottish kings. When Elizabeth I of England died in 1603, she was succeeded by James VI of Scotland who brought the unicorn into the heraldic menagerie of England. The mythical beast soon appeared with the lion as a supporter of the British Royal Arms.

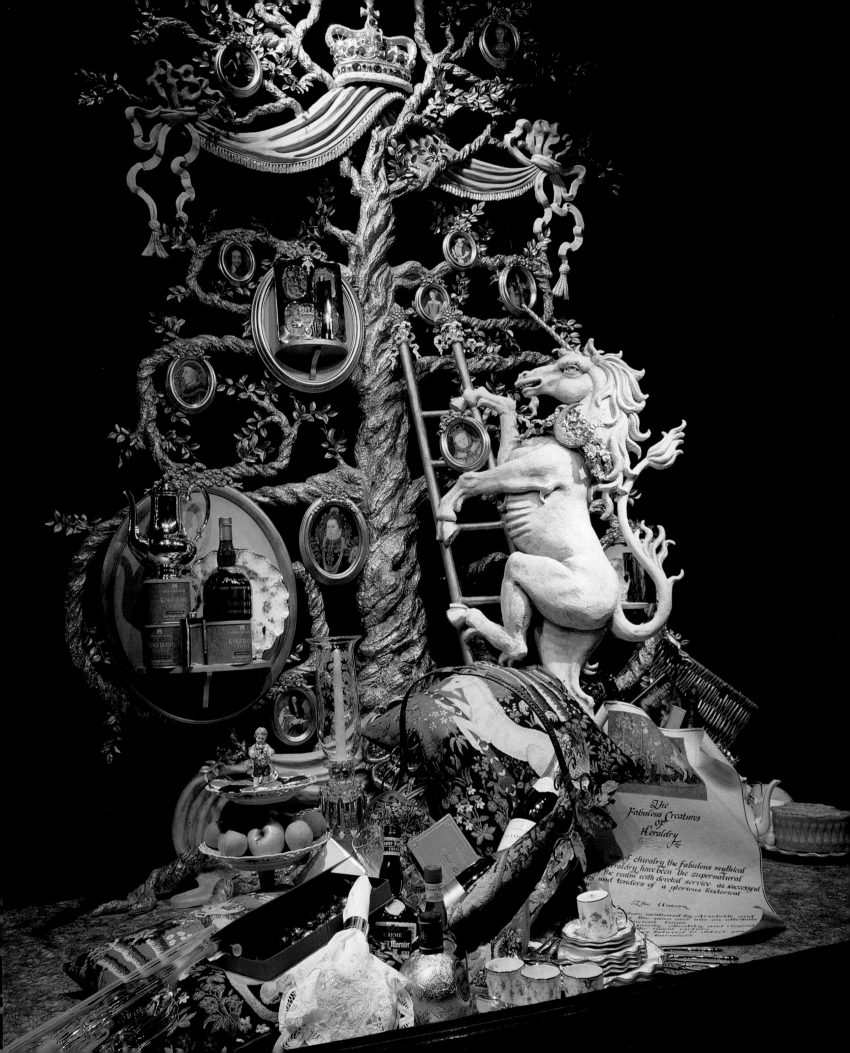

The Fabulous Creatures
of
Heraldry

...of chivalry the fabulous mythical
...heraldry have been the supernatural
...the realm with devoted service as successful
...rs and tenders of a glorious historical

The Unicorn

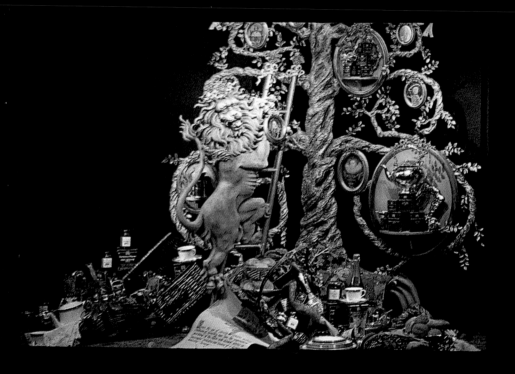

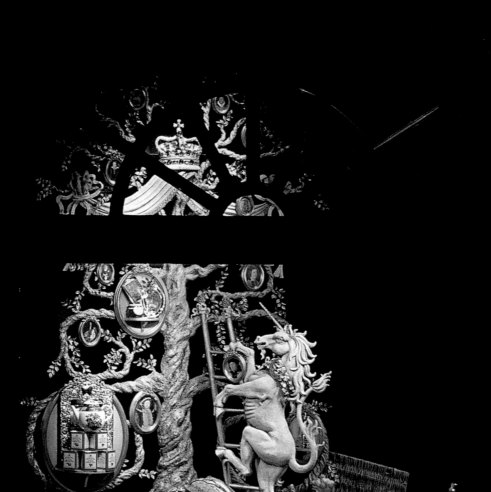

Some of the medieval icons of heraldry were later adopted by royalty as symbols of their
power. To decorate his palace at Hampton Court, Henry VIII commissioned sculptures
of those closely connected with British royalty. These included the lion and the unicorn
(*pages 82–3*) and the griffin (*opposite*). The griffin was engraved on Edward III's private seal
and is one of the most ancient of mythical beasts, while the Black Bull of Clarence (*above*)
was borne by Edward IV, and then Richard III and by the Houses of Lancaster and Tudor.

Since the age of **chivalry** the fabulous **mythical creatures** of **heraldry** have been the **supernatural** guardians of the **realm** with devoted service as successful protectors and tenders of a **glorious** historical heritage.

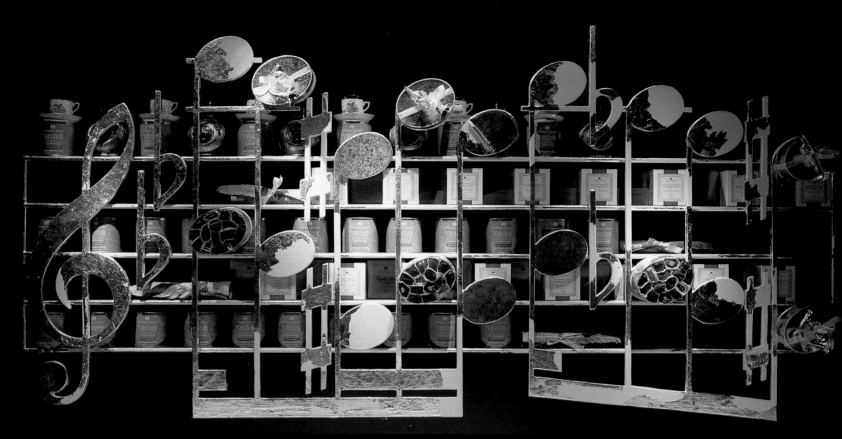

If musik be the food of love then

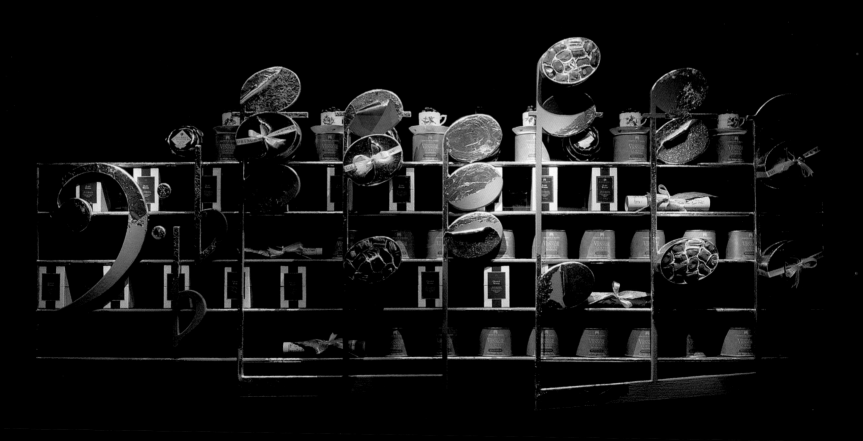

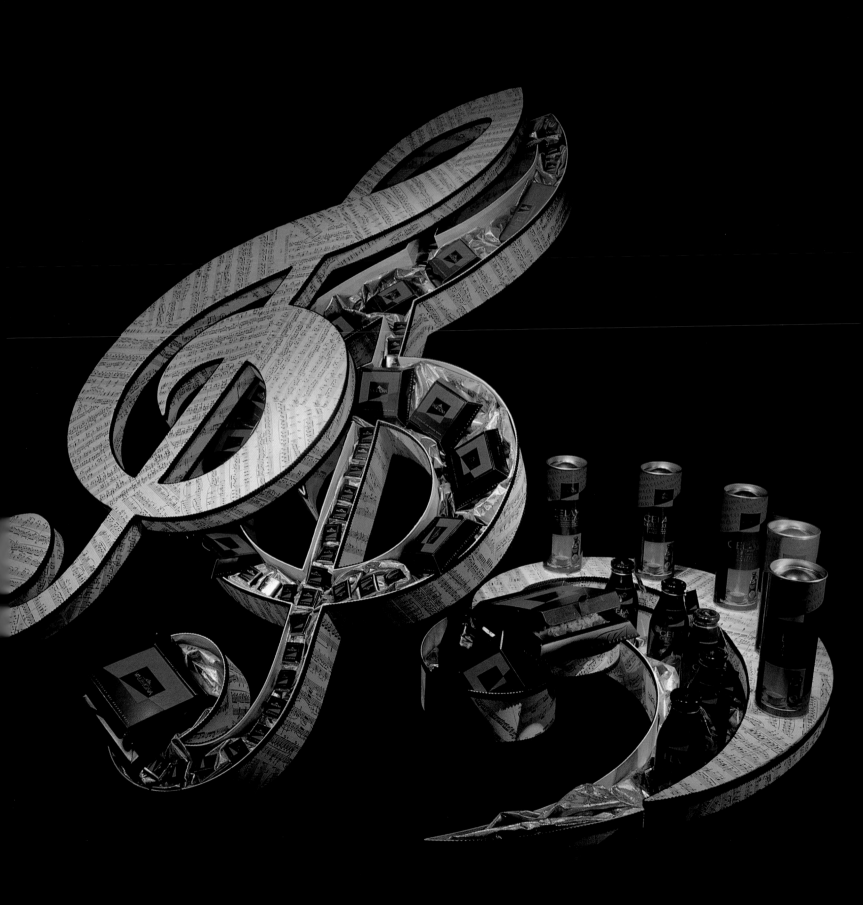

SWEET MUSIC

An ingenious play on words takes to the air with these notes of music (*below*). Each holds an elegant scent bottle full of the notes of perfume. The treble and bass clefs (*opposite*) are a chocoholic's dream, while on the following pages is the notation from *Ode for Saint Cecilia's Day*, whimsically composed of chocolate boxes.

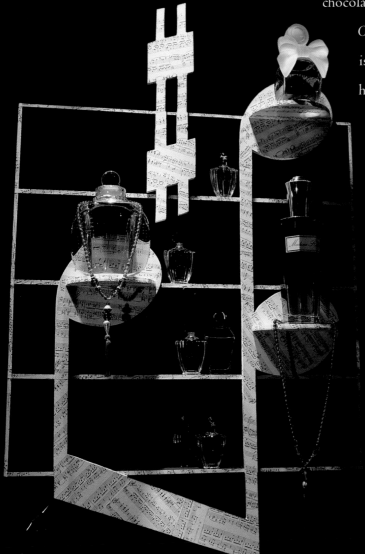

The ever-appealing combination of food and music is exploited in this affectionate tribute to Henry Purcell, the seventeenth-century composer and possibly England's greatest musical genius. Purcell set Henry Heveningham's poem *If music be the food of love* to music (the first line of the poem is taken from Shakespeare's *Twelfth Night*). The opening lines of this poem read, 'If music be the food of love, Sing on till I am fill'd with joy …' and this installation implies that the joy in this case is Fortnum & Mason's delicious confectionery, a tongue-in-cheek homage to both food and music.

In adjoining windows, the musical staves form shelves on which delectable merchandise is displayed. The 'notes' are created from boxes of chocolates. They form the actual notation of part of Purcell's choral work *Ode for Saint Cecilia's Day*, a particularly apposite piece as Saint Cecilia is the patron saint of music. In Purcell's day, Saint Cecilia was honoured by a group of music lovers who called themselves 'The Music Society'. To mark Saint Cecilia's Day (22 November), a divine service was held usually at St Bride's Church, London and commemorated with a new anthem composed each year. Purcell wrote *Hail! Bright Cecilia* for the 1692 festival, which, according to the *Gentleman's Journal*, was received with 'Universal applause, particularly the second stanza, which was sung with incredible graces by Mr Purcell himself'.

Giant chocolate boxes, in the shapes of the treble and bass clefs and covered with music manuscript, are a dramatic focus of this scheme. They lie tantalizingly open to reveal elegant boxes of hand-made chocolates. The whole mood is crisp and light, and the black and white notes of music float to fill the air with wit and sophistication.

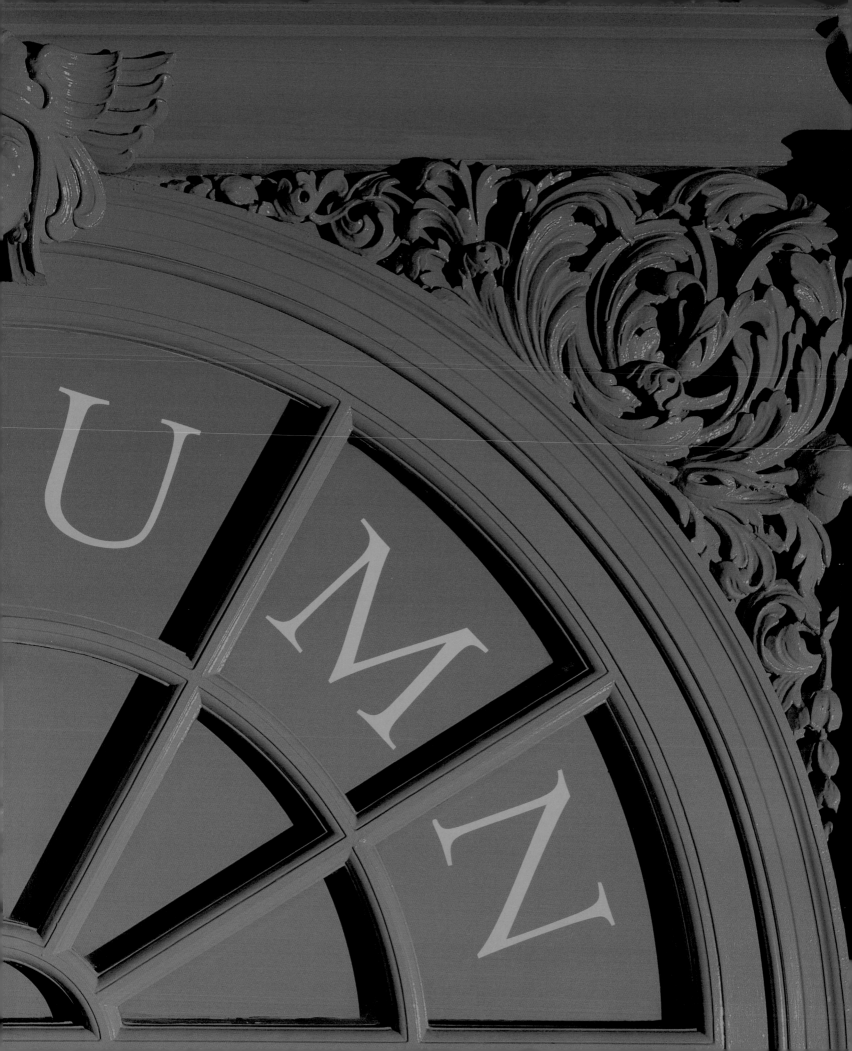

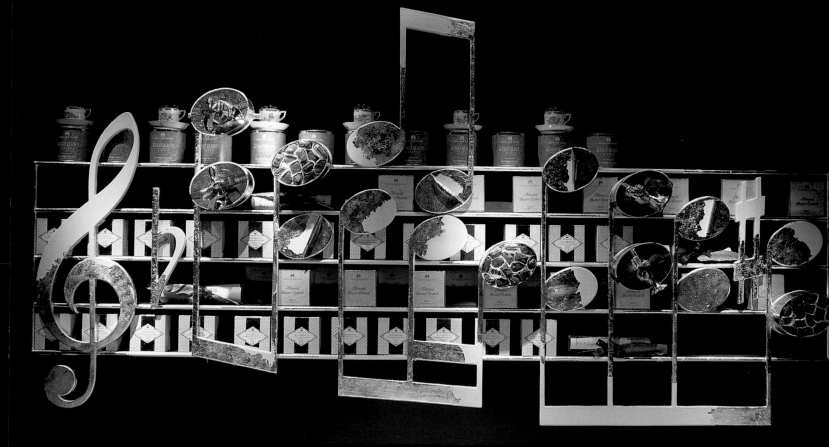

Fortnum & Mason is the maestro

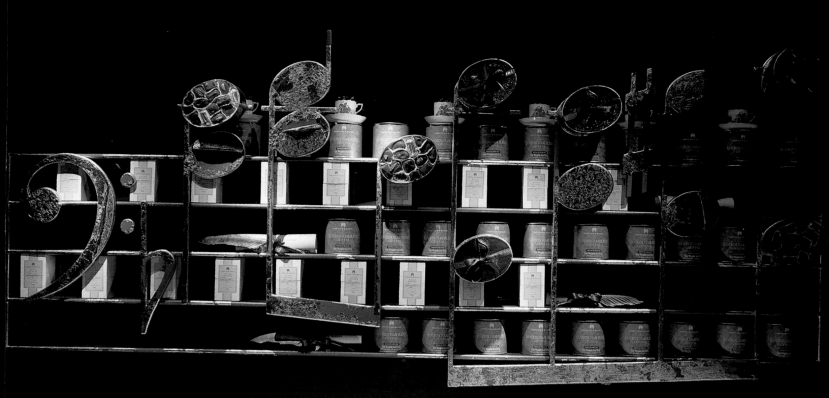

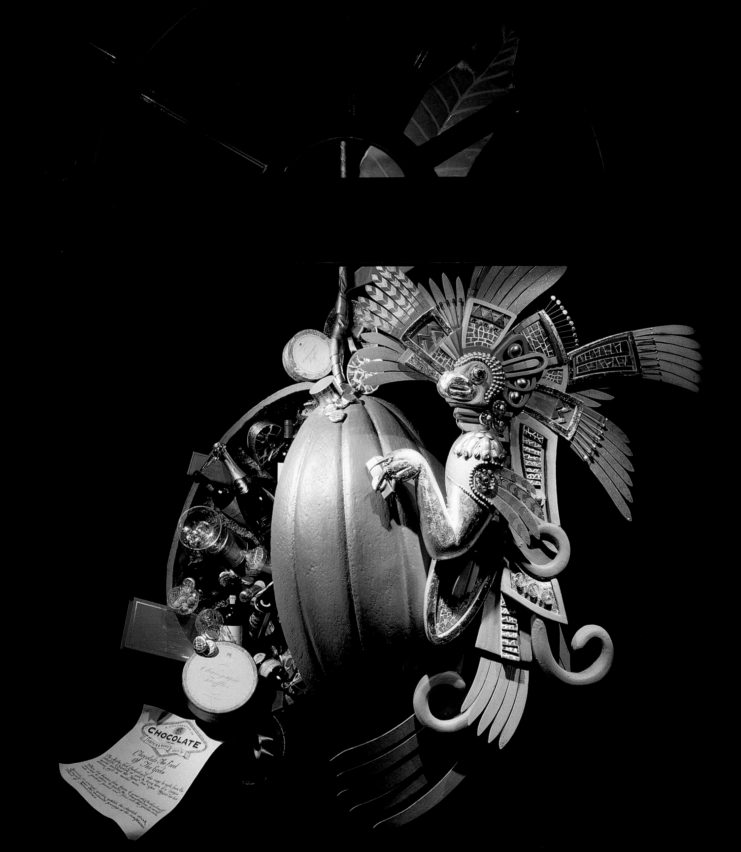

THE FOOD OF THE GODS

Chocolate, say the Aztec legends, was consumed by the gods in the celestial golden paradise. The Aztecs of Mexico believed that the seed of the cocoa tree was brought to Earth and given to man by the God of the Air, Quetzalcoatl, the feathered serpent, who travelled on a beam of the morning star to deliver his divine gift to mankind after being born of mortal woman. From Quetzalcoatl the Aztecs learned how to grind the roasted cocoa beans and mix it with vanilla and herbs to make a paste, which they whisked with water to make xocoatl, or 'bitter water'. Served in sacred goblets, this chocolate drink was the exclusive privilege of the sumptuous court of Montezuma.

Xocoatl was made irresistible by mystery and legend and the Aztecs drank it as a ceremonial drink, believing that it imbued universal wisdom and knowledge. When Cortez, the Spanish conquistador, visited the court of the last Aztec king in 1519, he noted that Montezuma consumed xocoatl in a golden goblet before entering his harem – an observation that fuelled the belief that it was an aphrodisiac.

When his human form began to grow old, Quetzalcoatl returned to paradise, leaving an image of himself as a quetzal, the brightly coloured parrot that lives in the cloud forest. He flew into the golden sun on a raft of feathered serpents, promising to return in the future.

Chocolate eventually found its way to Europe and chocolate houses began to open in London towards the end of the seventeenth century. In this homage to the compulsive allure of chocolate, vivid South American colours and dramatic and exotic symbols of folk art combine to provide a treasure trove of Fortnum & Mason's finest confectionery indulgences.

The Aztec calendar is reproduced in foil-wrapped chocolate (*above*). Quetzalcoatl (*opposite and following pages*), the God of the Air, in his quetzal parrot form and adorned with plumes of Aztec finery, swings from a ripe cocoa pod, which has burst open in fecund ripeness to show its feast of sybaritic Fortnum & Mason delights.

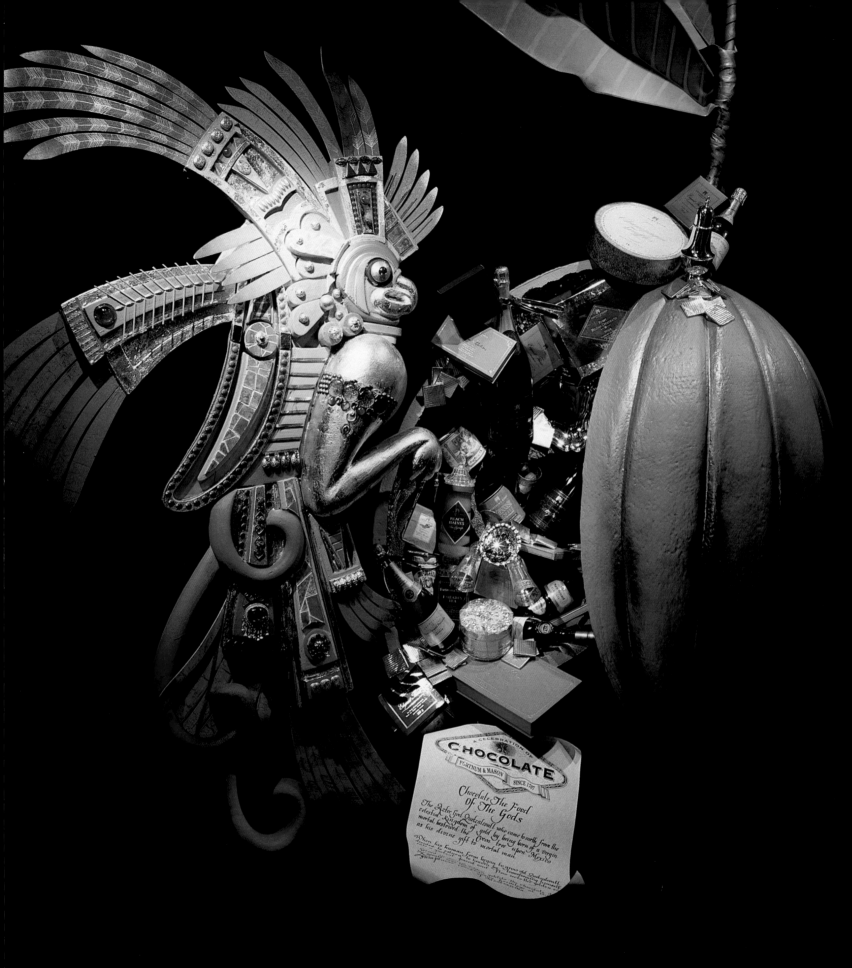

The Aztec God Quetzalcoatl bestowed the cocoa

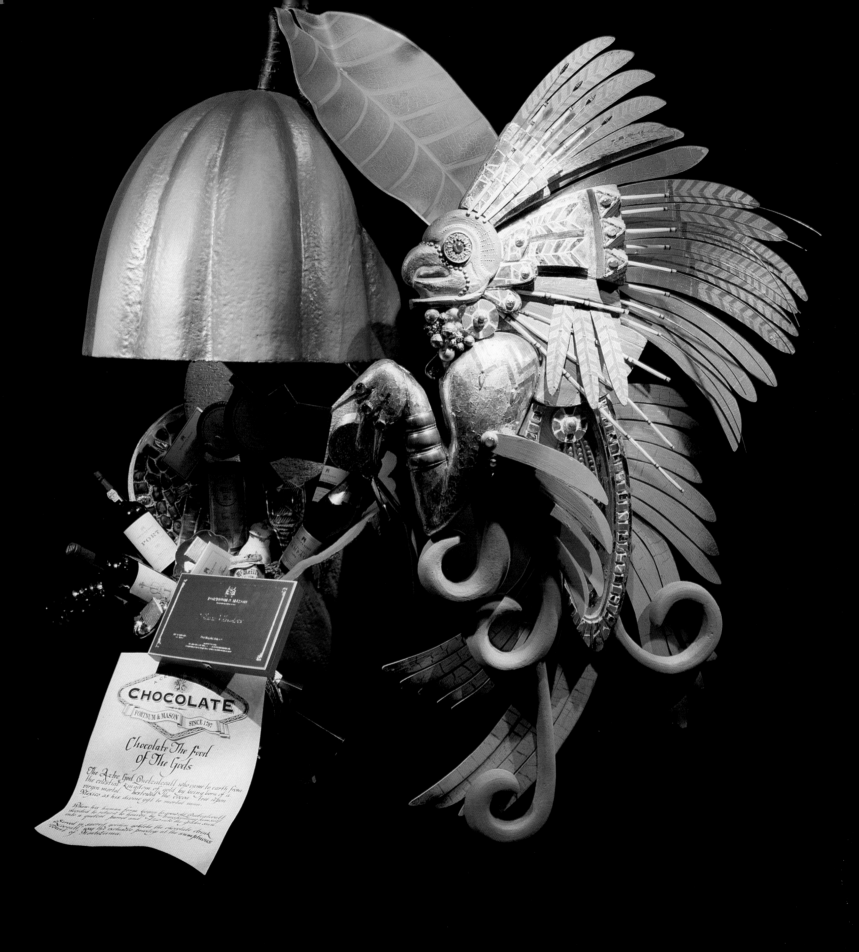

CHOCOLATE
FORTNUM & MASON · SINCE 1707

Chocolate The Food
of The Gods

...tree upon Mexico as his divine gift to mortal man

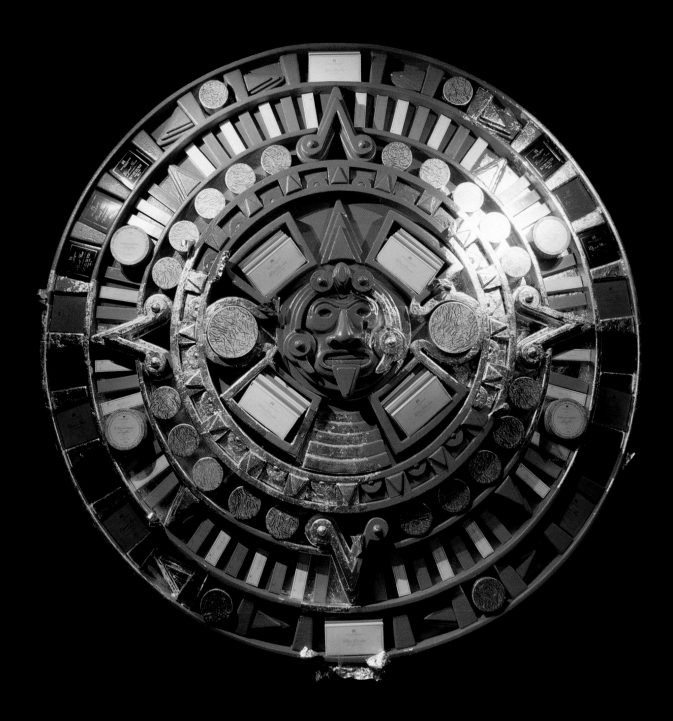

In the world-famous calendar stone of the Aztecs, the central panel depicts the day on which the Aztecs believed the world would be destroyed by earthquake. The inner circle contains the 20 day signs of the Aztec calendar. Here it is moulded in chocolate, its golden wrapper peeled back to reveal the food of the gods beneath. A golden cocoa pod (*opposite*), first brought to Earth by Quetzalcoatl, is slit to reveal a precious bottle of Coco.

Served in sacred golden goblets,
the chocolate drink Xocoatl
was the exclusive privilege of
the sumptuous court
of Montezuma.

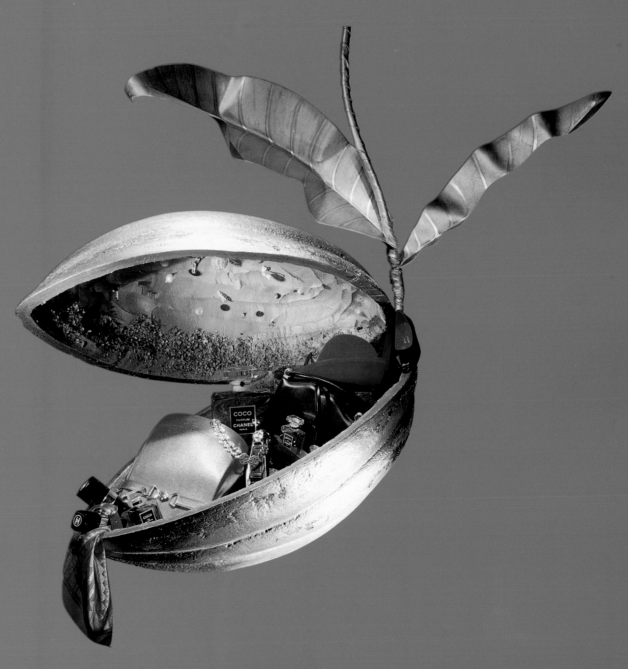

LIP SERVICE

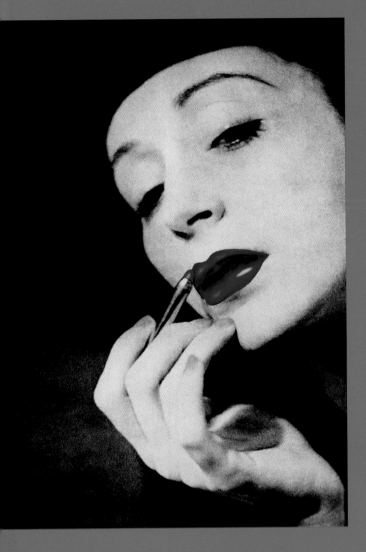

The stunning image of the voluptuous lips floating across a dark space in these windows epitomizes desire. Here, the lips are associated with the desirability of luxurious food and fashion. They are inspired by the surrealist work of the celebrated artist and photographer Man Ray, particularly by his 1932–4 painting *Observatory Time – The Lovers* (see page 102), in which a huge pair of lips floats across a moody sky.

The painting hung in Man Ray's Paris studio where he subsequently took a series of fashion photographs using it as a backdrop in which beautiful women recline beneath the painting wearing gowns by designers such as Jacques Fath. The photographs were taken for fashion journals including, among others, *Harper's Bazaar* (1936). Other surrealists used the potent image of lips too. In 1934–5, Salvador Dalí made a painting of the film star Mae West called *Mae West's Face which may be used as a surrealist apartment.* In it, West's features are transformed into the semblance of a room setting in which a sofa appears as her lips – Dalí later made an actual sofa based on the painting, which was bought by the fashion designer Elsa Schaparelli for her Paris boutique. The design for the window on pages 100–101 combines these surreal images. In the background is a replica of the Man Ray painting, but where the lips should be there is a black void, creating the illusion that the lips have somehow escaped the confines of the painting. They can be seen floating towards the foreground having transmuted into a red leather psychoanalyst's couch on which a reclining figure indolently dreams of desire.

The November 1937 issue of *Harper's Bazaar* carried an article about 'The Red Badge of Courage' (*above*). The editorial feature discussed the application of lipstick as a 'woman's gesture of courage in moments of stress'. In the Fortnum's window (*opposite*), a mannequin by Adele Rootstein chosen from a collection entitled 'Lipstick', paints her lips beneath the brim of a lip-shaped hat that was designed especially for this scheme by Philip Treacey.

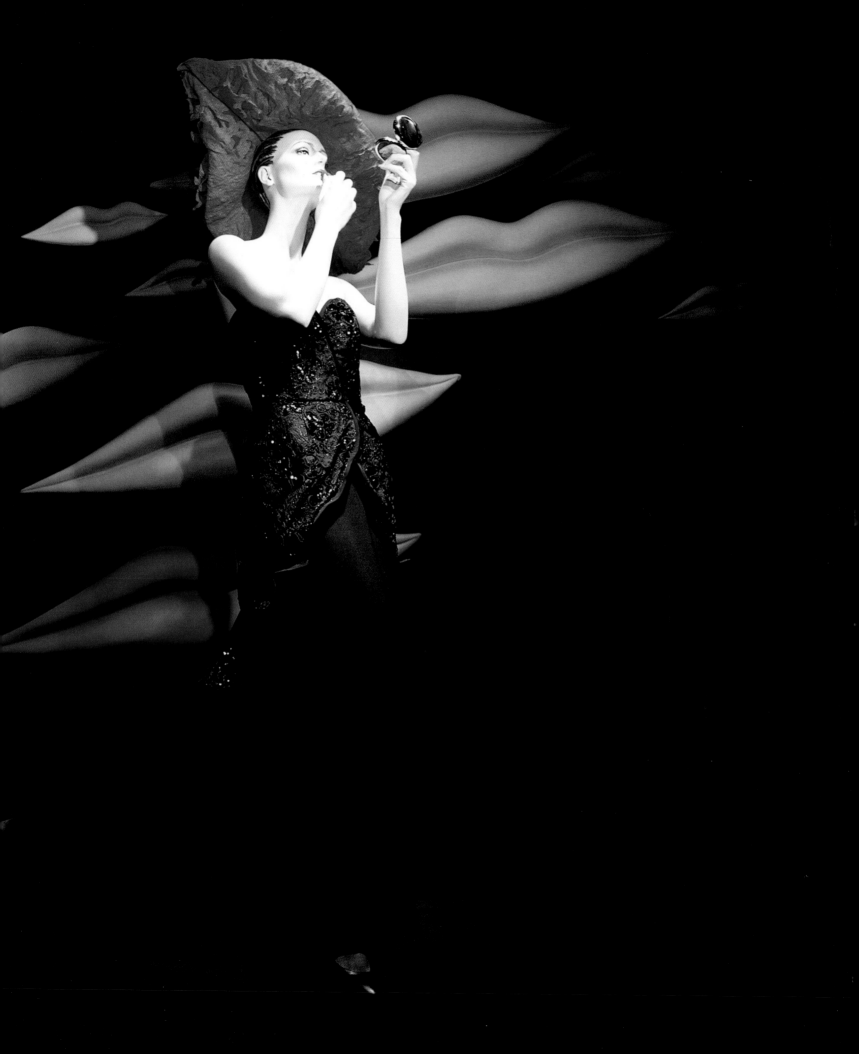

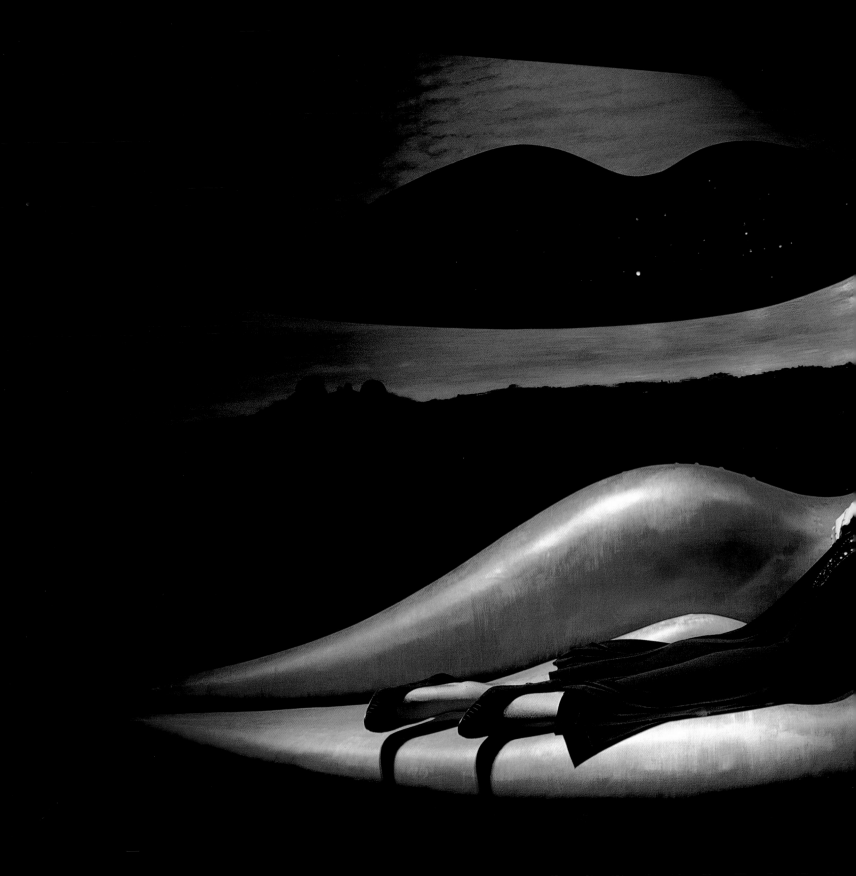

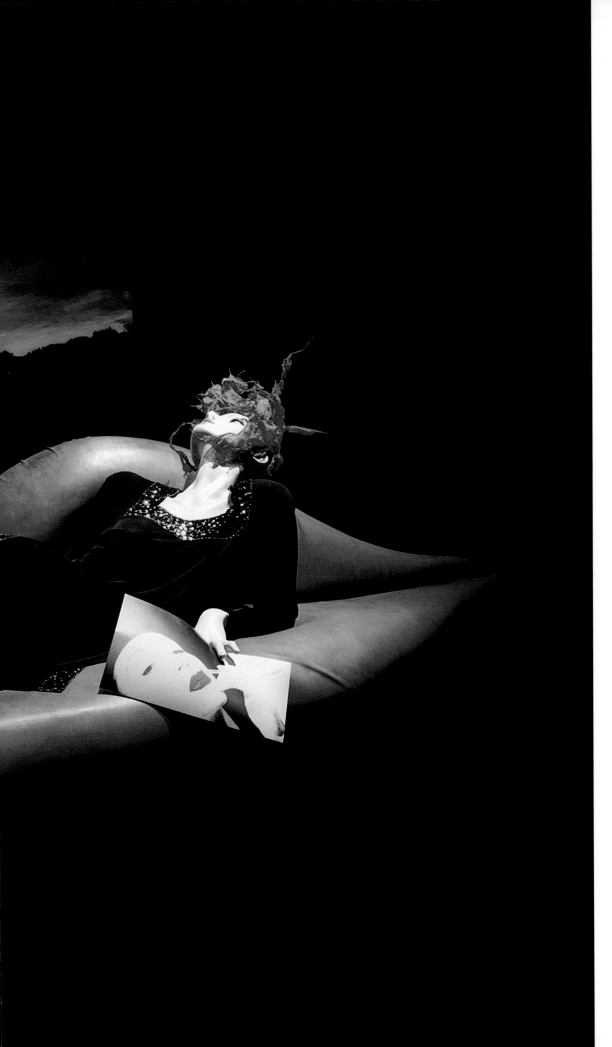

In this window, the lips have liberated themselves from Man Ray's painting (*Observatory Time – The Lovers*, see page 102) and metamorphosed into a Freudian couch of dreams.

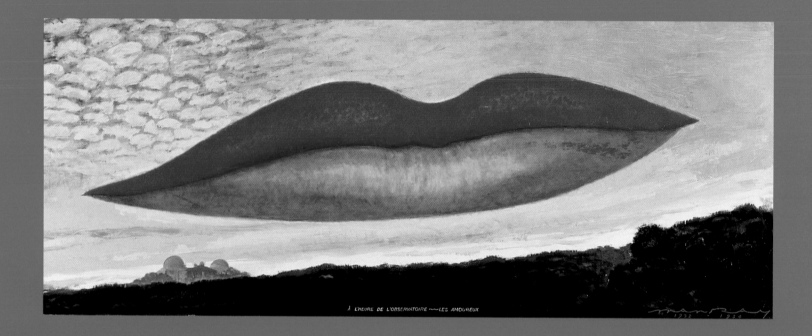

À L'HEURE DE L'OBSERVATOIRE ~~ LES AMOUREUX

Man Ray's surrealist painting *Observatory Time – The Lovers* (*above*) was the inspiration behind these designs. In the three-dimensional realization opposite, a huge pair of lips has floated out of the window into the real world, while its captive compatriots, labelled with words evocative of desire, display a selection of delectable speciality teas.

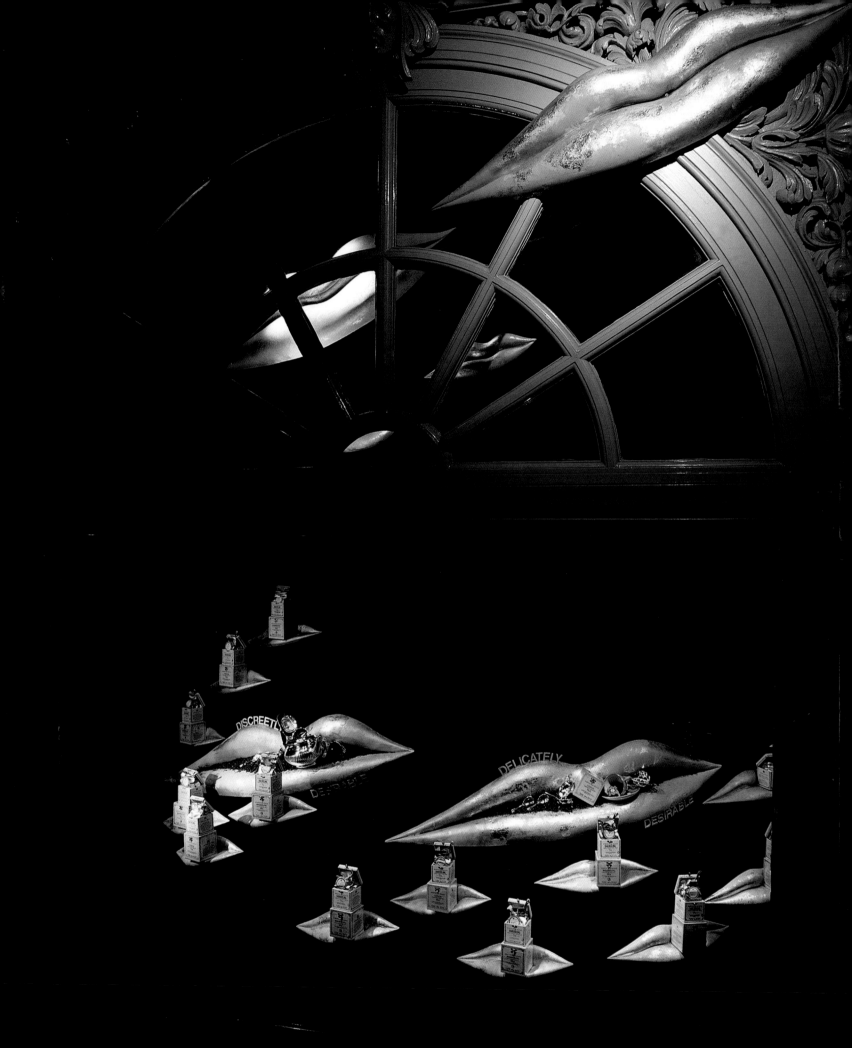

A FEAST FOR THE EYE

The Belgian surrealist painter René Magritte, who became associated with the Paris surrealists in the late 1920s, created a strange world of enigmatic logic. It is his intriguing and powerful image of a huge eye that is the inspiration for this sequence of windows entitled 'A Feast for the Eye'. When the viewer looks into the colossal eye in Magritte's painting *The False Mirror* (1928), an incongruous image is reflected at the spectator who does not see what he expects; instead the iris and white of the eye is formed of a cloudy skyscape with the pupil as a floating black sphere, creating a haunting and arresting image.

In the concept, the magic realism of Magritte's displaced and inverted everyday images is used to project Fortnum &

Honey is the theme for this massive fantasy eye (*opposite*). The pupil is a huge honeycomb surrounded by moulded petals with heather and other flowers forming the shape of the eye. Jars of honey adorn the lower lid and the lashes are huge, stylized petals backed by a dusting of delicate pollen-laden flower sprays.

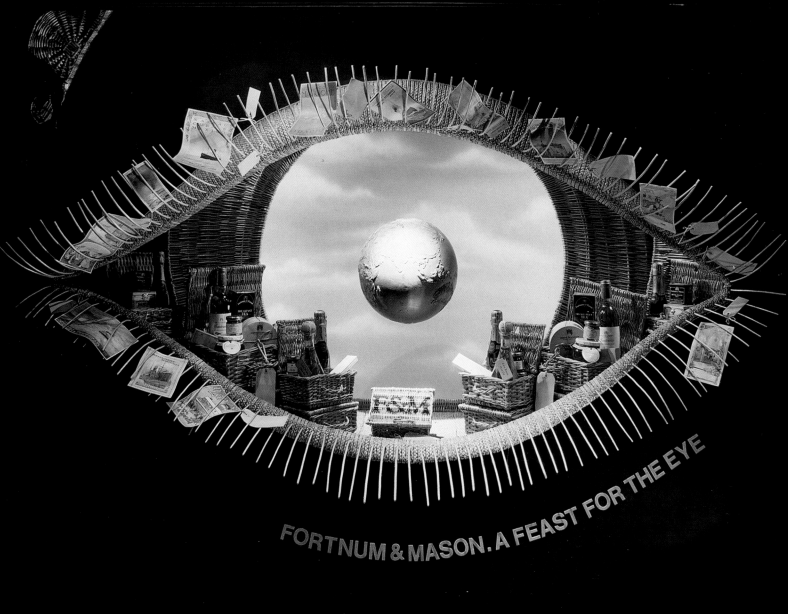

FORTNUM & MASON. A FEAST FOR THE EYE

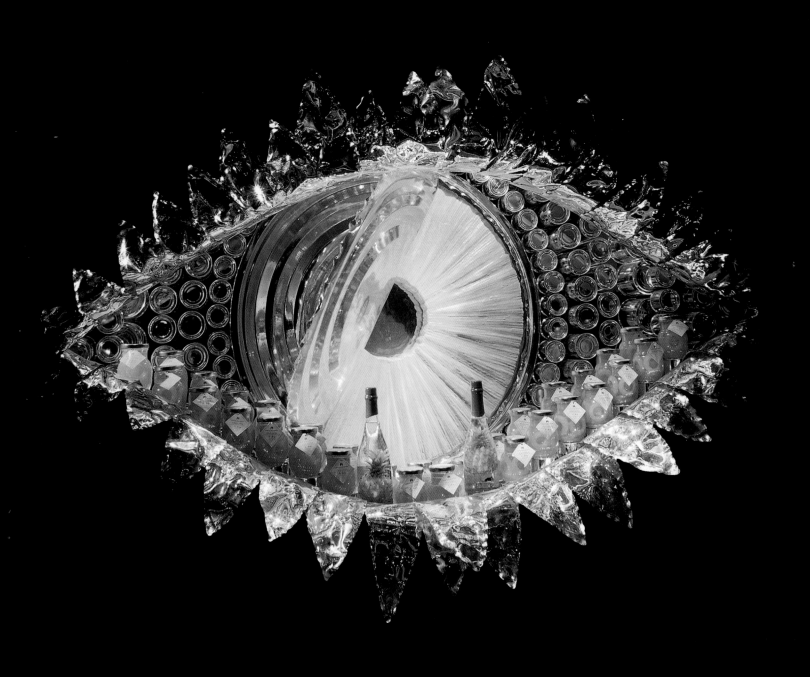

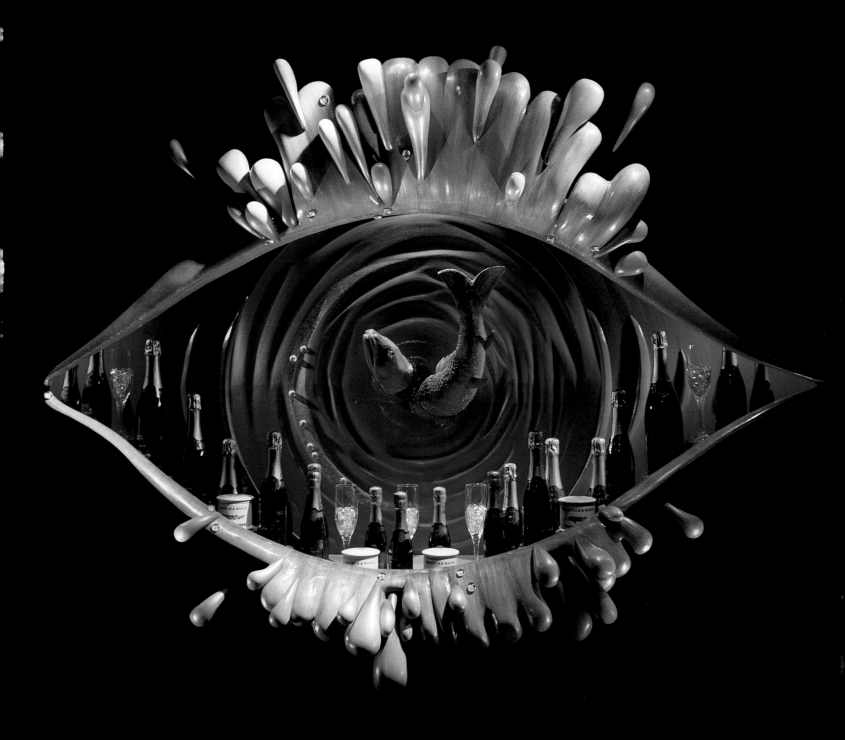

A sturgeon (*above*), representing that most luxurious of epicurean indulgences, caviar, leaps in the pool of an eye and lands with a splash that forms the eyelashes. Vintage champagne, crystal flutes and caviar are displayed in the rim of the eye while a shoal of fish swim sinuously to form the eyebrow. On the left, the iris is the lid of a huge can opened to reveal a giant-sized pineapple ring. Surrounding it, actual cans of pineapple form the white of the eye. The eyelashes are of serrated metal to represent opened cans. The lower lid is composed of jars of preserved pineapple – a veritable feast for the eye.

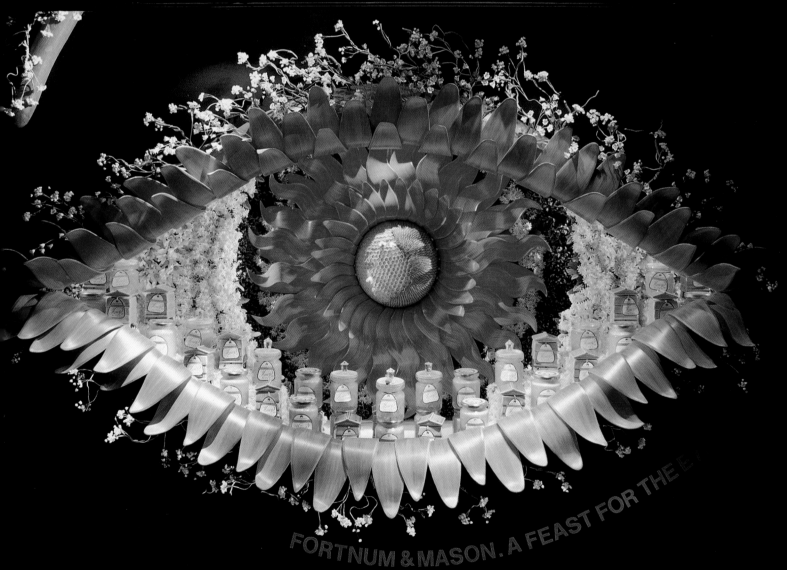
FORTNUM & MASON . A FEAST FOR THE E

MUSHROOM MYSTIQUE

These astonishingly life-like representations capture the quintessential spirit of natural mushrooms (*opposite*). Gills, stalks and caps appear from the rich leaf litter of the forest floor. The mushrooms' characteristic tilt is deployed to display Fortnum's merchandise, while little piglets root at the base of gigantic mushrooms, adding an air of mystery and magic to the scene.

Deep in the dark, smouldering atmosphere of a misty autumn forest, gilded piglets root among the amazing colours of the leaf-strewn forest floor in search of their treasured quarry. Autumn mushrooms have a mystical appeal and an element of surprise as the fungi appear overnight without warning. Their alluring mystique inspires this fairy-tale display that represents one of the most luxurious delicacies for the connoisseur.

Although various cultures have attempted to cultivate mushrooms, they still remain a phenomenon of nature, as the zealous truffle hunt in quest of the 'Black Diamond' testifies. Shrouded in the mystery of their seemingly miraculous growth from inert matter, mushrooms have acquired through history a symbolic association with longevity and regeneration. In mythology, they are a source of youth, and especially in oriental philosophy where the cap of the mushroom is seen as the dome of heaven, they are seen as an astral entity in supernatural beings.

These mushroom myths are accentuated by their gigantic size. The fact that the piglets are seen as life-sized makes the mushrooms seem even more improbable and amazing, emphasizing their illusory characteristics. There is a strong sense that the mushrooms have just thrust their way up through the forest earth as dawn breaks before our eyes. It is almost possible to smell the loamy earth and scent the truffles underground, while food and wine sprout from the tops of the mushrooms, adding to the sense of incredulity. In the fashion windows, luscious velvets, brocades, velours and silks in gloriously rich autumn colours cap the mushrooms luxuriously and are the perfect foil for designer knitwear, jewellery, shoes and handbags.

Fortnum & Mason's merchandise
is a feast, not only for the palate,
but also for the eye.

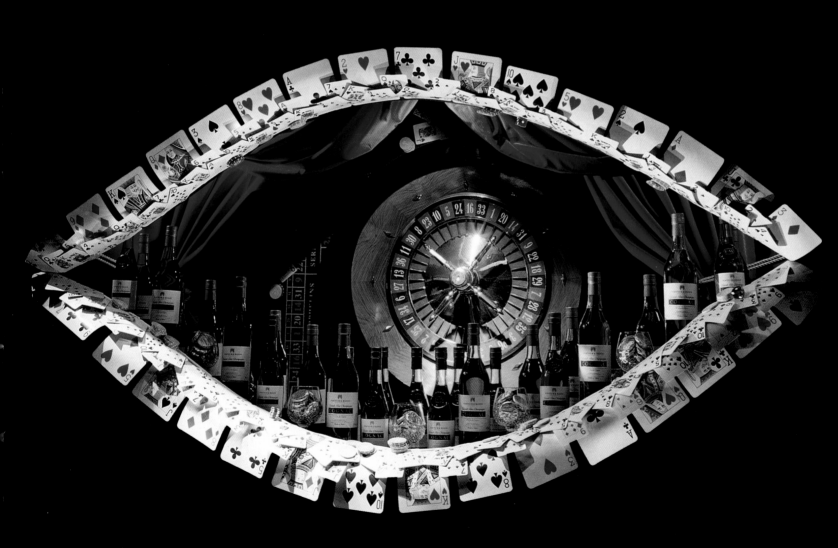

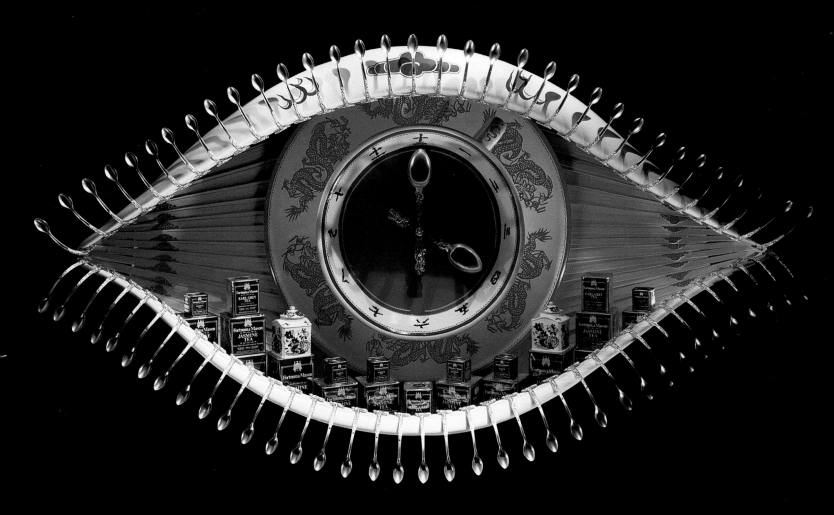

An oriental china cup filled with refreshing tea forms the iris for this eye (*above*). Two silver teaspoons float ingeniously on the surface, forming clock hands and, assisted by the rim of the cup, tells us it is teatime. Chinese fans fill the remaining shape, while more teaspoons bend themselves gracefully into sparkling lashes to complete an eyeful of tea. A revolving roulette wheel on a gambling table forms the iris and pupil of this casino eye (*left*). Fringed with fluttering playing-card lashes, the eye displays a selection of the finest cognac and chocolate chips backed by opulent drapes.

Mason's gastronomic wonders. In each of the displays, the eye is made up of actual and over-sized objects and this mixture of contradictory scales adds to the impact of a compelling world of very strange images. Contradictory

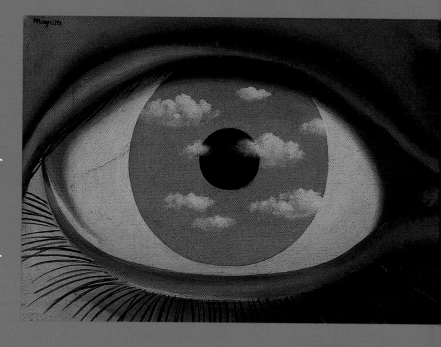

objects form huge eyes; a roulette wheel becomes the iris and pupil of an eye thickly fringed with playing-card lashes; a sturgeon leaps in a pool and the rippling water forms the pupil, while splashes form lashes; the lid of a giant tin is rolled back to reveal a pupil and iris of colossal rings of pineapple, surrounded by actual cans of fruit. The eye is used as a decorative symbol and treated in the manner of the marvellous paintings of Giuseppe Archimboldo (see page 6), which are portraits made up of miscellaneous objects that give a dual impression. However, the message that Fortnum & Mason's merchandise is a feast, not only for the palate, but also for the eye, is made beautifully clear.

A wicker theme (*opposite*) celebrates the Fortnum & Mason hamper. A globe pupil represents the journey that the hampers make across the world, and caught in the curling wicker lashes, antique travel labels spell out Fortnum's service around the world. Magritte's painting *The False Mirror* (*above*) inspired this installation.

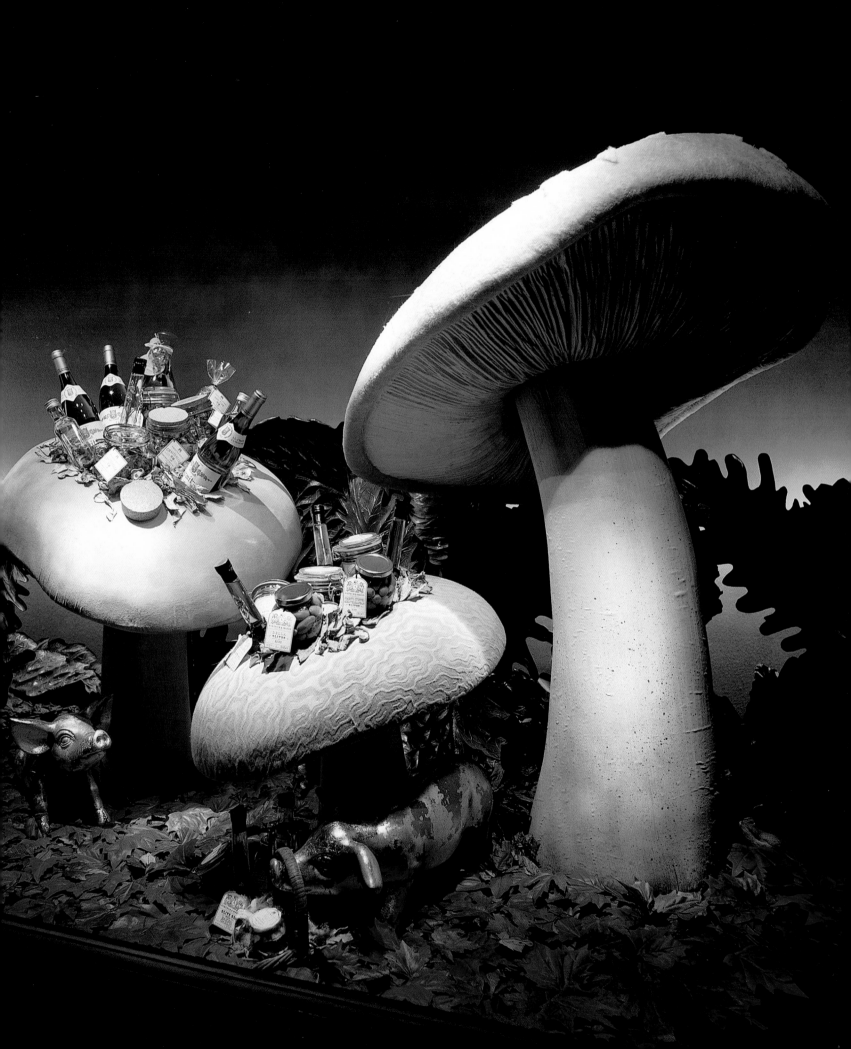

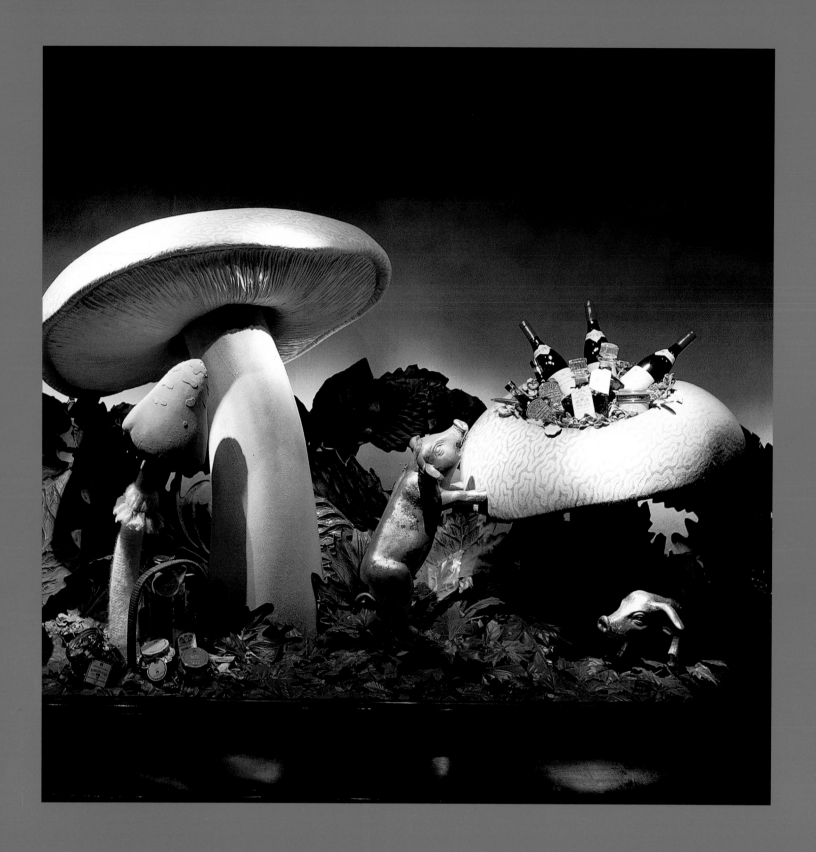

Merchandise sprouts and bristles on the mushroom caps in the morning sunlight, tantalizing the tastebuds and awakening the appetite (*above*). The giant mushrooms tower above the forest floor as piglets forage for treasure – in this case, the elusive truffle (*opposite*).

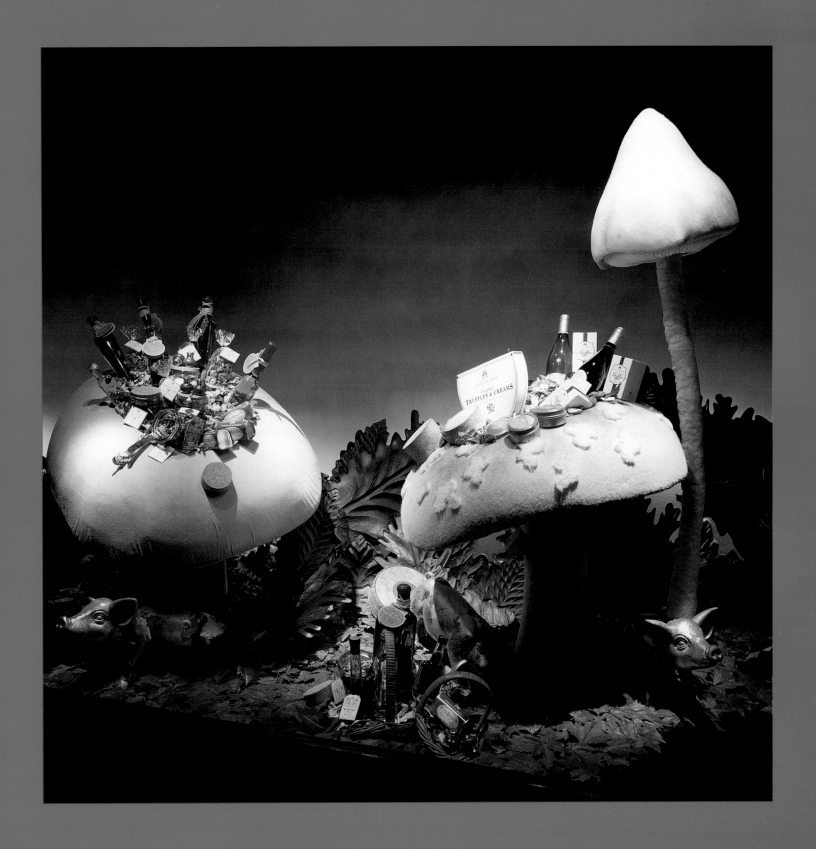

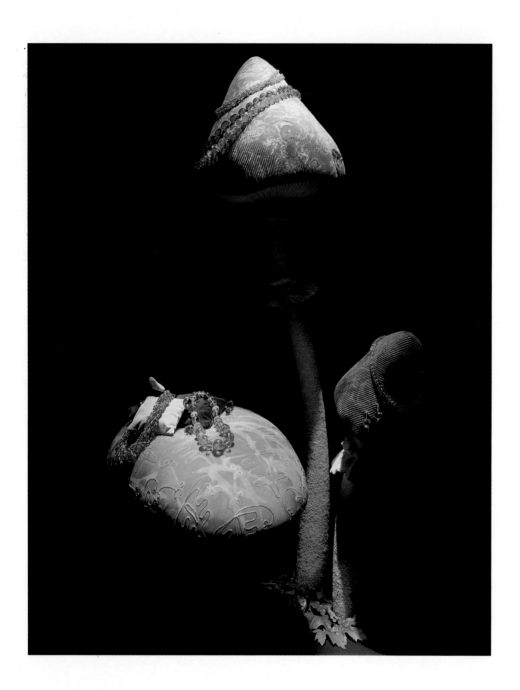

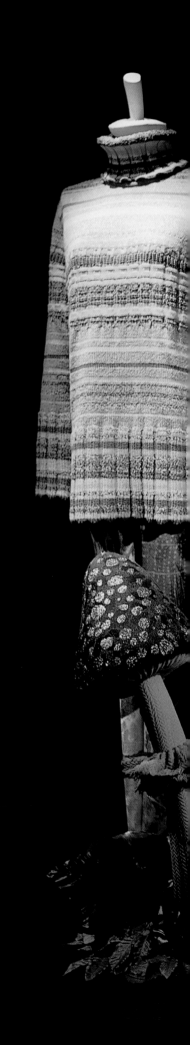

Elegant mushrooms rise sinuously on their long stalks (*above*). Each is capped
with sumptuous fabric in glowing autumn colours, made luminescent by the dark
background. Fabulous jewellery is looped around the cones, adding to the exotic
and mystical quality of the display. Against a dark ground (*opposite*), each mushroom's
opulently textured cap gleams in rich light. The subtle and intricate colours and pattern
of the designer knitwear in this fashion window are set off to perfection by the
surrounding mushrooms and fallen autumn leaves.

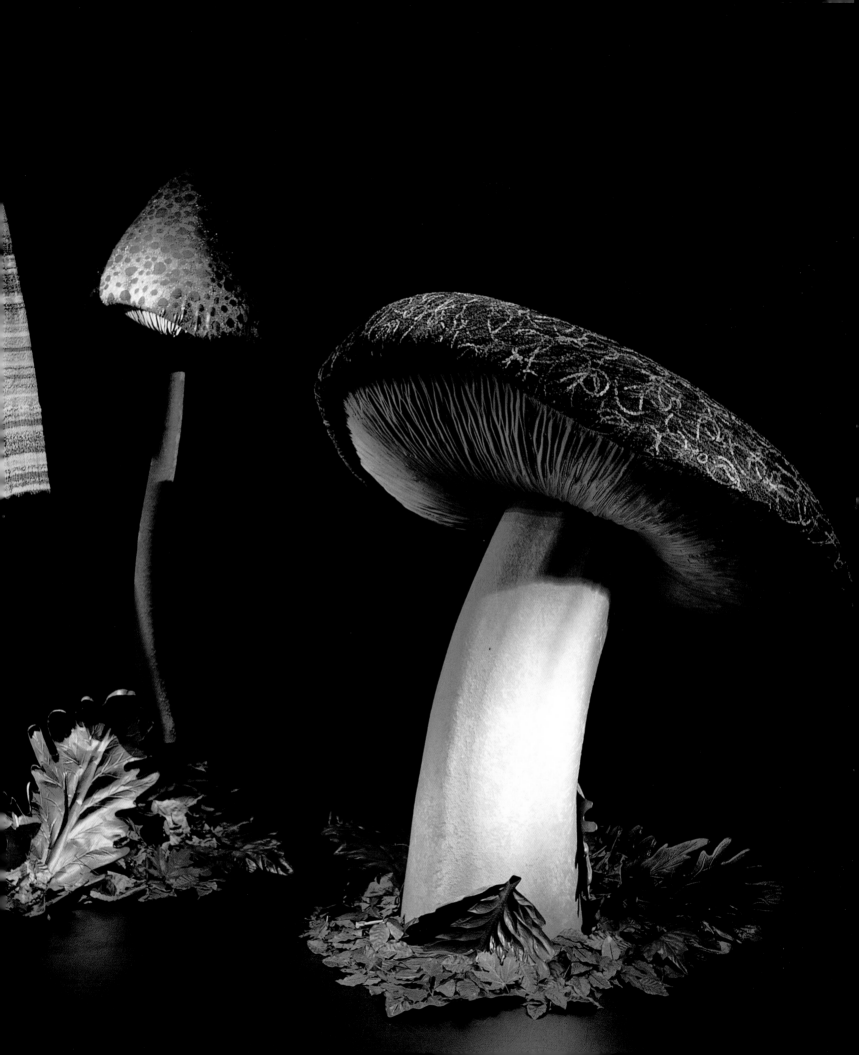

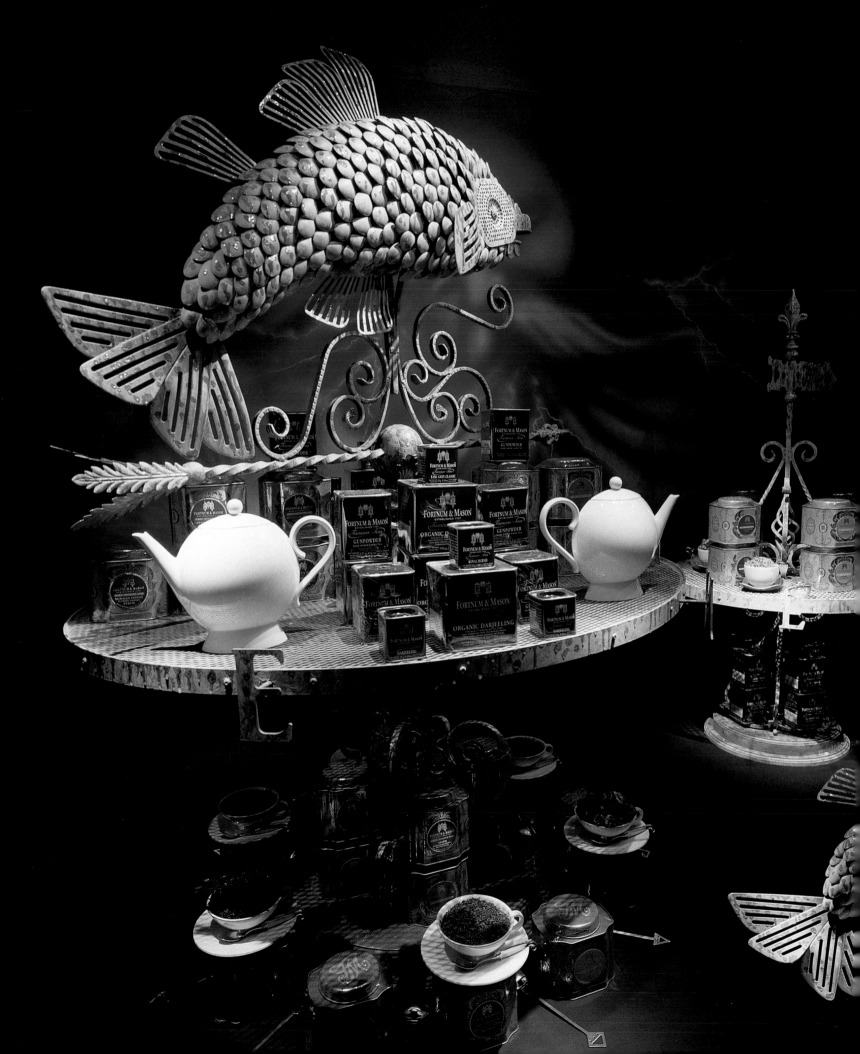

WHATEVER THE WEATHER

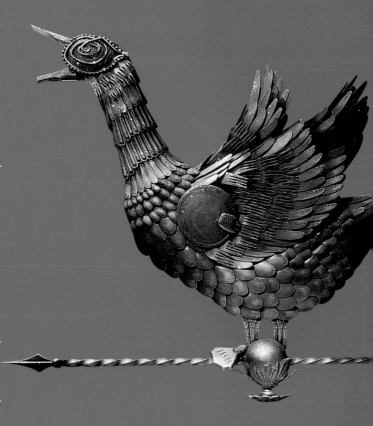

All retailers, but especially food merchants, are dependent upon the weather and the elements. The seasons can influence the flow of merchandise, depending upon availability and demand. These factors give weather a great significance and weathervanes are both a practical and a decorative attempt to forecast the vagaries of the elements. They are a particularly fitting theme for the changeable days of autumn when we start to think of the effects of adverse climatic conditions that lie ahead.

Traditionally, weathervanes reflect the use of the building that they crown, so that, for example, it is quite common to see representational horses above a stable. Each of the animals in this scheme is metal, but with a twist. Their bodies are made up of utensils: forks, spoons, knives, whisks, fish slices and other kitchenware — a subtle and mischievous reminder of their culinary associations. Perched on their roofs, metal weathervanes are subject to corrosion and these models also have their appropriate patina of verdigris and rust, so that they appear truly seasoned by the elements.

The weather's different moods and aspects — harsh or clement; frosty, windy, sunny or wet — are represented. An icicle hangs like a frosty pendant from the beak of a shivering duck; a goose gaggles into the warm wind that ruffles its feathers, and a wild boar looks as if it has just stepped out of the forest to savour a patch of autumn sunlight.

Resplendent on weathervanes are the four points of the compass — north, south, east and west — that symbolically represent the formation of order out of chaos. Many myths about the cycle of the seasons are formed around the intersection of these cardinal points.

A golden goose flaps its knife-feathered wings (*above*). The feathers on its plump body are formed of overlapping spoons. A whimsical weathervane fish (*opposite*) is composed of metal kitchen utensils. Its scales are made of spoons and its fins of fish slices. The fishy eye is a disk from a grating machine. On its traditional wrought-iron stand, the rain-splattered fish leaps convincingly over a display of Fortnum & Mason tea.

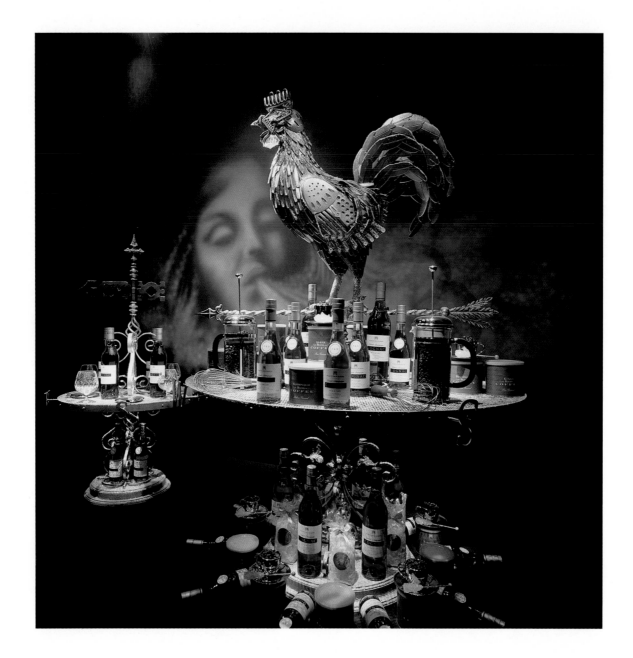

A cockerel stands proudly on his weathervane perch (*above*), dusted with the first flurries
of snow. His lordly spirit is captured to perfection, made all the more extraordinary by the
graters, cutlery and other metal kitchen objects of which he is composed. In the background,
shadowy faces like swirling clouds blow icy winds over each display. A duck (*opposite*) sits
shivering in silvery ice, plumping up its slotted-spoon feathers. Icicles hang from its wings
and from the display of Fortnum & Mason Icy Mints that surrounds it.

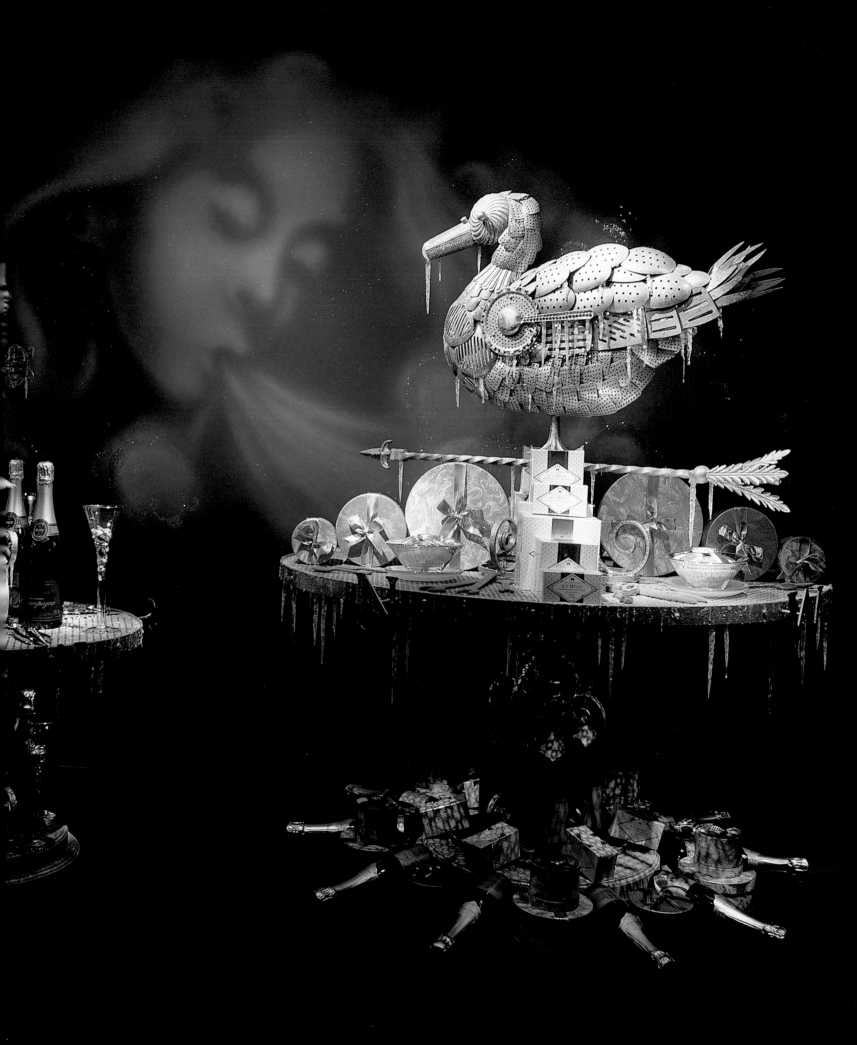

CARNAVAL PERPÉTUEL

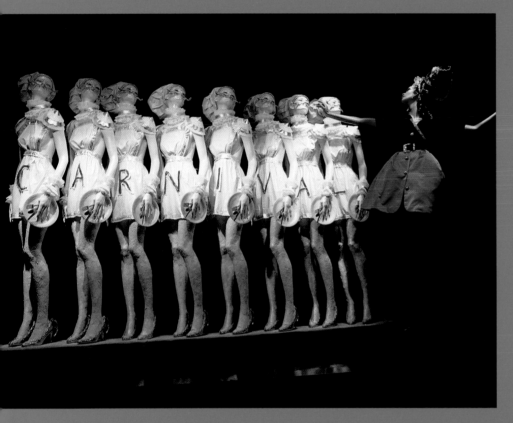

The universally recognized carnival was originally a pagan Druid festival in France known as the Fête du Soleil. It was adapted and assimilated into the early Christian church as Carnelevamen or 'consolation of the flesh', as a commemoration of Christ's resurrection, eventually becoming known as 'carnival' and widely celebrated by many different cultures across the globe. In New Orleans it became the internationally renowned Mardi Gras and in Europe it is still celebrated as a period of indulgence before the privations of Lent. Indeed, in eighteenth-century Venice, this festival reached much celebrated heights of artistry and extravagance in an exuberant carnival that lasted an incredible six months of the year.

A *maître d'* is preparing her chefs to serve a Carnaval Perpétuel (*above*). They capture the decadent spirit of the nineteenth-century Parisian variety theatre Folies-Bergère and link Fortnum & Mason's gourmet delights to the spirit of the carnival. The giant carnival head of the roué Monsieur le Comte de Montesquieu (*opposite*) continues the theme of *la vie Parisien*. A champagne bottle in the shape of the Eiffel Tower sports a garter, symbolizing the Naughty Nineties. Beside it, a saucer forms a working fountain of champagne that sparkles over a beguiling nymph – the focus of le Comte de Montesquieu's monocle. Champagne bubbles escaping from the glass fill the air, and the whole installation is made in the style of the crystal specialists, Lalique.

One of the most striking features of carnival revels is the giant papier mâché heads worn, carried on poles, or represented on elaborately decorated processional floats. Another is the great banquets that took place throughout the carnival. Invitations to these themed banquets were as precious as gold. These two features stimulated the theme for these installations: an invitation to dine with some of the fantastic characters that could have been the theme of one of these bizarre suppers.

In this concept, Germany, Holland, France, Spain, Italy and Britain are represented by characters from history and the arts, together with food appropriate to the country. In light-hearted and witty mood we are invited to dine with fantastical characters from history. The theme blends food and celebration into a joyful Carnaval Perpétuel.

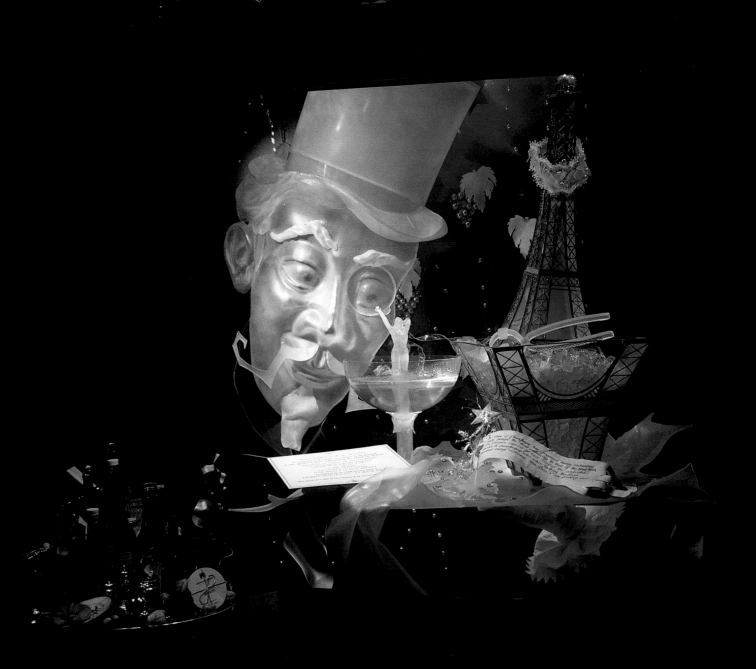

Monsieur le Comte de Montesquieu
Opera glasses are a must for the enjoyment
of the Can-Can cabaret that is to follow

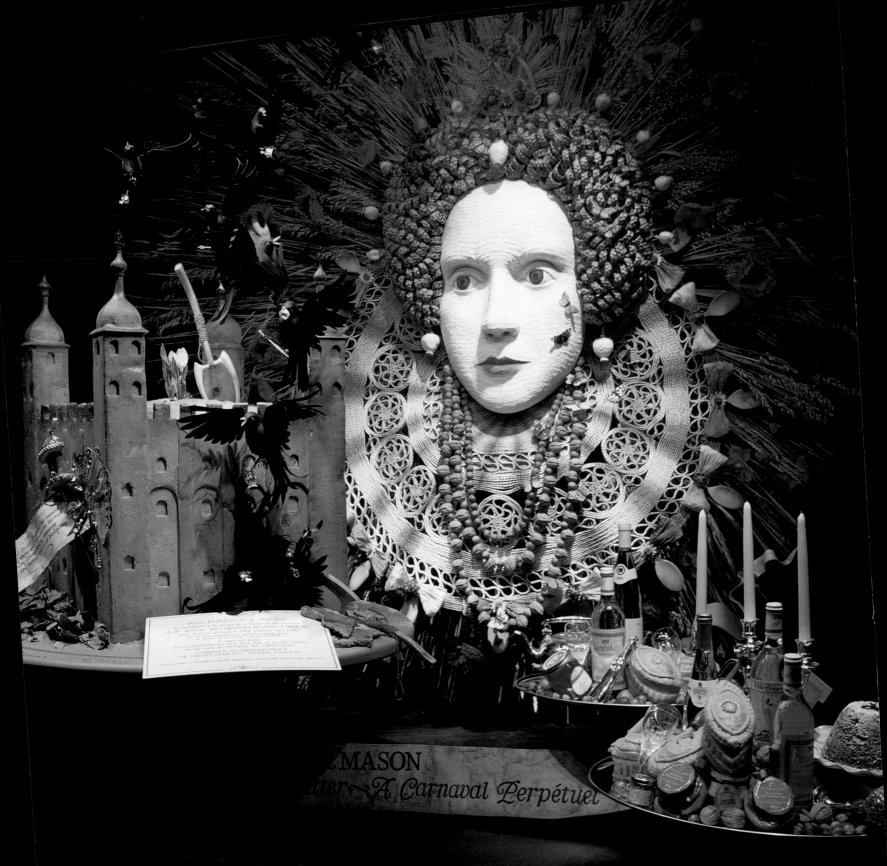

MASON
... *A Carnaval Perpétuel*

From Fortnum & Mason
An invitation to be served on a platter in the presence
of our glorious guest representing the nation
of Britain

Her regal majesty the faerie queene
To be acknowledged by a specially created menu
(in honour of our chosen city of London)

in which will feature
Executioner's bye bye pie & game chips
served with an extremely rare tomato sauce

Accompanied by the complementary music
of Sir Edward German's 'Merrie England'

Discrete conduct is advisable during this banquet
lest you lose more than just your reputation

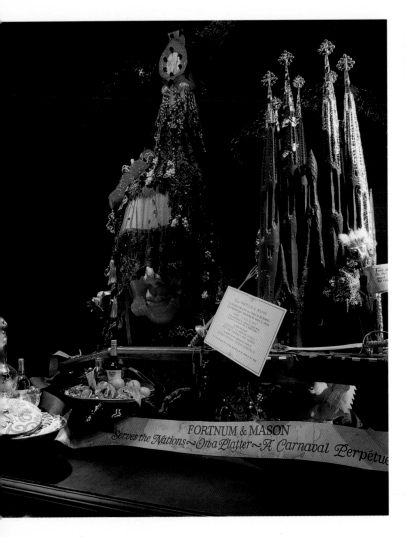

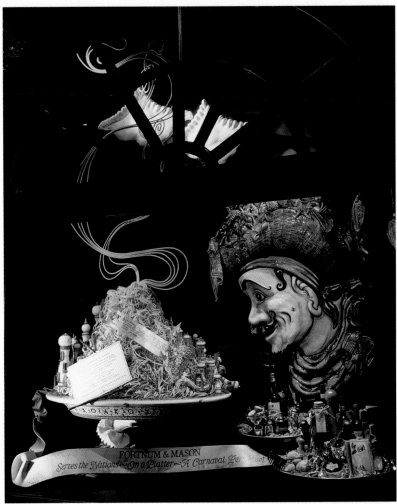

England is represented by Good Queen Bess (*previous pages*) and the rustic atmosphere of
Merrie England is implied by the straw from which her hair and face are made. Her national
platter is a raised game pie in the shape of the Tower of London. Blackbirds escaping from
the pie carry off the crown jewels in their beaks. Spain is represented by Goya's mantilla-
swathed Maja and Gaudí's Barcelona cathedral, reproduced here in chocolate (*above left*).
A Mount Vesuvius of spaghetti represents the food of Italy (*above right*) as a plume of
spaghetti smoke rises into the air, watched by an exuberant Neopolitan fisherman. Van
Gogh's *Sunflowers* are represented in Edam cheese with the rind peeled back to form
petals (*opposite*). Van Gogh's carnival head is based on the artist's own self-portrait.

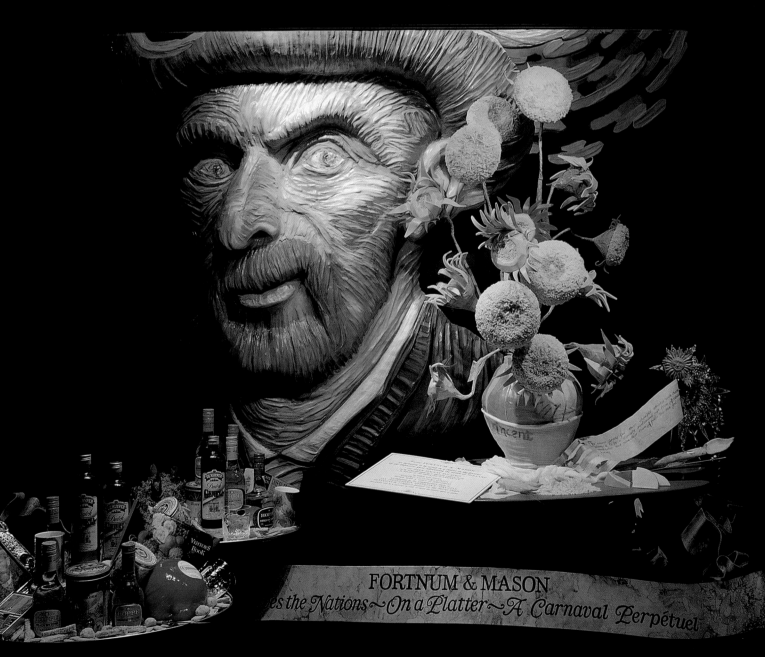

FORTNUM & MASON
...es the Nations ~ On a Platter ~ A Carnaval Perpétuel

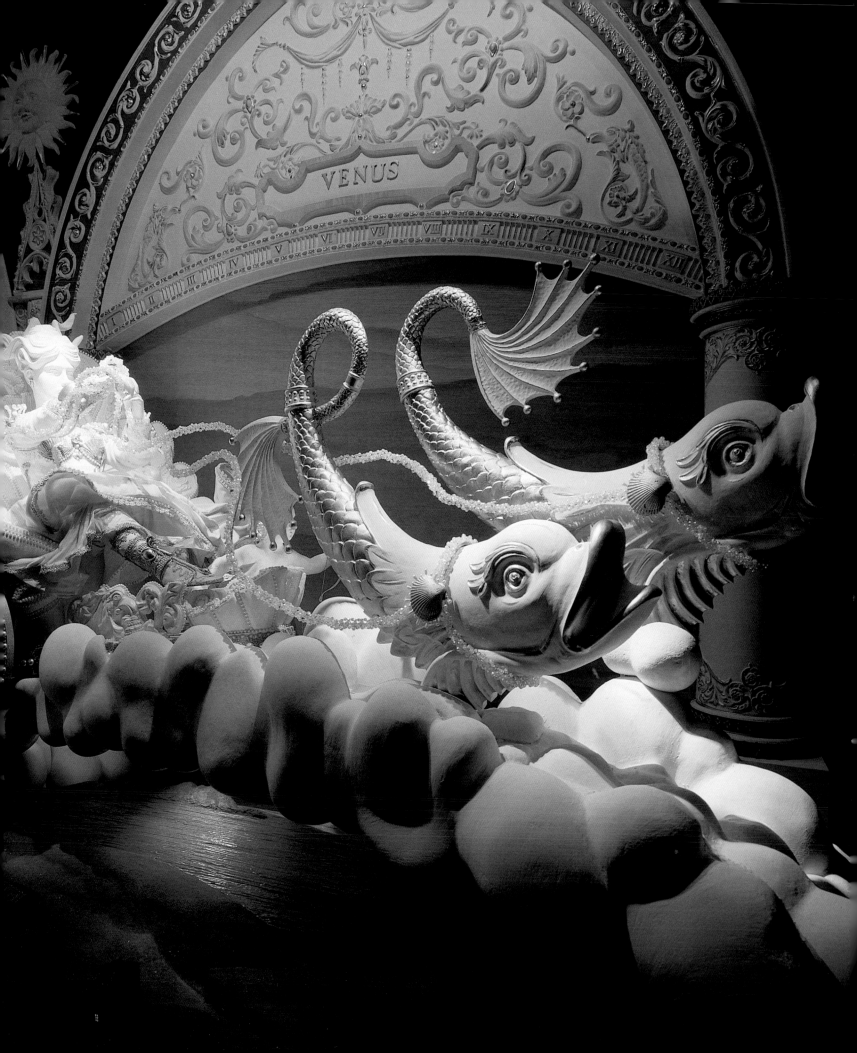

CHARIOTS OF THE GODS

Before the heliocentric theory of the universe devised by the Polish astronomer Copernicus in the sixteenth century, there were believed to be seven planetary heavens and directions of space, which became the origin of the seven days and nights of the weekly cycle and one of the most basic ways of measuring time. The days of the week were named after gods and goddesses of the ancient world.

The passage of time and the associated planets, stars, moons and celestial beings made an eminently suitable theme for the turn of one year into the next, and especially for the dawn of a new millennium. The idea of the gods riding across the sky in chariots comes from classical Greek and Roman mythology. Many of the deities were portrayed in a chariot drawn by symbolical animals or human forms. Indeed, the sun itself was represented by the god Apollo who drove his chariot across the sky each day.

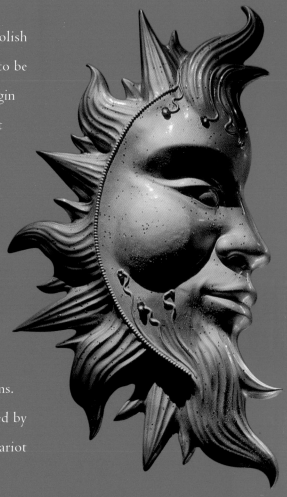

The chariots of the gods were a recurring theme in Renaissance art and they can be seen in both fine and decorative art of the period. The realization of the scheme at Fortnum & Mason was inspired by the grand stucco decoration of European palaces and churches. Here, the chariots of the gods travel majestically across bridges of sculptured clouds, while beneath them a miniature landscape with tiny illuminated buildings gives the spectator a god's eye view of the Earth below.

The iridescent Moon and the burning Sun (*this page*) are essential symbols of the passage of time. Venus, goddess of love and fertility and mother of Cupid, navigates the sea of night in her shell-shaped chariot drawn by dolphins (*opposite*). Representing Friday, she defends the Moon against the monsters of darkness.

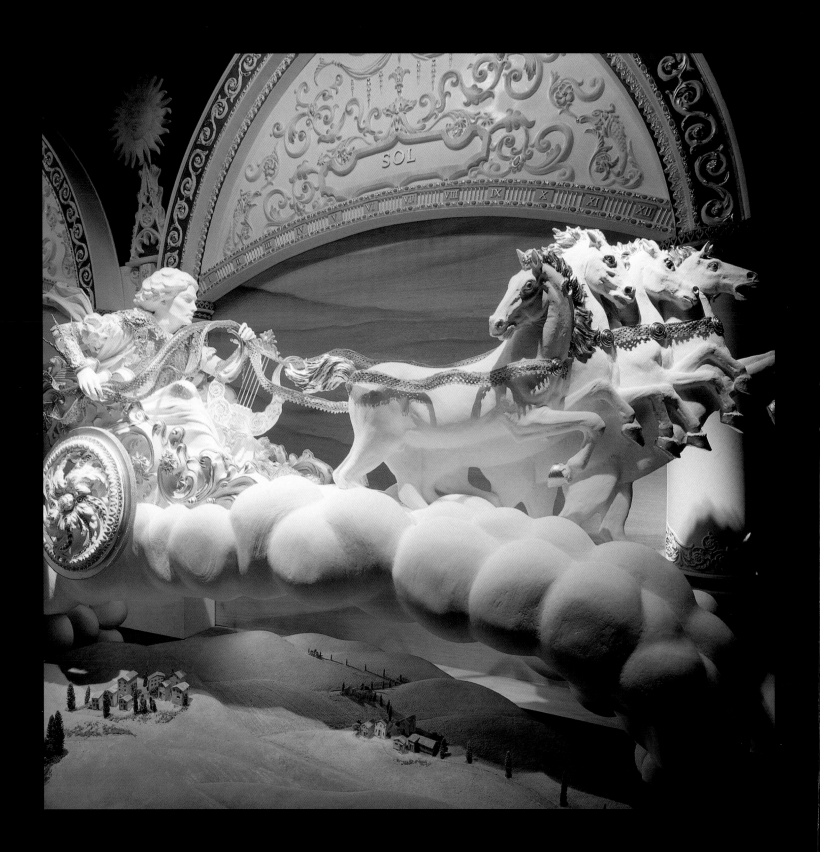

Sunday is represented by Apollo, the sun god. Patron of lyric poetry and the lyre, Apollo was also seen as the male counterpart of Venus and was the embodiment of the powers of intuition and imagination. Four white horses lead his chariot.

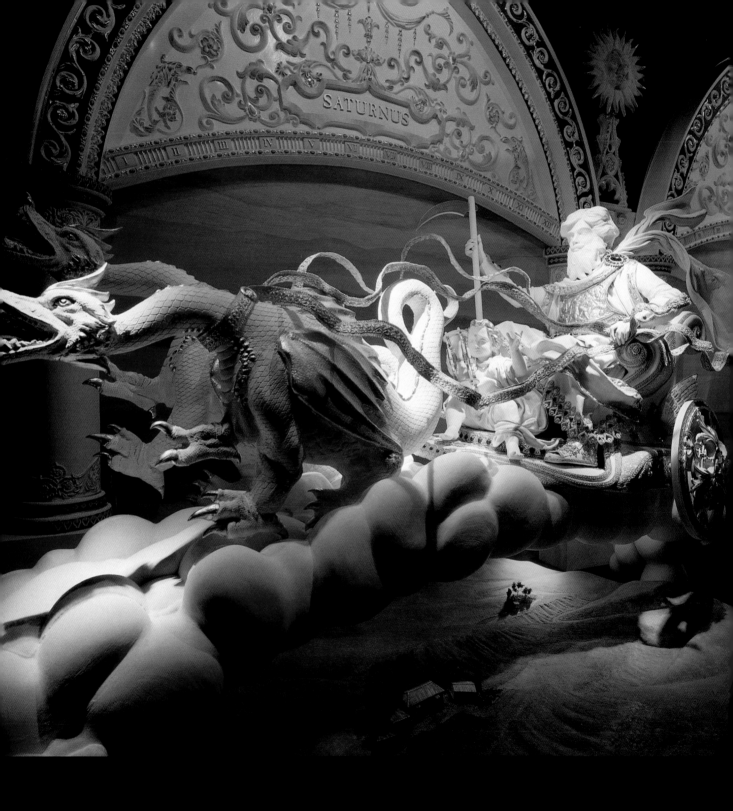

Saturday was named after Saturn, the god of the Golden Age. Saturn represented time and
fate. His attributes were the scythe and the hourglass and he embodied intellectual reason
and contemplation. Saturn's lead and gold chariot was drawn by vigilant dragons.

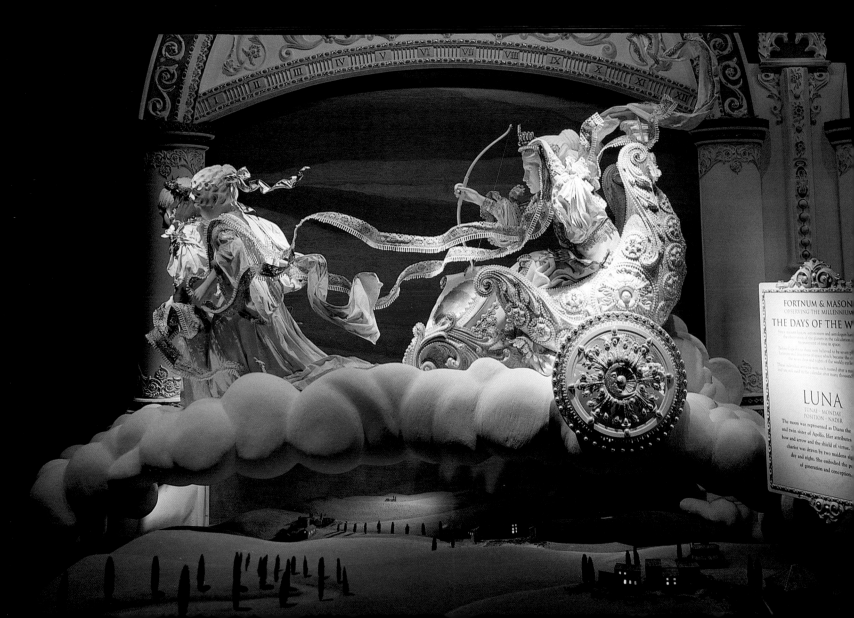

Food and wine are displayed on an imposing Renaissance credenza (*above*). These magnificent displays were used by the royal courts of Europe to affirm their wealth and power ('credenza' means credibility). Diana the huntress, twin sister of Apollo, represents the Moon and Monday (*opposite*). Her attributes are the bow and arrow and the shield of virtue. Her silver chariot is drawn by two maidens signifying day and night and Diana embodies the powers of generation and conception.

A revolving stylized armillary
sphere, mounted on a star-shaped
pedestal (*right*), represents the sun
and acts as a powerful arena for
a scarlet evening gown.

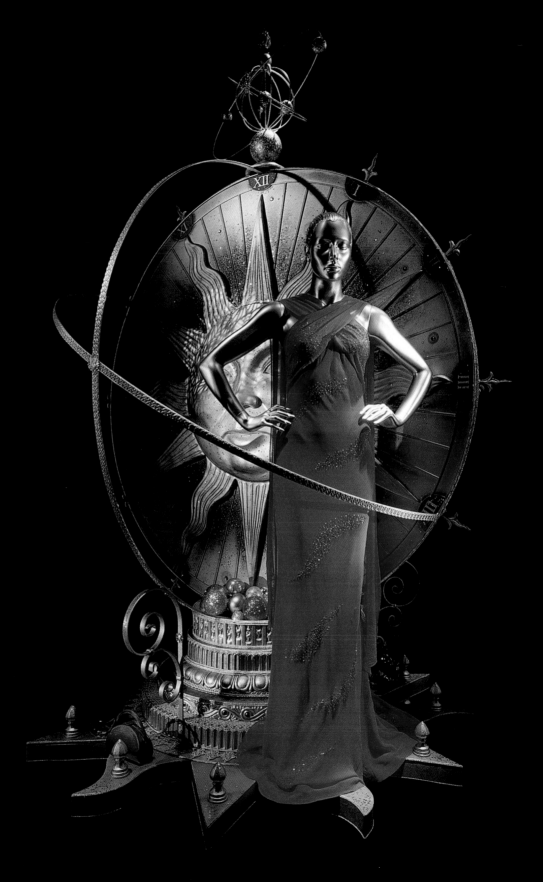

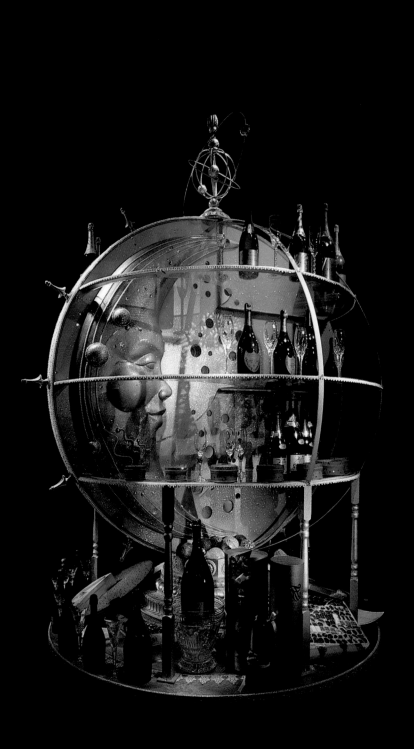

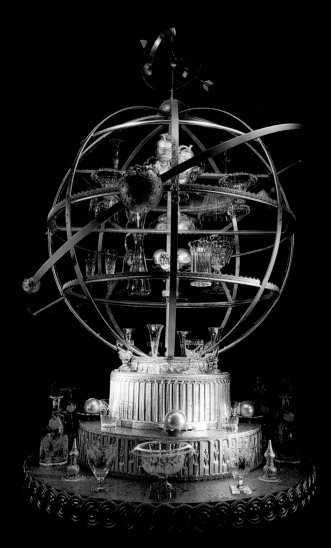

An armillary sphere (*above*) contains beautiful crystal artifacts – mementos of the Millennium to celebrate the future. A second fantasy armillary sphere (*left*) is devoted to champagne to welcome in the Millennium. Within, the Moon's serene face watches as bubbles rise continuously.

HEAVEN ON EARTH

Since the beginning of Man's history there has been a fascination with observing the night sky. All the ancient civilizations had some means of measuring the movements of the planets, sun and moon and their alignment with the seasons. These systems resulted in the symbols now known as the signs of the Zodiac. The twelve symbols are grouped in their respective elements of Earth, Air, Fire and Water and they were associated with a belief that they influence personalities and fortunes, one that is still held today, as shown by the continuing popularity of horoscopes.

In ancient astrology, it was believed that great events could be caused by the juxtaposition of the stars. By studying the heavens, the Three Wise Men predicted the birth of the Messiah and followed a star across many lands to his birthplace. This idea became the inspiration for an evocative winter installation.

The Art Deco style, which was influenced by ancient art and has a strong emphasis on geometric pattern, was chosen as the ideal style to convey the timelessness of this theme. A repetitive scroll motif became the embracing symbol, changing into swirls of stone, clouds, flames or waves to represent each of the elements. For each window, a giant light box was created that filled the entire window space, becoming, in effect, a frame for the central vortex that contained the zodiacs representing each particular element. This was tinted by amethyst-coloured filters to convey a celestial and mystical ambience suitable for this season.

This sculpture represents Aquarius, the water carrier (*above*). His attributes are the double-headed Janus representing January, looking both at the year just past and the year about to begin, and a jar overflowing with water. He is reclining against a backlit roundel displaying the twelve signs of the Zodiac together with shimmering stars. Opposite, the combined Air signs of Gemini, Libra and Aquarius represent the intellect.

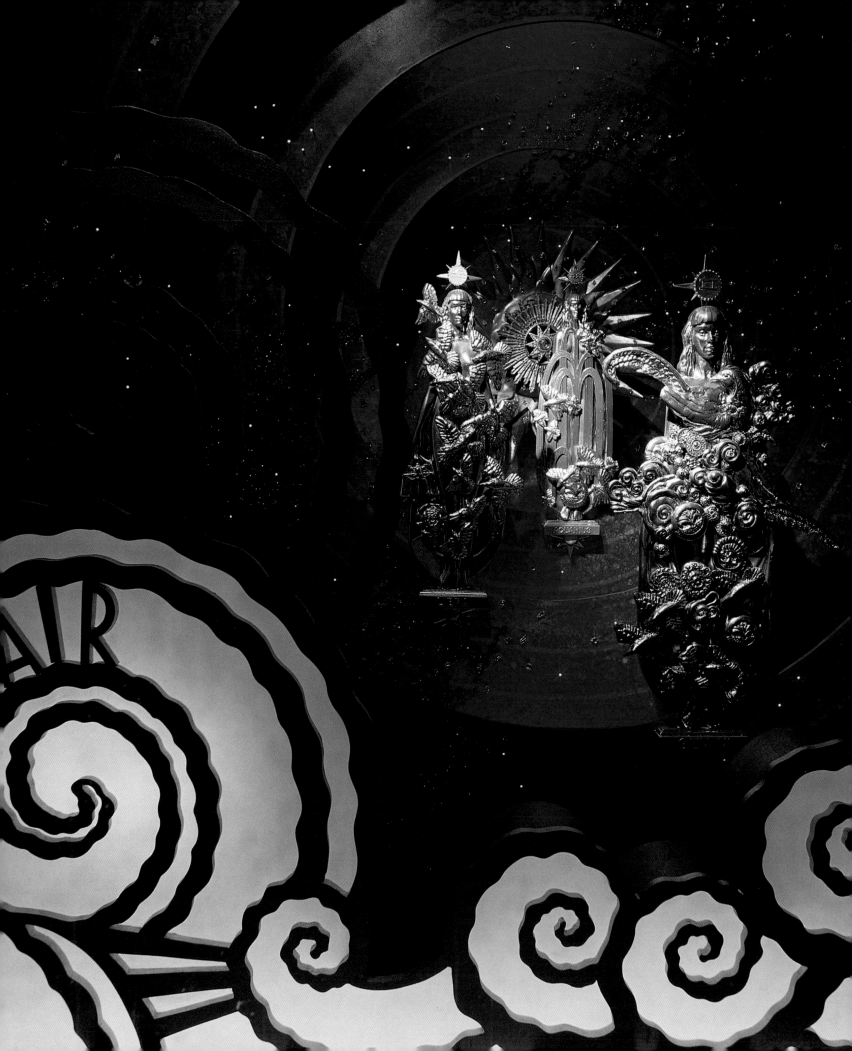

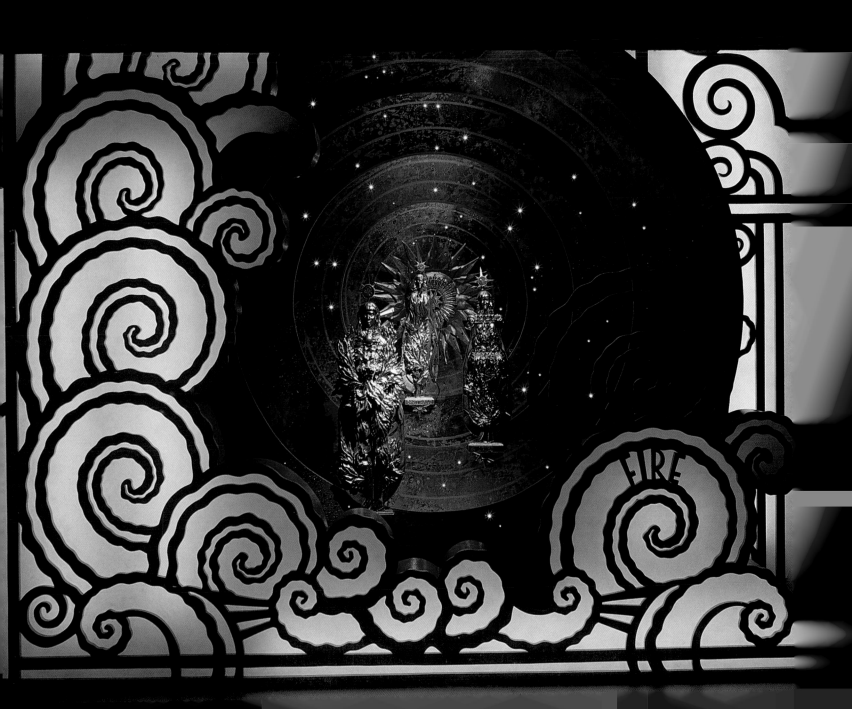

FIRE

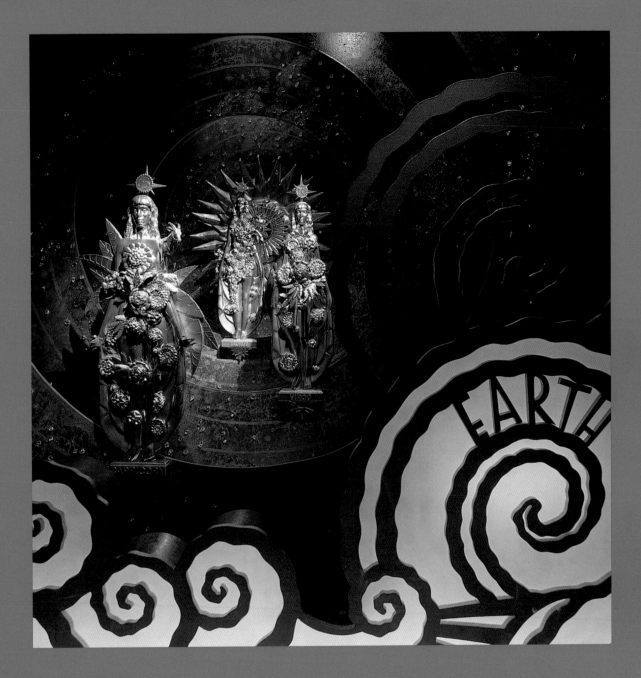

The deities of Taurus, Virgo and Capricorn combine forces to represent the practical element
of Earth (*above*), while the inspirational is represented in the Fire signs of Aries, Leo and
Sagittarius against a star-strewn backdrop (*opposite*).

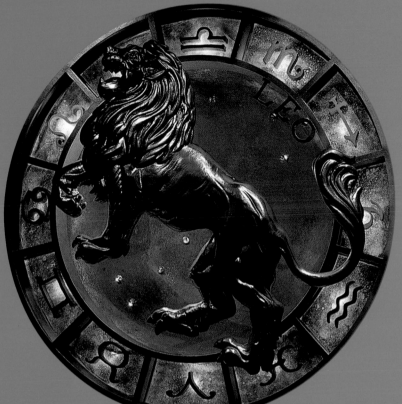

The element of Water (*opposite*) is reflected in the surrounding swirls that frame the signs of Cancer, Scorpio and Pisces.

Two backlit roundels represent Leo the lion (*above*) and Cancer the crab (*right*). A Fire sign, Leo represents the sun at its zenith and can be both benign and destructive by turn. Cancer is an aquatic sign and lunar symbol that, like the moon, can move forwards and backwards at will.

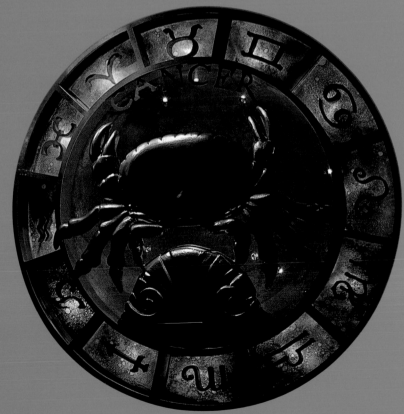

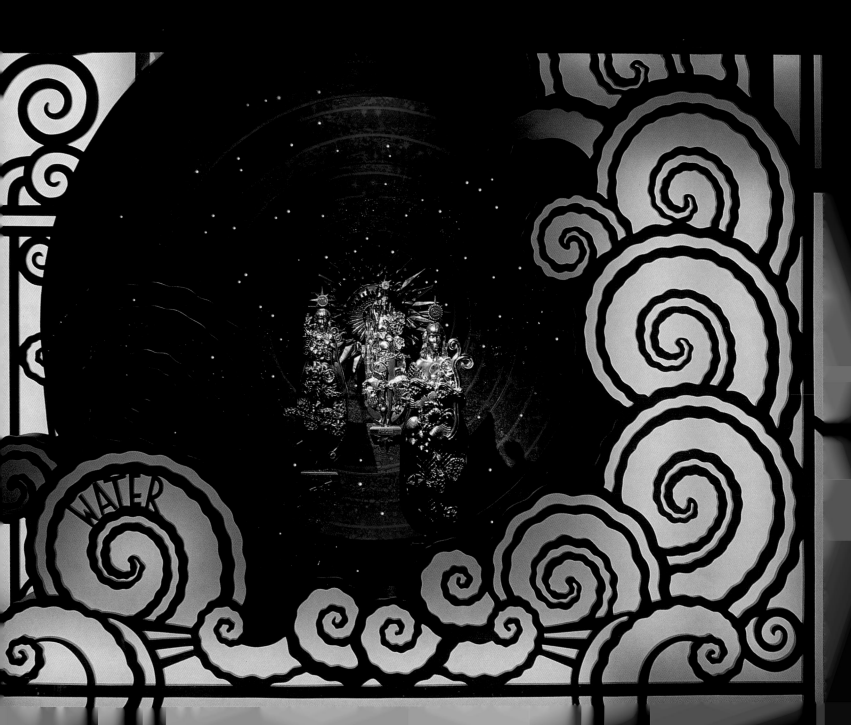

WATER

SENSATIONAL

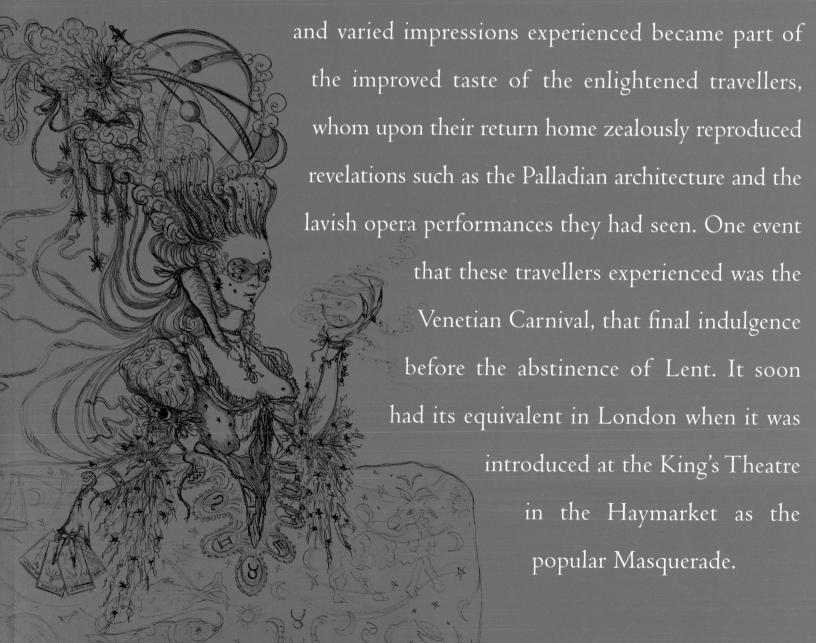

Behind a filmy gauze, light reveals the Sixth Sense (*opposite and below*). This figure of mysterious allure is dressed in a robe of night-sky blue chiffon strewn with stars, which is held by a pannier made up of armillary elements. The waist of the bodice is trimmed with embroidered cameos of signs of the zodiac, while her elaborate wig supports a full armillary sphere with a sun surrounded by strange planets. In one hand she holds tarot cards, in the other a crystal ball.

In eighteenth-century Britain, the essential education of the young, wealthy aristocrat was considered incomplete without the celebrated Grand Tour of Europe. The rich and varied impressions experienced became part of the improved taste of the enlightened travellers, whom upon their return home zealously reproduced revelations such as the Palladian architecture and the lavish opera performances they had seen. One event that these travellers experienced was the Venetian Carnival, that final indulgence before the abstinence of Lent. It soon had its equivalent in London when it was introduced at the King's Theatre in the Haymarket as the popular Masquerade.

THE
FORTNUM & MASON
THEATRE
of EPICUREAN
MARVELS
presents
AN ENTERTAINMENT IN THE MANNER OF A GRAND TOUR
MASQUERADE
PRODUCED TO BOTH NOURISH AND TANTALIZE
THE SENSES

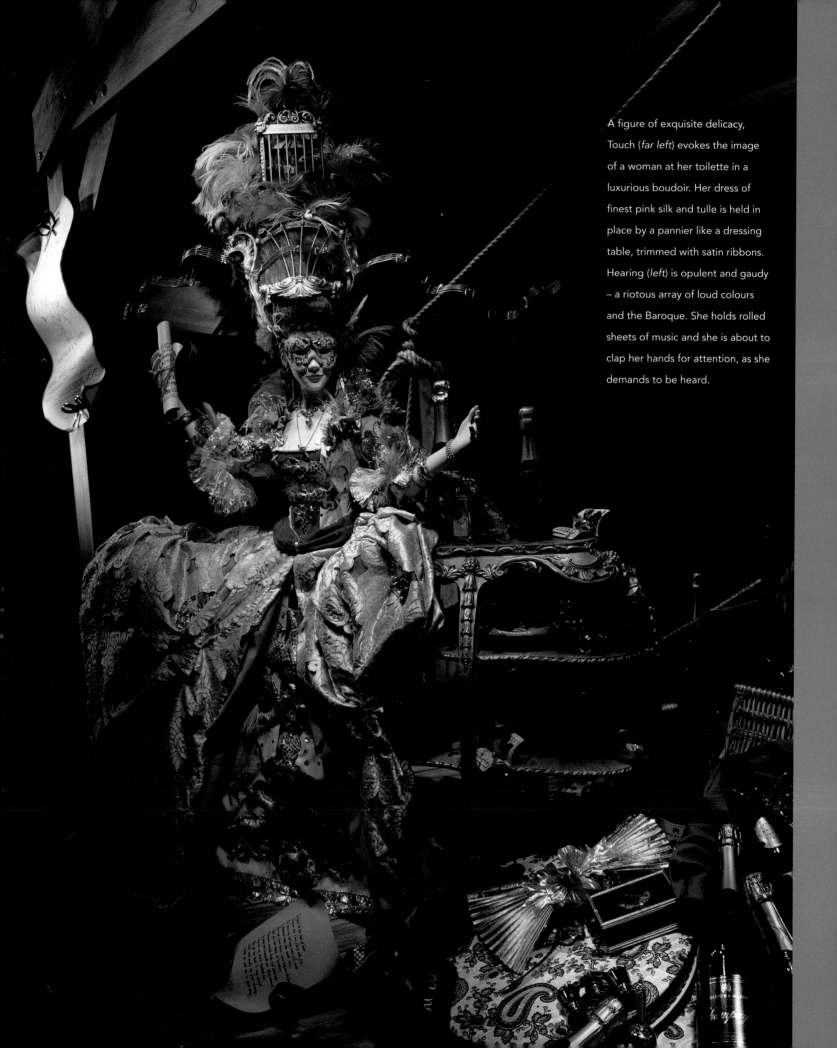

A figure of exquisite delicacy, Touch (*far left*) evokes the image of a woman at her toilette in a luxurious boudoir. Her dress of finest pink silk and tulle is held in place by a pannier like a dressing table, trimmed with satin ribbons. Hearing (*left*) is opulent and gaudy – a riotous array of loud colours and the Baroque. She holds rolled sheets of music and she is about to clap her hands for attention, as she demands to be heard.

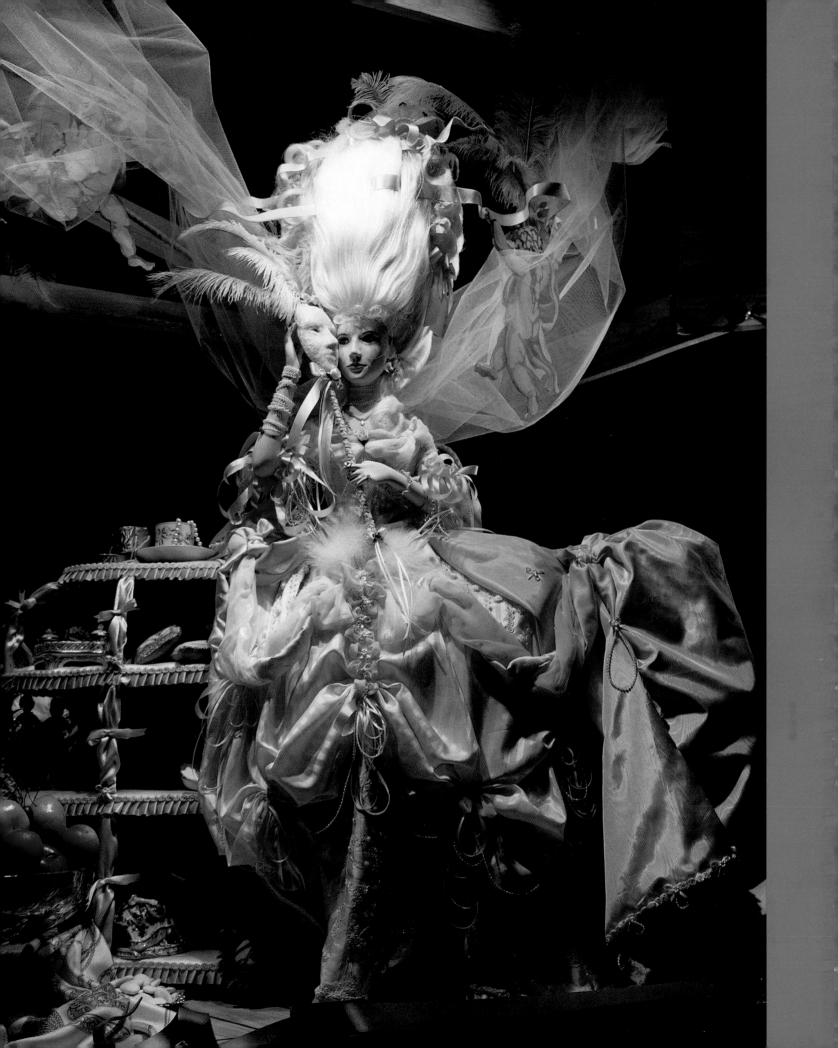

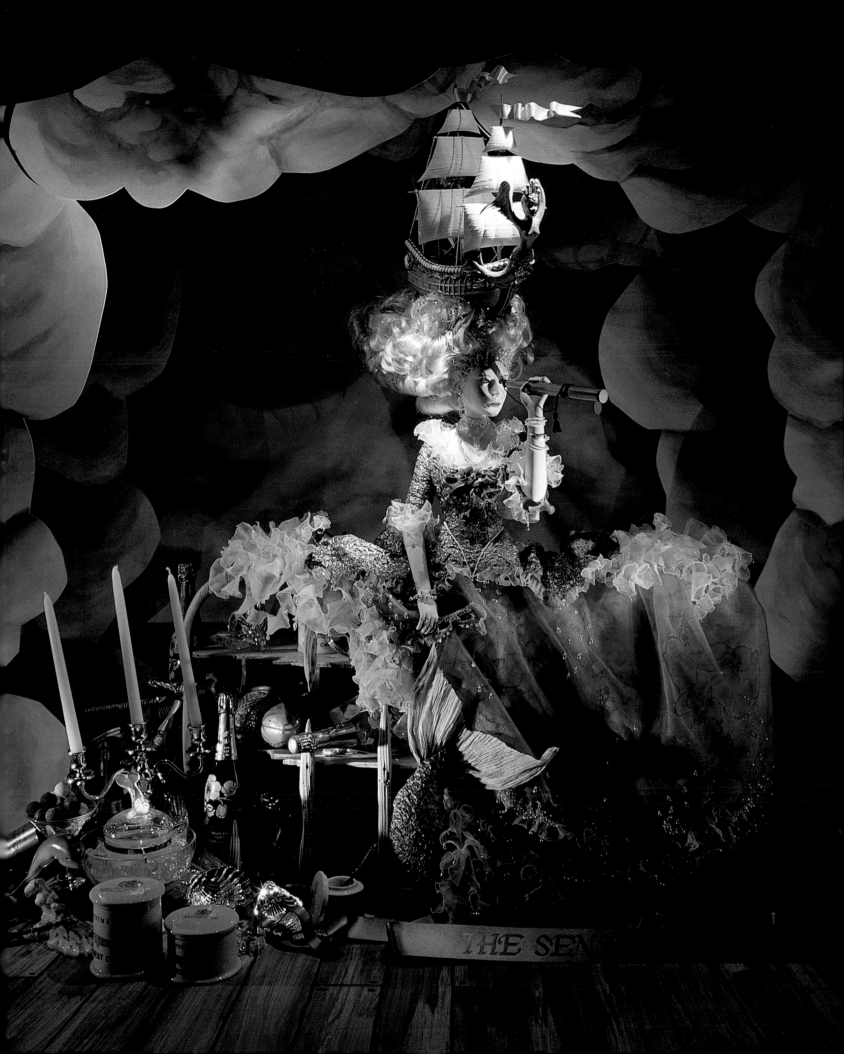

Although the operas and the plays of the day offered a spectacular array of magical stage effects, elaborate costumes and brilliant repartee, it was the irresistible opportunity for spectators to become players that made the Masquerade such an important part of eighteenth-century London society.

The Masquerade was the stimulus behind 'A Theatre of Epicurean Marvels'. Here, miniature figures based upon automaton dolls of the eighteenth century and dressed in elaborate masquerade costumes represent The Senses. They are set in a detailed model theatre of the period, complete with stage machinery. Magnificent in their eighteenth-century splendour, Taste, Touch, Smell and Hearing stand in the wings surrounded by backstage paraphernalia, waiting for the curtain to rise on Sight and the Sixth Sense. Their voluminous skirts are drawn back, to reveal the panniers, or skirt framework, beneath. Real-life panniers were also sometimes exposed in this manner as they were often of exquisite workmanship and decoration and were thought to be too beautiful to hide beneath a skirt. Here, they act as shelves upon which tempting epicurean delights indulge the senses.

The sense of Sight (*opposite*) has a nautical theme with undercurrents of wrecks and sunken treasure. Her chiffon gown falls in frothy frills like the crests of waves splashed with droplets of crystal. Beneath it, a pannier of bleached ship's timbers displays an array of Fortnum's treasures. Sight holds a spyglass to her eye, in search of more treasure.

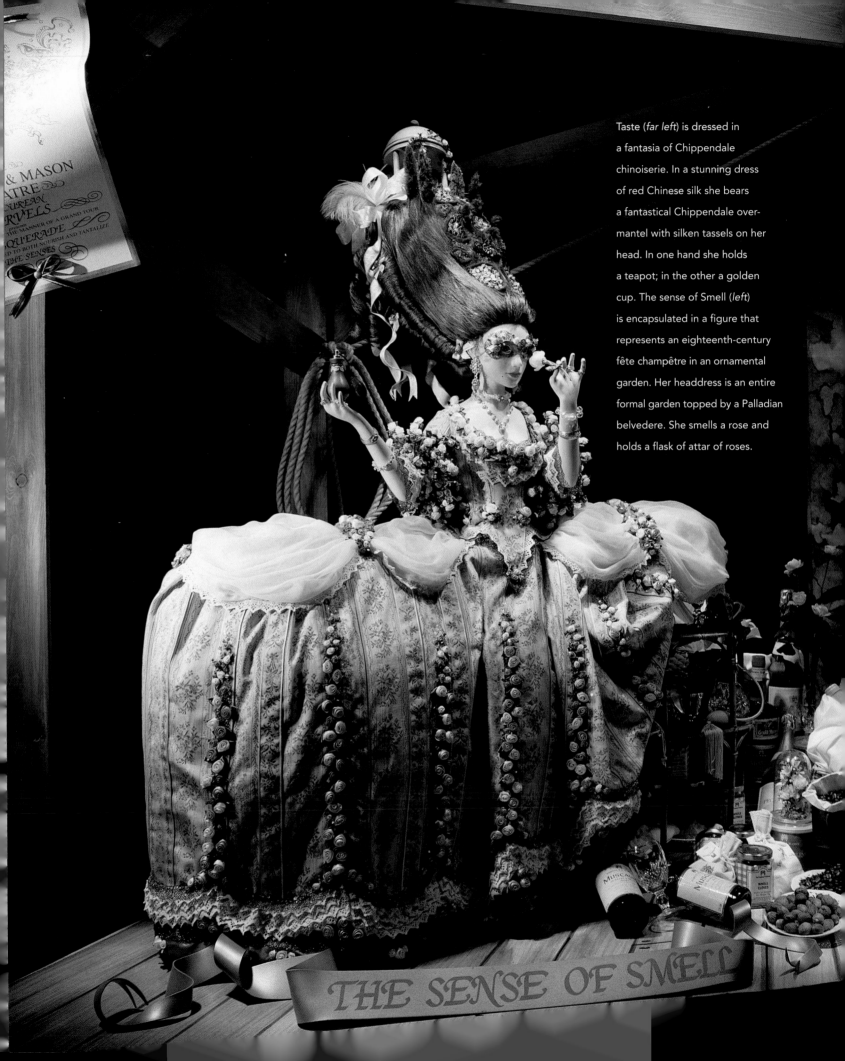

Taste (*far left*) is dressed in a fantasia of Chippendale chinoiserie. In a stunning dress of red Chinese silk she bears a fantastical Chippendale over-mantel with silken tassels on her head. In one hand she holds a teapot; in the other a golden cup. The sense of Smell (*left*) is encapsulated in a figure that represents an eighteenth-century fête champêtre in an ornamental garden. Her headdress is an entire formal garden topped by a Palladian belvedere. She smells a rose and holds a flask of attar of roses.

THE SENSE OF SMELL

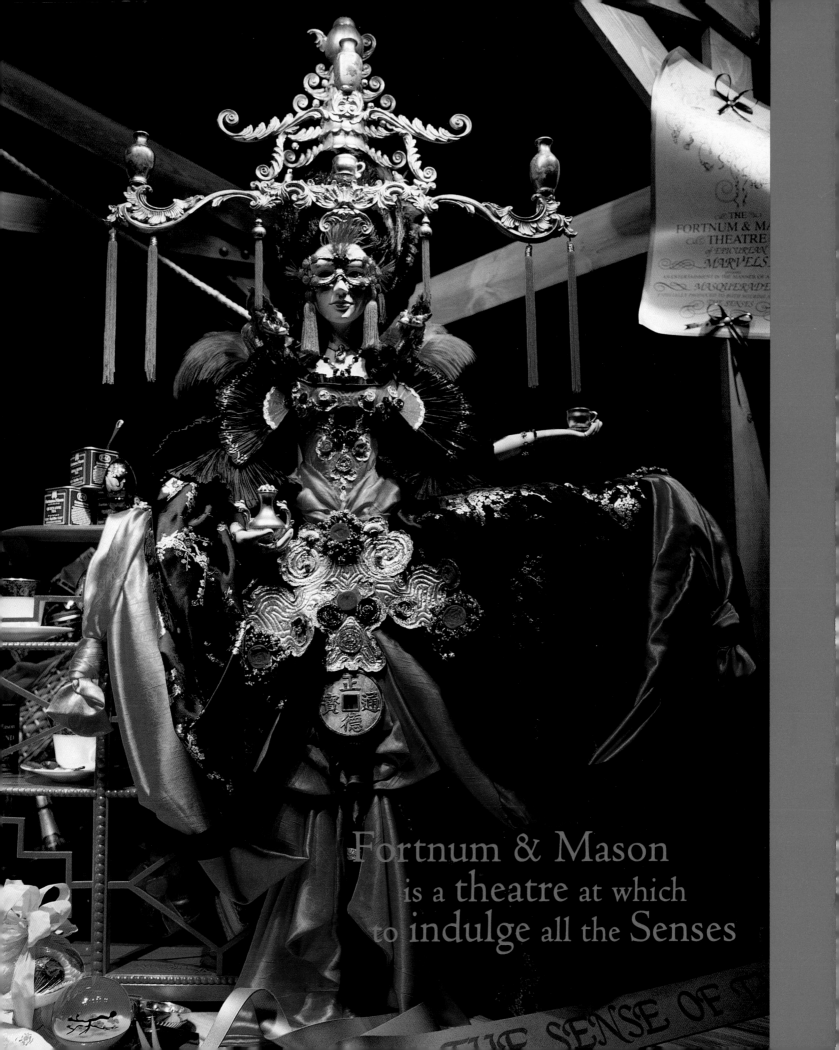

THE
FORTNUM & MA
THEATRE
of EPICUREAN
MARVELS

MASQUERADE

SENSES

Fortnum & Mason
is a theatre at which
to indulge all the Senses

THE SENSE OF S

PROGRESSION
OF THE DAY

A winged sun (*above*) shines over each window, its flaming rays increasing in progression to represent the passing of the time of day. In the tableau of dawn (opposite), Christ can be seen praying in a secluded place, where he is discovered by Simon and his followers. Nearby a sumptuous breakfast is being enjoyed by the inhabitants of the town of Capernaum, where Christ is staying.

To celebrate the first Christmas of the new Millennium, a series of tableaux taken from the New Testament describing Christ teaching at a particular time of the day or night were depicted. The realization of the scenes is inspired by the work of Cesare Ripa. Ripa compiled *Iconologia* (1593), his handbook of allegories and symbols, at a time when there was a widely held consensus about the way in which abstract ideas could be presented in a representational way. Concepts such as time, the virtues and the vices, and so on, were represented by figures and symbols. These ideas were based on religious, philosophical and even pagan symbols, as described by E H Gombrich in *Symbolic Images*.

Ripa intended his compendium to be used as a reference of metaphors for poets, preachers, artists, sculptors and theatrical designers. The installations shown here, based on the black and white engravings in the 1758–60 Hertel edition of *Iconologia*, were made three-dimensional in the manner of the elaborate and theatrical Neapolitan crèche. The colouration of the settings was strongly influenced by *Paradiso*, Giovanni Di Paolo's illuminated 1445 version of Dante's *Divine Comedy*.

Although *Iconologia* is a remarkable and influential book, relatively little is known about Ripa's life. It is believed that as a youth, Cesare Ripa worked at the court of Cardinal Salviati as a cook and eventually became a famous chef of his day. He was also majordomo of the household and acted as chief butler to other cardinals and princes for special occasions. This makes a pleasing connection with the founding Mr Fortnum, who also served as a butler in a royal court.

THE PROGRESSION OF THE DAY
The second phase: Meridies or Noon

'CHRIST PREACHING TO THE MULTITUDE'

*As sure as the eagle flies to the sun,
Will he who does God true peace have won*

ALLEGORY

The personification of midday is a blond winged male child with flame-coloured draperies. He flies through the air, holding a lotus blossom in one hand which reaches its full height and opens its flower at noon, with the radical symbol for Jupiter in the other. Midday is the sixth hour of the day, when the sun is at its Zenith and its rays are most powerful; hence the vigorous child wears the classical boots of the hunter or warrior. In the foreground is Mercury the mythical messenger of heaven.

Matthew 5:6
*Blessed are they which do hunger
and thirst after righteousness for
they shall be filled.*

TABLEAU

Jesus went throughout Galilee preaching in the temples and thus his fame spread throughout Syria and great crowds followed him through the Decapolis, Jerusalem, Judea and from beyond Jordan.

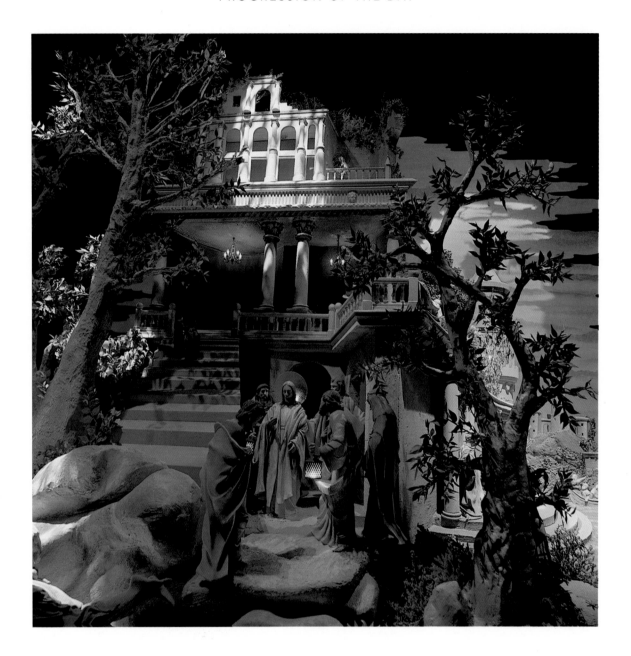

Midday (*opposite*) is a winged child with flame-coloured draperies, holding a lotus blossom in one hand, which opens its flower at noon. In the centre, Mercury, the mythical messenger of heaven, flies on winged feet. To the right of him Christ is seen preaching to the multitude. Evening is personified by Hesperus, the evening star (*above*), who is represented by a winged boy with a shining star on his head. The tableau shows Christ at the banquet given in his honour by Levi, the tax collector. Christ is discoursing with Nicodemus the Pharisee, who sought Christ's teaching under the cover of darkness (*page 157*). In the foreground, the allegorical figure of Night is a woman. On page 156 is the winged figure of Time.

Again the Almighty spake, 'Let there be lights
High in the expanse of heaven to divide
The day from night, and let them be for signs,
For seasons, and for days, and the circling years'

MILTON, PARADISE LOST

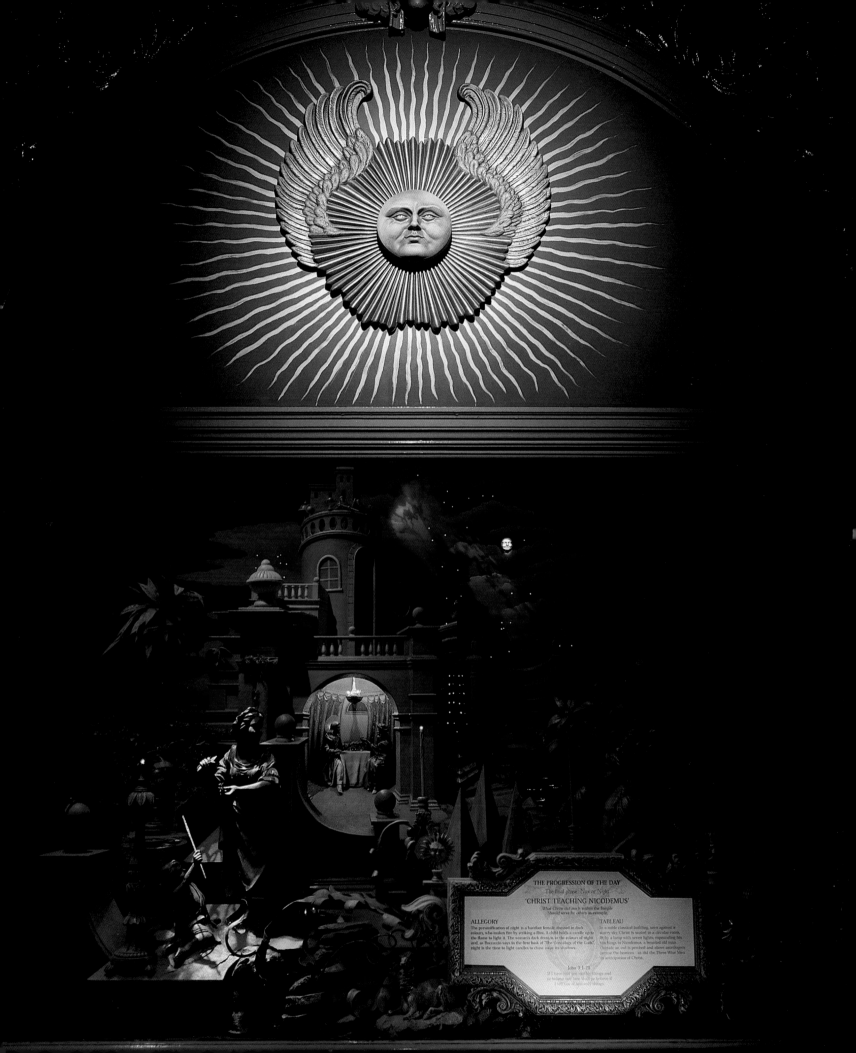

THE PROGRESSION OF THE DAY
The final phase: Now it Night

'CHRIST TEACHING NICODEMUS'
*What Christ did teach within the Temple
Should serve for others in example.*

ALLEGORY
The personification of night is a barefoot female, dressed in dark colours, who makes fire by striking a flint. A child holds a candle up to the flame to light it. The woman is dark dress is to the colours of night and, as Boccaccio says in the first book of 'The Genealogy of the Gods', night is the time to light candles to chase away its shadows.

TABLEAU
In a noble classical building, seen against a starry sky, Christ is seated in a circular room, lit by a lamp with seven lights, expounding his teachings to Nicodemus, a bearded old man. Outside an owl is perched and above astrologers peruse the heavens : as did the Three Wise Men in anticipation of Christ.

John 3:1-21
*If I have told you earthly things and
ye believe not, how shall ye believe if
I tell you of heavenly things.*

FORTNUM & MASON

Scene One
THE SPIRITUAL PROMISE
A protective armoury of twisted
branches and ice dutifully
guard Fay Viviane, the Lady of
the Lake, treasurer of the
magical sword, Excalibur, symbol
of intellectual aspiration and will.
An enchantress of the faerie
world, she is destined to
beguile the great wizard
Merlin, with prickly
indifference.

A LEGENDARY TALE

THE LEGEND OF ARTHUR

In the rich world of British folklore and mythology, the moral tale of King Arthur evokes a golden age of plenty and is compellingly evocative and enduring, with its potent blend of Celtic romance and Christian ethic. So this was the perfect way to depict the concept that Christmas at Fortnum's is legendary. Six characters from the Arthurian legends are portrayed in a highly symbolic winter setting where the atmosphere is one of enchantment and eeriness. The nostalgic world, inhabited by both men and spirits alike, who are entangled in the narrative of their own inescapable vanities, is germane to these resonant tales. It is the distillation of the supernatural, so vividly portrayed in the plays of Shakespeare, especially *Macbeth* and *Hamlet*, which gives such an evocative edge to the time of year.

Set in an icy, snowbound forest, the figures of Arthur, Guinevere, Morgan Le Faye, The Lady of the Lake and Merlin emerge from the ice as if they are lost in the drifts. To add to the sense of mystery, the figures are in a state of suspended metamorphosis and we are not sure whether they are emerging from, or disappearing into the gnarled and ancient trees of which they seem to be part.

The visual inspiration for this installation comes from Gustave Moreau, the nineteenth-century symbolist painter, who used ancient myths and fables as his sources. Moreau's work created a mysteriously enchanted world of forgotten dreams and indefinite shadows beyond time and space and appeared at a time when interest in the legend of Arthur was at its height. He influenced artists such as Salvador Dalí, who also plundered previous schools of painting without inhibition for his evocations of Ancient Greece, which blended profane and Christian iconography with implied impunity. The illustrations of Arthur Rackham, who convincingly represented the fairy world as if it actually existed, is also a key influence.

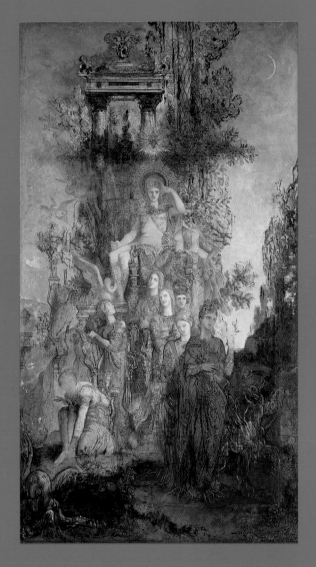

The Muses leaving their father Apollo to go and light the world, (1868) by Gustave Moreau (*above*). In this Olympian family portrait, the subjects appear as *dramatis personae* about to meet their destinies in a Greek drama. The Spiritual Promise (*opposite*). Fay Vivien, The Lady of the Lake, presents the sword Excalibur, the symbol of intellectual aspiration and will. An enchantress of the faerie world, she is destined to beguile the great wizard, Merlin. The eerie quality of this scene is intensified by winter's icy grip.

159

The Natural Realm (*above*). Bewitched by Vivien, Merlin is trapped for eternity in the ether of his own desire for knowledge. It is unclear whether he is emerging from, or retreating back into the tree. Two of his fingers are still part tree and taper to twisted twigs instead of finger nails. **The Mortal World** (*opposite*). Ice between the branches form a stained glass window trapping Guinevere, an icon of the material and formal aspect of life.

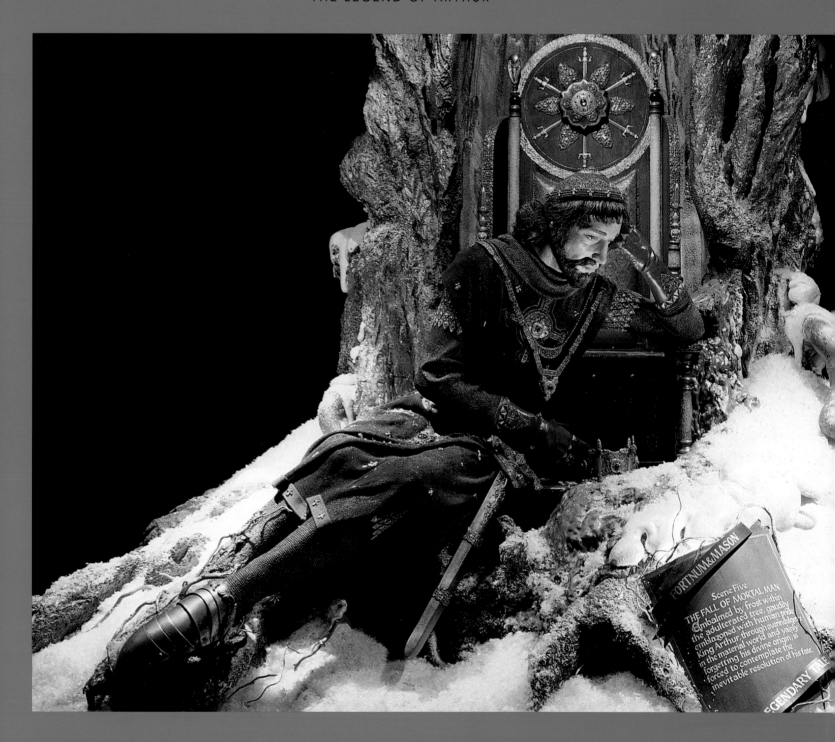

Nature's Dark Domain (*opposite*). The sorceress, Morgan le Fay, faerie half-sister to King Arthur, incessantly spins the web of fate. Her incestuous union with Arthur produces their son Mordred who will become Arthur's nemesis. **The Fall of Mortal Man** (*above*). Embalmed by frost, Arthur contemplates his fate on his destined throne, formed from an ancient tree.

The Perpetual Spirit
King Arthur is taken to Avalon,
the **mythical heaven,** where he awaits his
anticipated **return** to the round table.

THE ARABIAN NIGHTS

Enchantment by Maxfield Parrish (1913). The serene mood of this exotic portrait epitomizes the inspiration of this romantic scheme about Scheherazade and the Arabian Nights.

The love of Scheherazade and her Sultan is the embracing story of *The Arabian Nights*. There was once a Sultan who was so disillusioned with the fickle nature of humankind, that he could find no comfort in his life, not even through his fabulous wealth. On hearing of his despair, a young Indian maiden, named Scheherazade, who was as wise as she was beautiful, resolved to marry the Sultan although she knew that he had his wives executed the morning after the wedding as proof of their fidelity.

On their nuptial eve, Scheherazade began to tell her husband an enchanting story that utterly beguiled him. Tantalizingly, she broke the story before its end and promised to complete it the next night, thereby delaying her imminent death. The next night she finished the story and began another, which she again ingeniously left incomplete. The tales of Aladdin and his Enchanted Lamp, The Fisherman and the Djinn, Ali Baba and the Forty Thieves and many more, kept her husband spellbound and herself alive for 'one thousand and one nights'.

The story of Scheherazade's love, courage, wisdom and allure is the starting point for these serenely romantic scenes. Their ambience is enhanced by the unusual light emanating from two pillars lit from within, which seem to glow like amber or alabaster. The sets are based on one of Maxfield Parrish's illustrations for *The Arabian Nights* and create an opulent world of sensual and extravagant beauty in which Scheherazade can tell her fabulous tales. An identical set of stairs and columns appears in each of the four scenes, symbolic of the differing levels of awareness between the two characters. In the last scene, this physical barrier has dissolved into a tranquil lake on which Scheherazade and the Sultan are joined together in harmony. With them are their three children, who have appeared one by one in the previous scenes, indicative of the thousand and one nights passed.

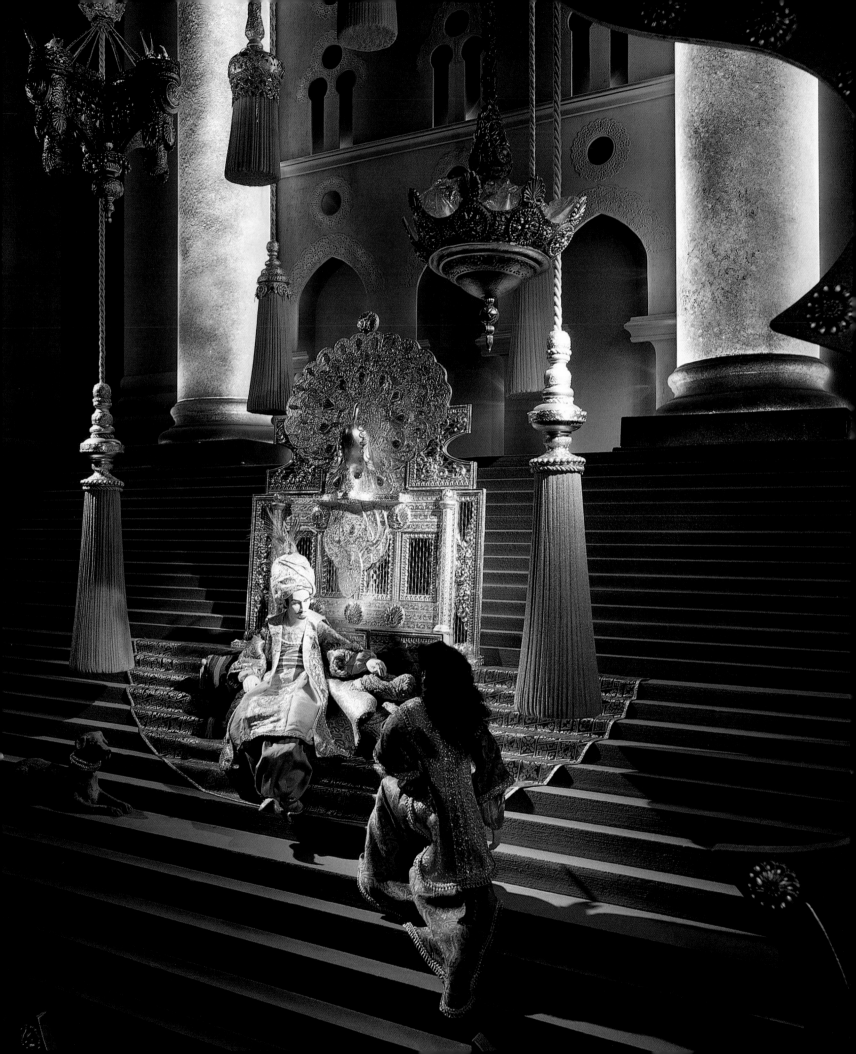

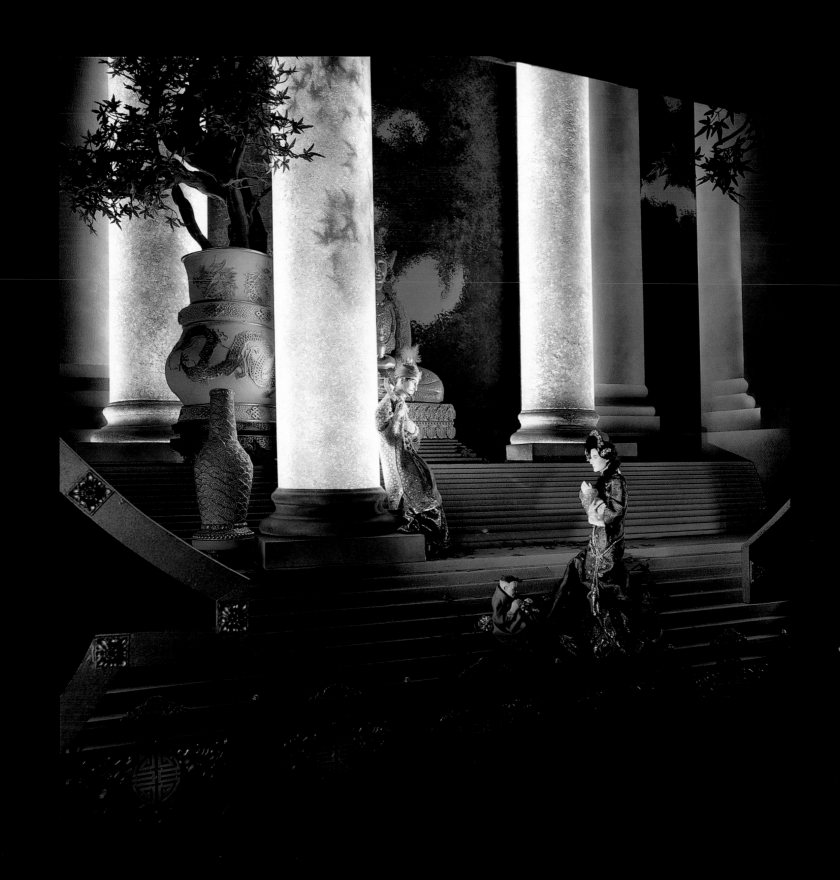

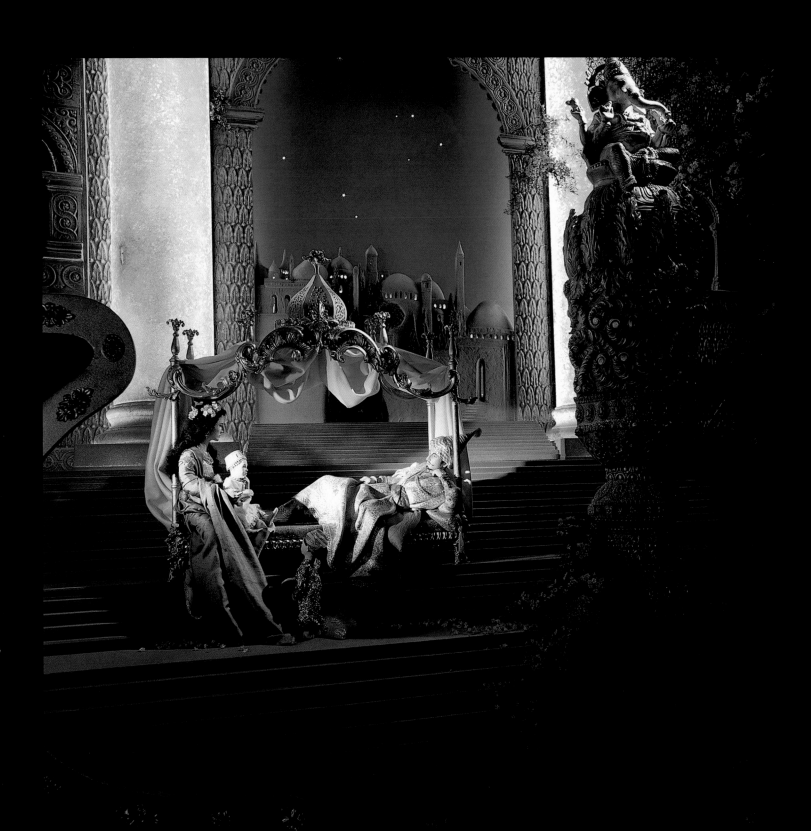

Scene One (interior, night, winter)
In the throne room of the Palace, the Sultan
hears the beginning of the first tale.

Scene Two (exterior, sunrise, spring)
In the Chinese garden of the Palace,
Scheherazade tells the tale of Aladdin
and the enchanted lamp.

Scene Three (interior, sunset, summer)
In the Indian pavilion of the palace, the Sultan
is told the story of the Fisherman and the Djinn.

Scene Four (exterior, moonlight, autumn)
On the ornamental lake of the Palace,
a boat drifts by with the Sultan, Scheherazade
and their three children, lit by the light
of the ever-constant moon.

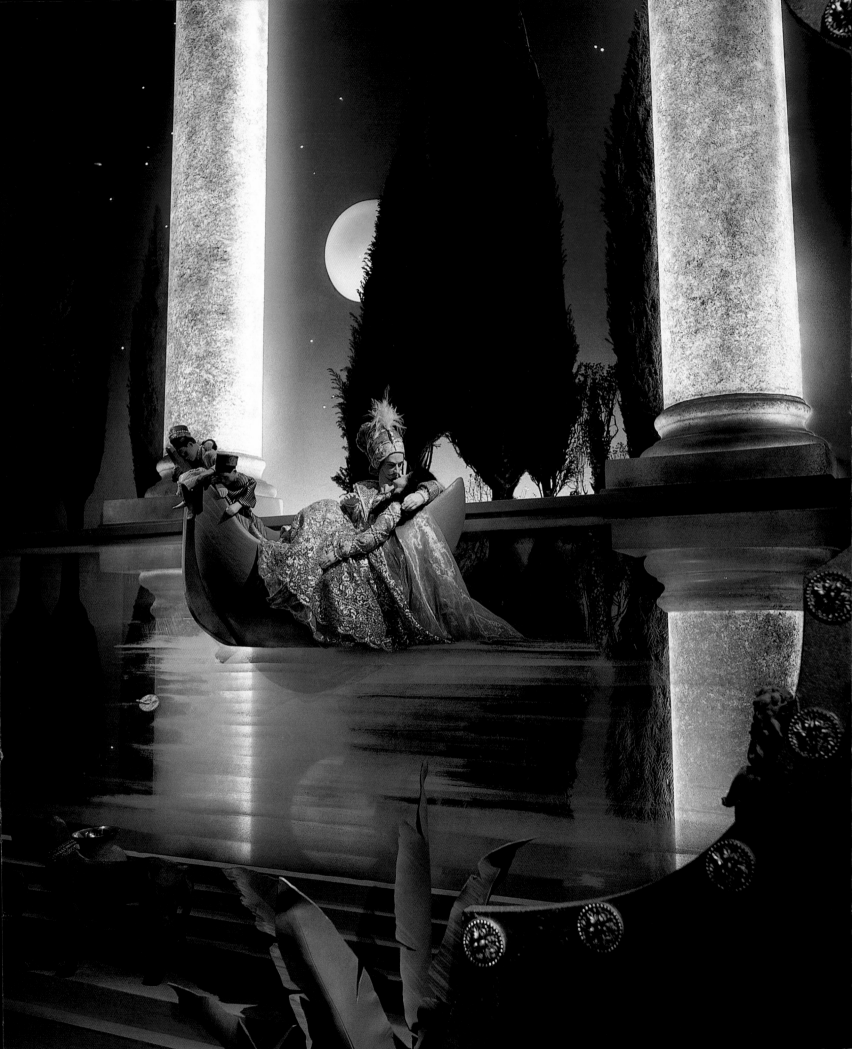

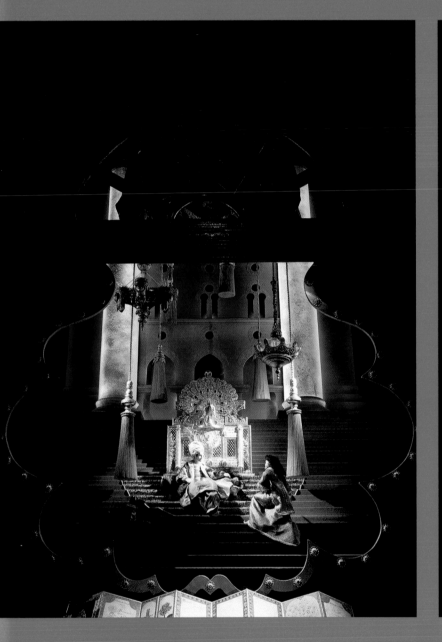
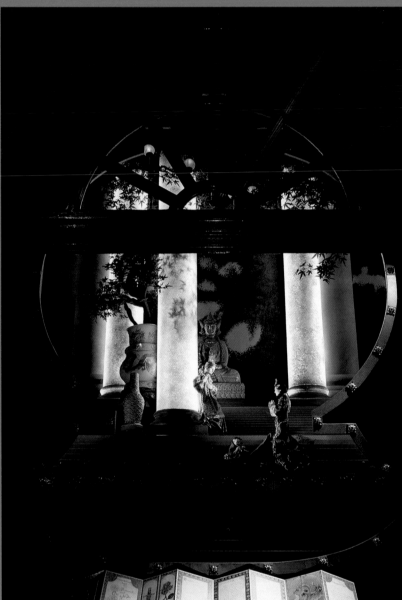

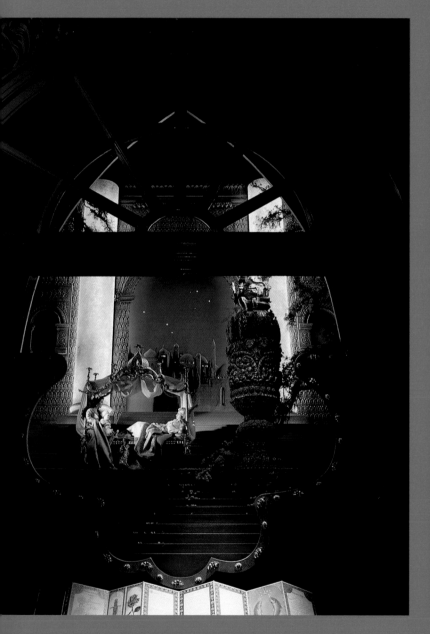
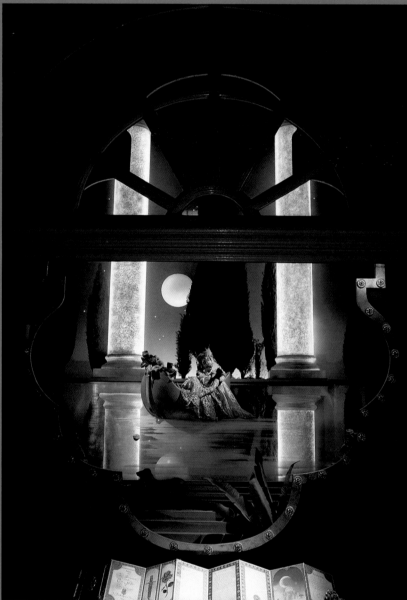

INDEX

ACKNOWLEDGEMENTS

Picture credits

Conran Octopus would like to thank the following photographers and organisations for their kind permission to reproduce the photographs in this book:

The Fortnum & Mason window displays were photographed by
Melvyn Vincent 1, 2–3, 4, 9, 14–9, 32–3, 35–41, 43, 45–7, 49–55, 57–63, 76–9, 86–97, 112–123, 130–143, 152–7, 167–9, 171–3.
David Edwards 20–30, 65–70, 73–75, 80–5, 99–101, 103–110, 124–6 128–9, 145–50, 158, 161, 163–5.
Martin Wonnacott 160, 162.

Jacket photography by David Edwards, except for back jacket by Melvyn Vincent.

6 AKG London/Erich Lessing; 10 AKG London/Kingdom of Spain/DACS 2001.; 11 Tate Gallery, London (Kingdom of Spain, universal heir of Salvador Dali/DACS 2001); 12 Christie's Images Ltd. (ADAGP, Paris and DACS, London 2001.); 44 Christie's Images Ltd.; 48 The Shickman Gallery, New York.; 98 left Telimage (Man Ray Trust/ADAGP, Paris and DACS, London 2001.); 102 Telimage (Man Ray Trust/ADAGP, Paris and DACS, London 2001.); 111 Phototeque Rene Magritte-GIRAUDON (ADAGP, Paris and DACS, London 2001.); 159 Bridgeman Art Library (Musee Gustave Moreau, Paris/Giraudon); 166 Artshows and Products (Photo courtesy of the Archives of the American Illustrators Gallery, New York City.)

Every effort has been made to trace the copyright holders. We apologise in advance for any unintentional omission, and would be pleased to insert the appropriate acknowledgement in any subsequent edition.

Author acknowledgements

This book is the collaboration of many individuals, and I gratefully thank everyone who has so passionately supported my work, both within and outside the company.

In particular, I must sincerely thank the Chairman and Directors of Fortnum & Mason whose enthusiastic support has been crucial to this project.

The creation of these windows has required the employment of many dedicated artists, sculptors and technicians, who released the ideas from my drawing board. Although it is not possible to acknowledge everyone, I would like to name two: firstly Janet Fairhead, who controls the In-house Merchandise Team and is responsible for all the styling throughout the windows, the virtuosity of which speaks for itself. The other is Rod Holt, who has faithfully created some of the most intricate installations from my designs with painstaking devotion to detail, and who always achieves the highest standard possible.

Bibliography

Baroque Baroque: The Culture of Excess
Stephen Calloway
Phaidon, London, 1994

Gustave Moreau – Between Epic and Dream
Geneviève Lacambre
The Art Institute of Chicago, 1999

Magritte
Jacques Meuris
Tabard Press, New York, 1988

Man Ray – Bazaar Years
John Esten
Rizzoli, New York, 1998

Maxfield Parrish
Coy Ludwig
Academy Editions, London, 1974

My Time At Tiffany's
Gene Moore
St Martin's Press, New York, 1990

Salvador Dalí – A Mythology
Dawn Ades and Fiona Bradley
Tate Gallery Publishing, London, 1999

Vital Mummies
Performance Design For The Show Window Mannequin
Sara K Schneider
Yale University Press, New Haven & London, 1995

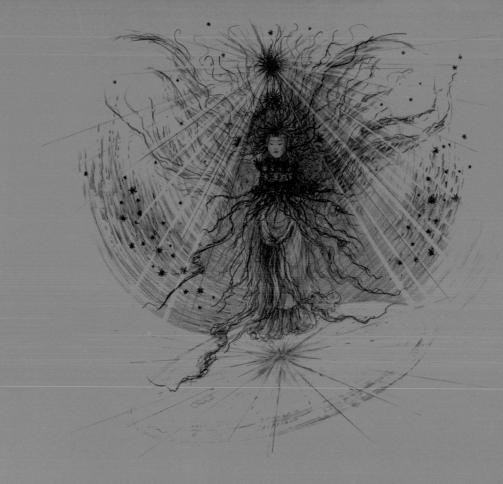

First published in 2001 by
Conran Octopus Limited
a part of Octopus Publishing Group
2–4 Heron Quays
London E14 4JP

www.conran-octopus.co.uk

Publishing Director Lorraine Dickey
Senior Editor Muna Reyal

Creative Director Leslie Harrington
Art Editor Megan Smith
Picture Researcher Sarah Hopper

Production Director Zoe Fawcett
Senior Production Controller Manjit Sihra

FORTNUM & MASON is a registered Trade
Mark of Fortnum & Mason plc and is used
with its permission.

British Library Cataloguing-in-Publication Data.
A catalogue record for this book is available
from the British Library.

ISBN 1 84091 186 7

Colour origination by Sang Choy International,
Singapore

Printed in China

WITHDRAWN